£ 2·00
D3

SOURCES AND DOCUMENTS IN THE
HISTORY OF ART SERIES

H. W. JANSON, *Editor*

D1423855

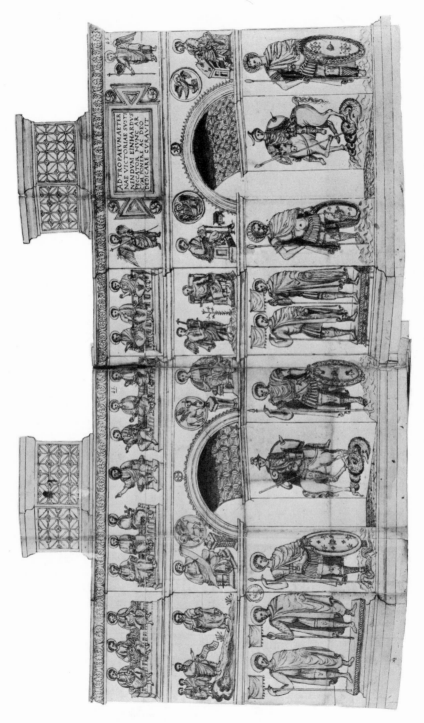

Einhard's lost silver reliquary in the form of a triumphal arch, 820, anonymous drawing of the 17th century. Photo: Bibliothèque Nationale, Paris.

Early Medieval Art

300-1150

SOURCES and DOCUMENTS

Caecilia Davis-Weyer

Newcomb College
(Tulane University)

PRENTICE-HALL, INC.
Englewood Cliffs, New Jersey

© 1971 by PRENTICE-HALL, INC., *Englewood Cliffs, New Jersey*

All rights reserved. No part of this book may be reproduced in any form, by mimeograph or any other means, without permission in writing from the publisher.

Library of Congress Catalog Card Number: 70–135404

Printed in the United States of America 13–222364–3

Current Printing (Last Digit)

10 9 8 7 6 5 4 3 2 1

PRENTICE-HALL INTERNATIONAL, INC., *London*
PRENTICE-HALL OF AUSTRALIA, PTY. LTD., *Sydney*
PRENTICE-HALL OF CANADA, LTD., *Toronto*
PRENTICE-HALL OF INDIA (PRIVATE) LIMITED, *New Delhi*
PRENTICE-HALL OF JAPAN, INC., *Tokyo*

Contents

Preface

The time span covered by this anthology extends over 850 years. The conversion of Constantine, the fall of Rome, the rise of the papacy and the early history of France, England and Germany all fall within this period. To maintain some degree of cultural unity in a time of such turbulent and radical change required the unremitting efforts of patrons, artists and intellectuals, who had to gain their own sense of historical continuity by submitting to what must have been an often painful process of education and transformation. The paucity of early medieval records tends to give a false air of impersonality to the art of this period, making us forget how very large a role individual choice and initiative had to play in its making. I have tried to correct this impression of anonymity by including a rather large number of selections that allow us to catch a glimpse of the activities of such patrons and artists as Theodoric, Charlemagne, Sidonius, Wilfred, St. Bernward, or St. Eloy.

Another obvious duty of this anthology was to make more easily accessible those sources which describe some of the significant lost monuments of this period. Reliable and instructive descriptions are hard to come by before the twelfth century. Those I have included are for the most part well known and have been used by art historians for many years. Few of them, however, have been translated, and for good reason. The somewhat equivocal character of medieval Latin becomes most apparent in factual accounts and descriptions, where seldom used words may assume a variety of meanings. I have tried to avoid a misleading preciseness in my translations, without having always been able to avoid the opposite pitfall of excessive vagueness.

In this anthology I have also tried to convey an impression of the very peculiar and somewhat illogical attitude early medieval intellectuals and theologians had towards the visual arts. This attitude seems to have been shaped by two contradictory considerations: admiration for the Roman past and its art on the one hand and, on the other, the never quite suppressed memory that images had been a scandal to both Jews and early Christians. Rome to the early middle ages meant a variety of things. It was the city of Peter and Paul and the seat of the Pope. It was also the city of Augustus and Trajan, great and just emperors who were remembered as having brought peace to their centuries. The religious and

political aspects of Rome coincided in the figure of Constantine who had christianized the empire and romanized the church. His lavish patronage was the model that early medieval princes and bishops tried to emulate. To build and adorn churches "according to the Roman manner" was for them not only a question of prestige but often also one of orthodoxy.

Latin theologians however, remained always somewhat embarrassed by the fact that art played such a conspicuous role in the church. The tradition of patronage, established with the authority of Constantine and the popes, made it impossible for them to indulge in wholesale condemnation. They therefore either let the subject alone or relegated art to a rather limited didactic function. It was only about 1100 that more positive attitudes began to appear. Unlike Byzantium, the early medieval West never produced a consistent theology of art. This gap in western theory left artists and patrons considerable freedom and allowed that variety and exuberance which made early medieval art so striking. Furthermore, when a specific religious function was denied to art, the way was opened for a return to pagan and allegorical themes, taken from mythology.

Many of my selections have been published in the anthologies of J. v. Schlosser, Victor Mortet, Otto Lehmann-Brockhaus and Elizabeth Gilmore Holt. Professor Richard Krautheimer was kind enough to bring others to my attention. I am grateful to him and my editor, Professor H. W. Janson for their encouragement and valuable advice. I am also grateful to Professor Richard M. Frazer for advice on certain difficult points of translation, and to Mrs. Frank V. Davis for reading the manuscript and offering many useful suggestions. I owe a special debt of gratitude to my husband, without whose help and encouragement I could never have undertaken or finished this project. Finally I extend my warm thanks to Miss Josephine Reid, who patiently and accurately retyped much of the manuscript.

CAECILIA DAVIS-WEYER

I

Early Christian Attacks

on

Idols and Images

TERTULLIAN: THE ARGUMENT FROM SCRIPTURE

Christians were not the first to attack idols. The Old Testament prohibited them and even forbade the making of a likeness. This view was emphatically reiterated by Tertullian. His Treatise On Idolatry, *which was written for a Christian audience, does not deal with idolatry as its title proposes, but with a more limited question. Can an artist, a maker of images and likenesses, be a Christian? Tertullian denies this passionately. At the same time he must acknowledge that artists are not only admitted into the church but into the priesthood as well. The bitter tone of Tertullian's attack seems to imply that he wrote against well established habits and that the church by 200 was accustomed to tolerate images as well as their makers. It is highly unlikely that a priest or any other Christian should have produced idols for pagan patrons, as Tertullian seems to imply. But for Tertullian there was no difference between an idol and a likeness. Scripture forbade both. Since every likeness, even that of an animal, might become the object of an idolatrous cult, it was mere sophistry to introduce a distinction between the two. For a Christian who had the misfortune to be also an artist Tertullian had only one piece of advice: he must give up art and become a simple workman.*

For some time in the past there existed no idol. Before the makers of this monster had risen up like mushrooms, there were only temples and the sanctuaries were empty, as in some places traces of the old state of affairs have maintained themselves even to our day. Yet idolatry was practised, not under that name but in actual fact, for also in our day it may be practised outside a temple and without an image. But as soon as the devil had brought into the world the makers of statues, portraits and every kind of representation, that practice so pernicious to man, which was still in a primitive stage, received from the idols both its name and its development, and then accordingly every form of art producing an idol in whatever way became a source of idolatry. . . .

Both the making and the worship of an idol are forbidden by God. Insofar as the making of a thing precedes its worship, so far, if the worship is unlawful, the prohibition of its making logically precedes the prohibition of its worship. For this reason, that is, in order to root out the material occasion of idolatry, the Divine Law proclaims: "you shall make no idol," and by adding to this: "nor a likeness of the things which are in heaven and which are on earth and which are in the sea,"[1] it has denied to the servants of God the practice of these arts to the whole world. For

[1] Exod. 20: 4–5.

3

had not he² gone before who prophesied this, that namely the demons and the spirits, that is the apostate angels, would employ all elements, everything belonging to the world, everything that the heaven, the sea and the earth contain, for idolatrous purposes, in order that these things should be consecrated against God instead of God Himself? Everything, therefore, is worshipped by human error except the Creator of everything Himself. The images of these things are idols, the consecration of the images is idolatry.

Every offence committed by idolatry must of necessity be imputed to every maker of every idol. Thus in his threat the same Enoch forejudges at the same time both the worshippers and the makers of an idol: "And again I swear to you, sinners, that unrighteousness has been prepared for the day of the destruction of blood. You, who serve stones and who make images of gold and silver and wood and stone and clay and serve ghosts and demons and spirits in sanctuaries and all errors, not according to knowledge, you will not find any help among them!" Further Isaiah says: "you are My witnesses whether there is a God except Me. And at that time there did not exist those who model and sculpt, all vain fools, who make things to their liking which will not avail them." And the whole subsequent pronouncement execrates makers and worshippers alike; it ends up with: "know that their heart is ashes and earth and that nobody can deliver his own soul."³ Where David equally includes the makers, he says: "may such become those who make these things."⁴ And why should I, a man of limited memory, suggest anything more, remind you of anything more from Scripture? As if either the voice of the Holy Spirit were not sufficient, or as if it deserved any further consideration, whether the Lord has in advance cursed and damned the makers of those things, of which He curses and damns the worshippers.

... If no law of God had forbidden us to make idols, if not a single pronouncement of the Holy Spirit threatened the makers of idols no less than their worshippers, even then we should infer simply from our sacrament of baptism that such forms of art are contrary to our faith. For how have we renounced the devil and his angels if we make them? What repudiation have we pronounced against them, I do not say: with whom, but on whom we live? What discord have we affected with them to whom we are bound for the sake of our subsistence? Can you deny with your tongue what you profess with your hands? Demolish with words what you build up in deed? Preach one God whereas you make so many? Proclaim the true God whereas you make false ones? "I make and do not worship," someone says. As if there were any reason for which he dare not worship

²Tertullian is referring here to Enoch, and citing the apocryphal book of Enoch 19: 1-3, which he regards as Scripture.
³Isaiah 44: 8, 9, 20.
⁴Psalms 115: 8.

except that one, for which he also should not make, that is, the offense to God in both cases. On the contrary, it is exactly you who worship, since you make worship possible. . . .

Each day the zeal of the faith might speak at length complaining about the following point: that a Christian comes from the idols into the church, comes from the worship of the enemy into the house of God, raises to God the father the hands that are the mothers of idols, prays to Him with the very hands whose works outside are prayed to against God, touches the Lord's body with those hands which give a body to the demons. Even this is not enough! It would be still too little if they would receive from other hands what they defile; no, they even transmit to others what they have defiled: makers of idols are chosen into the the ecclesiastical order. What a crime! The Jews have only once laid violent hands on Christ, but they illtreat His body daily. O hands deserving to be cut off! It is immaterial to me if this has been said as a similitude: "if your hand scandalizes you, you cut it off."[5] What hands are more worthy to be cut off than those in which the body of the Lord is scandalized?

Of course I shall take special care to answer the excuses of this kind of artist, who should never be admitted to the house of God. . . . Straightaway those words which are usually raised as an objection: "I have nothing else to live by," can be severely retorted: "so you must live? What have you to do with God, if you live according to your own laws?" . . . If the necessity of maintenance is extended so far, then the arts may offer some other branches providing the means to live without a transgression of the discipline, that is without the making of an idol. The stuccoworker also knows how to mend buildings and make plaster-work and to polish a cistern and trace ogees and to variegate the appearance of walls by way of many other decorations apart from images. Both a painter and a marblemason and a bronze-worker and any engraver know extensions of their trade belonging to their own province and which are at any rate much easier. For whoever designs an image, how much more easily does he plaster a panel! Who carves a Mars from lime-wood, how much more quickly does he put together a chest! There is no art which is not either the mother or the relative of another. Nothing is without connection with something else. The ramifications of the arts are as numerous as the desires of men. "But as to the payment and wages there is a difference!" Likewise there is a difference in labour. A smaller reward is made good by the fact that the work is done more often. How many walls ask for pictures? How many temples and chapels are built for idols? Dwellings on the other hand, and country houses and baths and tenement houses in how great numbers! A shoe and a sandal are gilded daily, a Mercury and a Serapis not daily. Luxury and ostentation will surely be sufficient to the

5 Matt. 18:8.

earnings of handicrafts, and at any rate they are more frequent than any form of superstition. Dishes and cups will rather be desired by ostentation than by superstition. Wreaths, too, are more used by luxury than by religious ceremonies.[6]

MINUCIUS FELIX: A PHILOSOPHICAL ARGUMENT
(c. 200)

Unlike Tertullian's treatise On Idolatry, *Minucius Felix's* Octavius *was written for pagan readers. Its setting is idyllic: a discussion of religion on the beaches of Ostia by three friends. Two of them are Christians, and the third a pagan soon to be converted. The language and the arguments are carefully chosen to appeal to a cultivated non-Christian audience. There are no quotations from Scripture, and nowhere in the dialogue is mention made of Christ. Minucius Felix's remote Godhead, which can neither be seen nor represented, is the god of a philosopher rather than the god who took human form in Christ. This incongruence troubled neither Minucius nor other Christian writers, who, like him, were eager to absorb those strains of pagan speculation that were critical of image worship.*

Do you suppose we conceal our objects of worship because we have no shrines and altars? What image can I make of God, when, rightly considered, man is an image of God? What temple can I build for him, when the whole universe, fashioned by his handiwork, cannot contain him? Shall I, a man, housed more spaciously, confine within a tiny shrine power and majesty so great? Is not the mind a better place of dedication? our inmost heart, of consecration? Shall I offer to God victims and sacrifices which he has furnished for my use, and so reject his bounties? That were ingratitude, seeing that the acceptable sacrifice is a good spirit and a pure mind and a conscience without guile. He who follows after innocence makes a prayer to God; he who practises justice offers libations; he who abstains from fraud propitiates; he who rescues another from peril slays the best victim. These are our sacrifices, these our hallowed rites; with us justice is the true measure of religion.

But you say, the God we worship we neither show nor see. Nay, but herein is the ground of our belief that we can perceive him, though we cannot see. For in his works, and in the motion of the universe, we behold

6 *Quinti Septimi Florentis Tertulliani de Idolatria*, Chaps. 3–7, ed. and trans., Proefschrift door Pieter Gijsbertus van der Nat (Leiden: Saint Lucas Society, 1960), pp. 16–19. Reprinted by permission of the author.

his ever present energy: in the thunder and the lightning, in the thunder-bolt or the clear sky. It is no cause for wonder if you see not God; wind and storm drive, toss, disorder all things, yet the eyes see not wind and storm. We cannot look upon the sun, which is to all the cause of vision; its rays dazzle our eyesight; the observer's vision is dimmed, and if you look too long all power of sight is extinguished. How could you bear the sight of the author of the sun itself, the fountain of light, when you turn your face from his lightnings and hide from his shafts? do you expect to see God with the eyes of the flesh, when you can neither see nor lay hold of your own soul, the organ of life and speech?[7]

[7] Reprinted by permission of the publishers and the Loeb Classical Library, from Minucius Felix, *Octavius*, Chap. 32, 1–6, trans. G. H. Rendall (Cambridge, Mass.: Harvard University Press; London: William Heinemann Ltd., 1953), pp. 413–15.

2

The Christian Empire

IMPERIAL FOUNDATIONS

Constantine's victory at the Milvian Bridge (312) made him master of Rome and the western half of the Empire. His Christian biographers claim that Christ bestowed this victory on the Emperor. Constantine seems to have believed this also, for he showed his gratitude by beginning soon afterward a long series of munificent gifts to the Christians of Rome and to their bishop. A great many churches were built, some on a scale hitherto reserved for public and imperial architecture. Among them were the Lateran Basilica, Rome's cathedral, built within the city and large enough to hold a congregation of several thousands, and the Vatican Basilica, a church of similar size built outside the city over a site which supposedly contained the grave of St. Peter. The Emperor's gifts of land as well as of gold and silver must have been carefully recorded at the time, for the anonymous sixth-century compiler of the Book *of the Popes was able to include in his life of Sylvester lists of Constantine's donations which seem to be authentic.*

Constantine's Gifts to the Lateran and St. Peter's (313-37)

The Book of the Popes

In his time Constantine Augustus built the following basilicas and adorned them: the Constantinian basilica,[1] where he offered the following gifts: a ciborium of hammered silver, which has upon the front the Saviour seated upon a chair, in height 5 feet, weighing 120 lbs., and also the 12 apostles, who weigh each 90 lbs., and are 5 feet in height and wear crowns of purest silver; further, on the back, looking toward the apse are the Saviour seated upon a throne in height 5 feet, of purest silver, weighing 150 lbs., and 4 angels of silver, which weight each 105 lbs. and are 5 feet in height and have jewels from Alabanda[2] in their eyes and carry spears; the ciborium itself weighs 2025 lbs. of wrought silver; a vaulted ceiling of purest gold; and a lamp of purest gold, which hangs beneath the ciborium, with 50 dolphins[3] of purest gold, weighing each 50 lbs., and chains which weigh 25 lbs.

4 crowns[4] of purest gold with 20 dolphins, weighing each 15 lbs.;
a covering for the length and breadth of the apse vault of the basilica of purest gold, weighing 500 lbs.;

[1] The Lateran basilica.
[2] A precious stone, named after a region in Asia Minor (Arab-Hissar).
[3] Dolphin shaped pendants of a chandelier which served as receptacles for the oil.
[4] Circular chandeliers.

7 altars of purest silver, weighing each 200 lbs.;

7 golden patens, weighing each 30 lbs.;

16 silver patens, weighing each 30 lbs.;

7 goblets of purest gold, weighing each 10 lbs.;

A single goblet of coral set all about with prases and jacinths and overlaid with gold, which weighs in all 20 lbs. and 3 ounces;

20 silver goblets, weighing each 15 lbs.;

2 pitchers of purest gold, weighing each 50 lbs. and holding each 3 medimni;[5]

20 silver pitchers, weighing each 10 lbs. and holding each one medimnus;

40 smaller chalices of purest gold, weighing each one lb.;

50 smaller chalices for service, weighing each 2 lbs.

For ornament in the basilica:

a chandelier of purest gold before the altar, wherein burns pure oil of nard, with 80 dolphins, weighing 30 lbs.;

a silver chandelier with 20 dolphins, which weighs 50 lbs., wherein burns pure oil of nard;

45 silver chandeliers in the body of the basilica, weighing each 30 lbs., wherein burns the aforesaid oil;

on the right side of the basilica 40 silver lamps, weighing each 20 lbs.;

25 silver chandeliers on the left side of the basilica, weighing each 20 lbs.;

50 silver candelabra in the body of the basilica, weighing each 20 lbs.;

3 jars of purest silver, weighing each 300 lbs., holding 10 medimni;

7 brass candlesticks before the altars, 10 feet in height, adorned with figures of the prophets overlaid with silver, weighing each 300 lbs.;

and for maintenance of the lights there he granted . . .[6]

At the same time Constantine Augustus built the basilica of blessed Peter, the apostle, in the shrine of Apollo,[7] and laid there the coffin with the body of the holy Peter; the coffin itself he enclosed on all sides with bronze, which is unchangeable: at the head 5 feet, at the feet 5 feet, at the right side 5 feet, at the left side 5 feet, underneath 5 feet and overhead 5 feet: thus he enclosed the body of blessed Peter, the apostle, and laid it away.[8]

And above he set porphyry columns for adornment and other spiral columns which he brought from Greece.

He made a vaulted apse in the basilica, gleaming with gold, and

5 Three bushels.

6 There follows a list of gifts of land made by Constantine to the Lateran basilica. They were all situated in regions which were in Constantine's possession by 312, a fact which is thought to indicate that the Lateran basilica was founded soon after Constantine's entry into Rome in 312.

7 The passage may refer to the sanctuary of Cybele, which was near St. Peter's.

8 This description of St. Peter's tomb was not confirmed by the arrangements found underneath the high altar of the church during the recent excavations.

over the body of the blessed Peter, above the bronze which enclosed it, he set a cross of purest gold, weighing 150 lbs.,... and upon it were these words: "CONSTANTINE AUGUSTUS AND HELENA AUGUSTA ... THIS HOUSE ... SHINING WITH LIKE ROYAL SPLENDOR A COURT SURROUNDS,"[9] inscribed in clear letters of niello work.

He gave also 4 brass candlesticks, 10 feet in height, overlaid with silver, with figures in silver of the acts of the apostles, weighing each 300 lbs.;

3 golden chalices, set with 45 prases and jacinths, weighing each 12 lbs.;

2 silver jars, weighing 200 lbs.;

20 silver chalices, weighing each 10 lbs.;

2 golden pitchers, weighing each 10 lbs.;

5 silver pitchers, weighing each 2 lbs.;

a golden paten with a turret of purest gold and a dove, adorned with prases, jacinths and pearls, 215 in number, weighing 30 lbs.;

5 silver patens, weighing each 15 lbs.;

a golden crown before the body, that is a chandelier, with 50 dolphins, which weighs 35 lbs.;

32 silver lamps in the basilica, with dolphins, weighing each 10 lbs.;

for the right of the basilica 30 silver lamps, weighing each 8 lbs.;

the altar itself of silver overlaid with gold, adorned on every side with gems, 400 in number, prases, jacinths, and pearls, weighing 350 lbs.;

a censer of purest gold adorned on every side with jewels, 60 in number, weighing 15 lbs.

Likewise for revenue, the gift[10] which Constantine Augustus offered to blessed Peter, the apostle, in the diocese of the East.[11]

Prudentius: St. Peter's and St. Paul's in 400

Prudentius begins his poem on the martyrdom of St. Peter and St. Paul with a description of the two Roman sanctuaries dedicated to them. He wastes no word on the Vatican basilica but was obviously much taken with the beauty of the new baptistery, which had been added by Pope Damasus (366–84), who also built the aqueduct which furnished it with water and at the same time drained the Vatican hill. The basilica of St.

9 This inscription has been emended to read: "Constantine Augustus and Helena Augusta beautify with gold this royal house, which a court shining with like splendor surrounds."

10 A subsequent list of gifts of land made by Constantine to the Vatican basilica includes territories which came into the Emperor's possession only after 324. The foundation of this basilica must therefore be dated during the second half of Constantine's reign, a period in which he himself resided in Constantinople.

11 *The Book of the Popes*, trans. and annot. L. R. Loomis, *Records of Civilization*, No. 3 (New York: Columbia University Press, 1916), pp. 47–49. Reprinted by permission of Columbia University Press.

Paul was probably only just finished when Prudentius saw it during his
stay in Rome between 401 and 403. It had been founded in 386 by the
Emperors Valentinian II, Theodosius and Arcadius to replace a smaller
Constantinian church, and was still under construction in 390. By focus-
sing his descriptions on color and light, Prudentius evoked the image of an
architecture as luminous and airy as the heavenly dwellings in which
Theodosian mosaics depict the saints. He chose his metaphors, moreover,
entirely from nature, thus interspersing his descriptions with a taste of
Paradise.

People are gathering more than is usual for rejoicings. Tell me,
friend, what it means. All over Rome they are running about in
exultation.

Today we have the festival of the apostles' triumph coming round
again, a day made famous by the blood of Paul and Peter. . . .

Tiber separates the bones of the two and both its banks are con-
secrated as it flows between the hallowed tombs. The quarter on the right
bank took Peter into its charge and keeps him in a golden dwelling,
where there is the grey of olive-trees and the sound of a stream; for water
rising from the brow of a rock has revealed a perennial spring which
makes them fruitful in the holy oil. Now it runs over costly marbles, glid-
ing smoothly down the slope till it billows in a green basin. There is an
inner part of the memorial where the stream falls with a loud sound and
rolls along in a deep, cold pool. Painting in diverse hues colours the glassy
waves from above, so that mosses seem to glisten and the gold is tinged
with green, while the water turns dark blue where it takes on the sem-
blance of the overhanging purple, and one would think the ceiling was
dancing on the waves. There the shepherd himself nurtures his sheep
with the ice-cold water of the pool, for he sees them thirsting for the rivers
of Christ.

Elsewhere the Ostian Road keeps the memorial church of Paul,
where the river grazes the land on its left bank. The splendour of the
place is princely, for our good emperor dedicated this seat and decorated
its whole extent with great wealth. He laid plates on the beams so as to
make all the light within golden like the sun's radiance at its rising, and
supported the gold-panelled ceiling on pillars of Parian marble set out
there in four rows. Then he covered the curves of the arches with splen-
did glass of different hues, like meadows that are bright with flowers in
the spring.

There you have two dowers of the faith, the gift of the Father
supreme, which He has given to the city of the toga to reverence. See, the
people of Romulus goes pouring through the streets two separate ways,
for the same day is busy with two festivals. But let us hasten with
quickened step to both and in each get full enjoyment of the songs of

praise. We shall go further on, where the way leads over Hadrian's bridge,[12] and afterwards seeks the left bank of the river. The sleepless bishop performs the sacred ceremonies first across the Tiber, then hurries back to this side and repeats his offerings. It is enough for you to have learned all this at Rome; when you return home, remember to keep this day of two festivals as you see it here."[13]

Galla Placidia's Church of St. John the Evangelist in Ravenna

In memory of a storm at sea during which she had invoked the aid of St. John the Evangelist, the Empress Galla Placidia founded a church dedicated to him in Ravenna in 426. The earliest mention of it occurs in Agnellus' ninth-century life of St. Peter Chrysologus, bishop of Ravenna from 425 to 449. But the most comprehensive description of it is by G. Rossi, a learned historian of the Christian antiquities of Rome and Ravenna, who saw it shortly before it was pulled down in 1568. According to his account, published four years later, the mosaics of the apse and apse wall contained portraits of at least fifteen Christian emperors, their wives and their children, most of whom belonged to the family of the Empress. When Galla Placidia came to Ravenna as regent for her young son Valentinian III, she obviously seized the opportunity to begin her rule by building a church which would not only express her gratitude for a miraculous deliverance but would also be a monument to the reigning family. Although the worldly purpose of this church seems unusually evident, its fusion of piety and imperial propaganda was probably typical of much of the art produced within the orbit of the court.

Agnellus: A Ninth Century Description of the Portrait of St. Peter Chrysologus

And on account of his (S. Peter Chrysologus') great holiness, Galla Placidia ordered his picture to be executed in mosaic in the church of St. John the Evangelist, behind and above the seat where the pontiff sits. The portrait is made thus: it shows him with an ample beard, his hands uplifted as if chanting mass. The host is placed on the altar and close to the altar God's angel is depicted as he receives the pontiff's prayers.[14]

[12] The bridge which led to the tomb of the Emperor Hadrian, today's Castel Sant'Angelo.

[13] Reprinted by permission of the publishers and the Loeb Classical Library from Prudentius, *Crowns of Martyrdom*, XII, 1–4, 29–66, trans. H. J. Thompson, Vol. II. (Cambridge, Mass.: Harvard University Press, London: William Heinemann Ltd., 1953), 323, 325–27.

[14] Agnellus, *Liber Pontificalis, Petrus* I, Chap. XVII, ed. A. Testi Rasponi, *Codex Pontificalis Ecclesiae Ravennatis, Raccolta degli Storici Italiani ... Ordinata da L. A. Muratori*, new edition, Vol. I. (Bologna, 1924), 74–75.

G. Rossi: A Sixteenth-Century Description of the Mosaics

At the same time Galla Placidia built a church in honor of St. John the Evangelist in Ravenna. . . . Rare stones from all over the world were used and suitable columns were prepared. The floor was inlaid with mosaics. On the walls, also in mosaic, [Galla Placidia's] peril at sea and her vow were depicted. Toward the east Galla Placidia built the apse, which rests on two very large columns, incrusted by her with gilded silver. One saw there also the Lord in majesty presenting a book to the Evangelist, underneath which was written *St. John the Evangelist*. On both sides was the glassy sea, on which two ships were agitated by turbulent storms and powerful winds. In one St. John has come to the aid of Placidia. There are also the seven chandeliers[15] and other mystical images from the Apocalypse. Furthermore there are images of Constantine, Valentinian, Gratian and others who belong to the imperial family. To them referred the inscription *Galla Placidia fulfilled her vow for herself and for all these*. The following portraits were on the arch of the apse, five on the right side with the following inscriptions: *Divus Constantinus,*[16] *Divus Theodosius,*[17] *Divus Arcadius,*[18] *Divus Honorius,*[19] *Theodosius Nepos;*[20] on the left wall: *Divus Valentinianus,*[21] *Divus Gratianus,*[22] *Divus Constantinus,*[23] *Gratianus Nepos, Ioannes Nepos.*[24] Close to the choir bench at the right in the outermost position were: *Dominus Theodosius and Domina Eudokia;*[25] at the left: *Dominus Arcadius and Domina Eudoxia Augusta.*[26]

In the middle of the apse vault was a most beautiful image of our

15 Apoc. 1: 12.

16 Constantine the Great, Roman Emperor (306–37).

17 Theodosius the Great, Roman Emperor (379–95), Galla Placidia's father.

18 Arcadius, Roman Emperor in the East (395–408), son of Theodosius and brother of Galla Placidia.

19 Honorius, Roman Emperor in the West (395–423), son of Theodosius and brother of Galla Placidia.

20 Theodosius Nepos, a son of Galla Placidia from her marriage to the Visigoth Ataulf (414). Theodosius Nepos died in infancy.

21 Probably Valentian II, Roman Emperor in the West (375–92).

22 Gratian, Roman Emperor in the West (367–83), brother of Valentinian II.

23 The reference to Constantine is probably a misspelling of the name of Constantius III, Roman Emperor in the West (421), Galla Placidia's second husband and the father of Valentinian III and Justa Grata Honoria.

24 Gratianus Nepos and Iohannes Nepos, were probably sons of Theodosius and brothers of Galla Placidia who died as children.

25 Theodosius II, Roman Emperor in the East (408–50) and his wife Athenais-Eudokia. Theodosius II was a son of Arcadius and a nephew of Galla Placidia.

26 Children of Theodosius II and Athenais-Eudokia. Eudoxia afterwards married Valentinian III (437).

Lord, seated on a throne and illuminating the whole basilica. He was sur-
rounded by the twelve holy books, which are sealed. This image remained
always visible, wherever one stood in the church. It had the following
inscription: *The Empress Galla Placidia with her son the Emperor Placi-
dus Valentinianus*[27] *and her daughter Iusta Grata Honoria*[28] *fulfills her
vow for her deliverance from the sea.* The Lord Christ himself carried an
open book in which was written: *Blessed are the merciful, for they shall
obtain mercy.*[29] There was also, as we have already mentioned, a portrait
of Peter Chrysologus saying Mass, amazed by the heavenly presence that
receives his prayer. The following inscription has been attached to the
images of the Emperors: *"Confirm, O God, what thou hast wrought in us.
From Thy temple in Jerusalem, kings shall offer presents to Thee."*[30]

EARLY CHRISTIAN ICONOGRAPHY

Paulinus of Nola: The Decoration
of his Churches

*In 394 Paulinus and his wife left their native Spain for Campania,
the south Italian province that he had administered during his earlier,
secular career as an imperial official. Both had decided to settle by the
tomb of St. Felix in the vicinity of Nola and there to dedicate themselves
and their considerable fortune to the service of Christ and his martyr.
Like many of his rich and pious contemporaries, Paulinus devoted his
wealth and energy to the endowing and constructing of churches.*

*He completely remodeled an older structure over the grave of St.
Felix, built a new basilica to the north of the older one and joined both
by a small but exquisitely finished courtyard. A few years later he added
two more buildings and a larger courtyard to the complex. He also
adorned the old as well as the new church with paintings and mosaics,
fragments of which have been recovered during recent excavations.*

*In a poem written in the first years of the fifth century Paulinus
describes a cycle of scenes from the Old Testament to Nicetas,*[31] *a visiting*

27 Valentinian III, Roman Emperor in the West (425–55), son of Galla
Placidia and Constantius III. Cf. fn. 23.

28 Honoria, daughter of Galla Placidia and Constantius III (cf. fn. 23).
Honoria fell into disgrace in 434; a date earlier than this year must therefore
be assigned to the mosaic decoration of San Giovanni Evangelista.

29 Matt. 5: 7.

30 Psalms 67: 29–30. The selection is taken from H. Rossi, *Historiarum
Ravennatum libri decem* (Venice: Paolo Manuzio, 1572), pp. 85–86.

31 Nicetas was bishop (366?-414) of Remesiana near Naissus, today's Nish.

*friend. The frescoes were probably painted along the walls of the new
church, above the colonnades which divided nave and aisles.*

*Paulinus seems to have been well aware of a lingering hostility to
images in the church. He takes great care to point out that they have been
introduced merely in order to instruct and edify the simple-minded. The
allegorical interpretations however, which Paulinus attaches to the scenes
of Ruth and Orpah, betray his own involvement and interest in iconog-
raphy and make this excuse seem somewhat disingenuous.*

Biblical Frescoes in the New Basilica of Nola

Now I desire thee to see the paintings on the porticoes decorated
with a long series and to take the slight trouble of bending thy neck back-
wards, taking stock of everything with head thrown back. He who on see-
ing this recognizes Truth from the idle figures, feeds his faithful spirit
with a by no means idle image. For the painting contains in faithful order
everything that ancient Moses wrote in five books,[32] what Joshua did,
marked by the name of the Lord, under whose guidance the Jordan stayed
with its current in its momentum, the waves remaining fixed, and fell
back before the countenance of the divine Ark. An unknown force divided
the river, a part stopped because of the water having flowed back and a
part of the river, gliding on, rushed seawards and left the bed dry, and at
the side where the river with powerful current poured forth from its
source, it had held fast and piled high the waves and as a quivering mass
a water mountain hung menacing, seeing beneath it that feet were cross-
ing a dry bottom and that in the middle of the river-bed dusty human
soles were speeding over hard mud without the feet getting wet.[33] Now
run tense eyes over the portraiture of Ruth, who separates periods by a
booklet, the end of the time of Judges and the beginning of that of Kings.
This seems to be a short history, but it points to the mysteries of a great
war that two sisters part from each other for different regions.

Ruth follows her holy relative, whom Orpah leaves;[34] one daughter-
in-law gives proof of faithlessness, the other of faithfulness. The one places
God above her country, the other her country above life. Does not, I ask,
this discord remain in the whole world, as a part follow God and a part
rush through the world? And if only the part of death and that of salva-
tion were equal, but the wide road takes many, and irrevocable error
sweeps down those who slip.

It may be asked how we arrived at this decision, to paint, a rare
custom, images of living beings on the holy houses.

[32] The Pentateuch: Genesis, Exodus, Leviticus, Numbers and Deuteronomy.
[33] Josh. 3.
[34] Ruth 1: 6–22.

Hark and I will attempt briefly to expound the causes. What crowds the glory of St. Felix drives hither, is unknown to none; the majority of the crowd here, however, are peasant people, not devoid of religion but not able to read. These people, for long accustomed to profane cults, in which their belly was their God, are at last converted into proselytes for Christ while they admire the works of the saints in Christ open to everybody's gaze.

See how many from all parts come together and how they look wonderingly round, their rude minds piously beguiled. They have left their remote dwellings, they despised the hoar frost, not becoming cold because of the fire of their faith. And now, behold, in great numbers and waking they extend their joy over the whole night, keeping sleep from them with merriment and the darkness with torches. If only, however, they would spend this joy with wholesome wishes and not intrude into the sacred houses with their beakers! Even though a sober congregation lets us hear a preferable service making the sacred hymns ring with undefiled voices, and presenting a song of praise to the Lord as an offering without having drunk, I think such joys should be pardoned, if they derive them from small meals, because the error stole upon rude minds; and simplicity, unconscious of such heavy guilt, falls in piety, in the false belief that the saints are glad when reeking wine is poured over their graves. . . .

Therefore it seemed to us useful work gaily to embellish Felix' houses all over with sacred paintings in order to see whether the spirit of the peasants would not be surprised by this spectacle and undergo the influence of the coloured sketches which are explained by inscriptions over them, so that the script may make clear what the hand has exhibited. Maybe that, when they all in turn show and reread to each other what has been painted, their thoughts will turn more slowly to eating, while they saturate themselves with a fast that is pleasing to the eyes, and perhaps a better habit will thus in their stupefaction take root in them, because of the painting artfully diverting their thoughts from their hunger. When one reads the saintly histories of chaste works, virtue induced by pious examples steals upon one; he who thirsts is quenched with sobriety, the result being a forgetting of the desire for too much wine. And while they pass the day by looking, most of the time the beakers are less frequently filled, because now that the time has been spent with all these wonderful things, but few hours are left for a meal.[35]

[35] Paulinus of Nola, *Carmina* XXVII, 512–95 in *Paulinus' Churches at Nola*, Academisch Proefschrift door Rudolf Carel Goldschmidt (Amsterdam: N.V. Noord-Hollandische Uitgevers Maatschappig, 1940), pp. 61–65. Reprinted by permission of the publishers.

Apse Mosaics in Nola and Fundi

Paulinus' letter to Sulpicius Severus,[36] written in 403, was sent to a friend who lived in Gaul and who, like Paulinus, was busy with the construction of a new church. The letter described the church that Paulinus had built at Nola and another, not yet finished, that he had founded at nearby Fundi. Paulinus had composed a number of poetic inscriptions for both churches, among them two long poems explaining their apse mosaics. From these poems we learn that the themes of the mosaics, "The Trinity" and "The Last Judgement," were depicted with emblems and symbols drawn from scriptural metaphor and imperial imagery. Some of their elements, the lamb, the dove, the palm tree, the purple cloth and the wreath, appear on many other Christian monuments of the fourth and early fifth centuries and were not invented by Paulinus. The compositions as a whole, however, were probably his own.

Paulinus' letter lets us catch a glimpse of the learned iconographer at work. He was as much the author of the iconographic programs as of the poems which accompanied them and took an equal pride in both.

That basilica, therefore, which has been dedicated to the Lord God, our common Protector, in the name of Christ, and is now added to His four other basilicas, is venerable not only on account of the cult of blessed Felix but also by virtue of the holy relics of apostles and martyrs placed under the altar within the three-fold apse. The apse, which has a floor and walls of marble, is adorned by a vault decorated with luminous mosaics: their pictures are explained by the following verses:

In full mystery sparkles the Trinity:
Christ stands as a lamb, the voice of the Father thunders from heaven
and in the form of a dove the Holy Ghost flows down.
The Cross is surrounded by a wreath, a bright circle,
around which wreath the apostles form again a wreath,
the image of whom is expressed in a chorus of doves.
The holy unity of the Trinity meets in Christ,
Who likewise has His insignia in threefold:
being revealed as God by the Fatherly voice and the Ghost,
the Cross and the Lamb testifying Him as the sacred sacrificed One,
Kingdom and Triumph being indicated by the purple and the palm.
He Himself, the Rock of the Church, is standing on a rock
from which four seething springs issue,
the Evangelists, the living streams of Christ.

On the girdle under it, where a border of plaster has been inserted

[36] Sulpicius Severus, a friend and countryman of Paulinus, settled in Tours after the death of his wife in 392 and became a follower and the first biographer of St. Martin of Tours. He died between 420 and 425.

which connects or separates the meeting of wall and vault, the following inscription indicates the holy of holies which has been laid down under the altar:

> Here is piety, here invigorating faith, here Christ's glory;
>> here the Cross is brought together with its martyrs.
> Since a little chip of the wood of the Cross is a big pledge
>> and in a diminutive piece of it the whole power of the Cross is present.
> This, brought to Nola by the gift of Saint Melania,[37]
>> came as highest good from the city of Jerusalem.
> The holy altar enwraps a double gift of honour to God,
>> as it brings together with the Cross the ashes of Apostles.
> How well the bones of saints are combined with the wood of the Cross,
>> so that those who were killed for the Cross, find rest on the Cross!

The whole space, however, outside the apse of the basilica widens under a high and coffered ceiling, with similar colonnaded aisles on either side, each having one row of columns following each other, arch after arch on each side. Four little rooms within the colonnades inserted in the longitudinal sides of the basilica offer suitable places for the isolation of those praying or meditating in the law of the Lord, besides furnishing for the graves of the religious and their households places to rest in eternal peace. Each room is marked on the lintel by two lines of verse, which I have not wanted to insert in this letter. Those verses, however, which the entrances of the basilica themselves bear, I have written down, because, if you care to use them, they would also be suitable for the doors of your basilicas, such as this one:

> Peace be with all ye who enter the mysteries
> of Christ the Lord, pure with peaceful minds.

Or this one over the sign of the Lord above the entrance, painted in the following form as indicated by the verse:

> Behold the wreathed cross of Christ the Lord
> standing aloft above His courts with promises of high rewards for hard work.
> Take up the Cross, ye who wish to carry off the wreath.

A side entrance, as it were from a little garden or orchard, leads to the other basilica. These verses open this secret door:

> Enter, worshippers of Christ, the heavenly roads along lovely brushwood;
> entering here from a gay garden is very seemly too,
> for hence an exit is given, as reward for merit, to holy Paradise.

The same little door is marked with other verses on its inner side:

[37] The older Melania, a cousin of Paulinus. She visited Nola in 400.

> All ye who, having duly performed your prayers,
>> leave the house of the Lord, return with your bodies but remain
>> there with your hearts.

The basilica does not, however, as is more usual, look to the East, but is turned towards the basilica of my blessed Lord Felix, facing his tomb; yet an undulating apse unfolds itself with two recesses, one to the right and one to the left within the space left open around it, one of these offering place to the priest when he makes the offers of jubilation and the other receiving the praying congregation behind the priest in a spacious bend. It is a splendid sight, the way in which this basilica suddenly in its entirety opens in the direction of the basilica of the renowned confessor in three similar arches with a lattice, pervious to light, by which the buildings and the spaces of the two churches are connected. But because the apse of another monument had been built between, and an obstructing wall separated the old basilica from the new, as many doors were opened in the side wall of the confessor's church as existed on the front of the new church. And thus this wall gives a vista, which might be called open-work, from one church into the other, as is indicated by the inscriptions placed between the two rows of doors. Consequently there are just above the entrance of the new church the following lines:

> The bountiful house is open with triple arch to those entering,
>> and this threefold doorway bears testimony to pious faith.

Likewise there are to the right and left next to crosses painted in red-lead these epigrams:

> The high cross is surrounded by the orb of a flower-bearing wreath,
>> and is red, dyed by the Lord's shed blood.
> The doves perched above the heavenly sign
>> intimate that the Kingdom of God is open to the simple of heart.

And:

> Slay us unto the world with this cross and the world unto us,
>> by virtue of Thy giving life to our soul through the downfall of
>> guilt.
> Us too wilt Thou make doves pleasing to Thee, Christ,
>> if Thy followers have strength through purity of heart. . . .

Let us now go out of this Nolan church and proceed to that at Fundi. Fundi is the name of the town which was equally familiar to me, as long as my property, which I had there and visited regularly, existed there. Consequently it was a wish of mine, a pledge, so to say, of my attachment as a resident or in memory of my former fortune, to found a basilica in that town, since it was certainly in need of it, for the church it possessed was dilapidated and small. Therefore I thought I should add the following verses too, which we have prepared for the inauguration of

that church in that town. For it is still in the making, but if God be propitious, it is nigh unto consecration. The reason that induced me to do this was especially, that my friend Victor also thought the painting destined for the apse of this church very fine and wanted to bring you the texts, in case you should make a choice from the two for a painting in your newest church too, in which, according to his statement, an apse has also been made. But whether I had better refer to this as absida or abside, you may settle for yourself; I admit I do not know, because I do not remember having seen this case of the word anywhere. But also to this little church the holy ashes of the blessed relics of apostles and martyrs will give their consecration in the name of Christ, the saint of saints, the martyr of martyrs and the Lord of Lords. For He Himself has testified that He in His turn would become the confessor of His confessors. Therefore there is a separate second inscription with regard to this mercy which is detached from the painting.

As regards the painting:

> The labour and the reward of the saints are justly connected with
> each other,
> the high cross and the sublime prize for the cross, the wreath.
> God Himself, for us the Predecessor in cross and wreath,
> Christ, stands in the heavenly forest of flower-bearing Paradise
> under the blood-red cross, in the form of a white lamb,
> lamb because He was delivered up to unjust death as innocent
> sacrifice.
> From on high the Holy Ghost imbues the yearning lamb, and out
> of a ruddy cloud the Father wreathes it.
> And because it stands as a judge on a high rock,
> there are around its throne cattle of a twofold kind,
> goats which are at discord with lambs; the shepherd turns
> from the goats on his left and he welcomes the lambs on his right,
> which have performed their duty.[38]

Instructions for a Painter of Miniatures (Fourth Century)

The same pious and wealthy patrons who poured their riches into the building of churches must also have wanted to possess or donate sumptuous editions of Biblical books. Luxurious Scriptural manuscripts are mentioned by St. Jerome,[39] who scoffs at them. Fragments of such a manuscript, coming from Quedlinburg and containing passages from the Books of the Kings, have survived. Dated between 350 and 410, the manuscript still uses an old Latin translation of the Bible, the so-called Itala,

[38] Paulinus of Nola, *Epist.* 32, Chaps. 10–14, 17 in *Paulinus' Churches at Nola,* Academisch Proefschrift door Rudolf Carel Goldschmidt (Amsterdam: N.V. Noord-Hollandische Uitgevers Maatschappig, 1940), pp. 39–47. Reprinted by permission of the North-Holland Publishing Company, Amsterdam.

[39] See below, pp. 37–40.

which by the end of the century was to be replaced by the Vulgate, the translation of St. Jerome. Each page of this manuscript seems to have been faced by a corresponding picture page, containing two or four framed miniatures. Four of these pages survive. Much of the color has fallen off, revealing instructions for the painter written underneath. They tell him not only what elements to include in his painting, but at the same time furnish him with a summary of the story. The completeness of the instructions seems to indicate that the painter was expected to follow them without further recourse to a prototype.

Make the tomb by which Saul and his servant stand and two men, jumping over a ditch, who talk to him and announce that the asses have been found.[40]

Make Saul by the oak and his servant and three men who talk to him, one carrying three kids, one three loaves of bread, one a wineskin.[41]

Make prophets, one with a cithara, another with a flute, the third one with a drum, and Saul prophesying and his servant with a harp.[42]

Make where the prophet Samuel and Saul meet in Mapha and talk to the people.[43]

Make the prophet in a carriage, talking against the king, Saul sacrificing and two of the king's servants.[44]

Make where the prophet withdraws, and when King Saul tries to hold him by the end of his mantle, cuts it off and withdraws running.[45]

Make where King Saul begs the angry prophet that they may pray God for him and pleads his ignorance.[46]

Make a city and outside the city make where the prophet kills the foreign king with a spear and Saul standing on the other side with two servants.[47]

Make a tripartite scene. Make King Solomon where he sent a messenger to King Hiram asking him to send carpenters to help with the building of the Temple.[48] Make the workshop where the workmen of King Solomon and King Hiram[49] build the Golden House and bronze columns[50] and between and above them make two rows of pomegranates[51] and make the Molten Sea[52] and make twelve bronze fruits on the four

40 I Kings 10: 2.
41 I Kings 10: 3.
42 I Kings 10: 4–6.
43 I Kings 10: 17–24.
44 I Kings 15: 12–14.
45 I Kings 15: 27.
46 I Kings 15: 30-31.
47 I Kings 15: 32–33.
48 III Kings 5: 1–7.
49 III Kings 5: 18.
50 III Kings 7: 15–23.
51 III Kings 7: 42.
52 III Kings 7: 23–26.

corners of the ceiling; . . . and within the temple the bronze lions and crowns and the cherubim and the braided borders[53] and make also the place where Solomon will sacrifice before the Lord and kneeling with extended arms will pray and where all the people with him stood praying before the Lord.[54]

Prudentius: Inscriptions for Scenes
from the Old and New Testaments

Paulinus of Nola had placed episodes from the Old Testament in the new basilica at Nola and episodes from the New Testament in the older church. This was one way of expressing their complementary role. In Rome another arrangement became usual. It stressed the correspondence of the two Testaments by assigning opposite walls of the nave to scenes from each. The following poem, written by Prudentius shortly after 400, may have been either a blueprint for or a reminiscence of such an arrangement. It consists of 48 quatrains, half of which deal with the Old Testament, and half with the New. The stories chosen by Prudentius appear, with very few exceptions, in surviving monuments. Given the enormous wealth of Biblical material and the rather limited scope of early Christian iconography, this can hardly be accidental, especially since the title of Prudentius' poem suggests that its verses were composed as inscriptions. In Prudentius' cycle the house of Caiphas and the house of Rahab, and also the rejected Cornerstone of the Temple and Joseph sold and found, would have occupied facing portions of the walls. There is thus some attempt in the poem to draw parallels between the two Testaments, but the comparisons are still much less systematic than in the sixth-century cycle described by Bede.[55]

I. ADAM AND EVE

Eve was then white as a dove, but afterwards she was blackened by the venom of the serpent through his deceitful tempting, and with foul blots she stained the innocent Adam. Then the victorious serpent gives them coverings of fig-leaves for their nakedness.[56]

II. ABEL AND CAIN

God's pleasure appraises differently the offerings of two brothers, accepting the living and rejecting the products of the earth. The farmer

[53] III Kings 7: 29.
[54] III Kings 8: 22. The selection is taken from H. Degering and A. Boeckler, *Die Quedlinburger Itala Fragmente* (Berlin: Cassiodor Gesellschaft, 1932), pp. 66–67, 69–72, 74–75.
[55] See below, p. 75.
[56] Gen. 3: 1–7.

from jealousy strikes down the shepherd. In Abel is shown forth the figure of the soul, our flesh in the offering of Cain.[57]

III. Noah and the Flood

Telling that the flood is now abating, the dove brings back to the ark in her mouth a branch of a green olive tree. For the raven being possessed with voracity had stayed among the loathsome bodies, but the dove brings home the joyful news of the gift of peace.[58]

IV. Abraham and his Entertainment of Guests

This is the lodging which entertained the Lord, where a leafy oak at Mamre covered the old herdsman's shelter. In this cabin Sarah laughed to think that the joy of a child was offered to her late in life, and that her husband in his decline could so believe.[59]

V. Sarah's Tomb

Abraham purchased a field wherein to lay his wife's bones, inasmuch as righteousness and faith dwell as strangers on the earth. This cave he bought at a great price, and here a resting place was acquired for her holy ashes.[60]

VI. Pharaoh's Dream

Twice seven ears of corn and as many cows appearing to Pharaoh in his sleep portend by their different figures that a time of plenty and a time of famine over two spans of seven years are coming upon him. This the patriarch expounds, learning its meaning from Christ.[61]

VII. Joseph Recognised by his Brethren

The same boy who was sold by his brothers' stratagem gives in his turn secret order that a bowl be hidden in a sack of corn; and when Joseph detains them on accusation of theft the treacherous sale is discovered. They recognise their brother and are put to shame by his forgiveness.[62]

VIII. The Fire in the Bush

God in the form of fire playing on the thorn-bushes with flashing countenance accosts a young man who was at that time, as it chanced,

57 Gen. 4: 3–8.
58 Gen. 8: 6–11.
59 Gen. 18: 1–12.
60 Gen. 23: 8–20.
61 Gen. 41: 14–32.
62 Gen. 44–45.

the master of a herd. He being bidden takes his rod, and the rod becomes a serpent. He unlooses the ties on his feet, and hastens to Pharaoh's court.[63]

IX. THE PASSAGE OF THE SEA

The righteous man passes on his way in safety even through the great waters. Behold, the Red Sea yawns apart for the servants of God, while the same sea drowns the furious evil-doers. Pharaoh is overwhelmed, but the way was free and open for Moses.[64]

X. MOSES HAS RECEIVED THE LAW

The mountain-top is smoking with the divine fire, where the tables of stone inscribed with the ten commandments are handed to Moses. Taking up the law he returns to his people, but their only god is in the shape of a calf, their god is gold.[65]

XI. THE MANNA AND THE QUAILS

The fathers' tents are white with bread that angels sent. Belief in the fact is sure; for a golden pitcher holds manna kept from that time. To the ungrateful people comes another cloud, and heaps of quails glut their hunger for flesh.[66]

XII. THE BRAZEN SERPENT IN THE WILDERNESS

The dry way through the wilderness was swarming with deadly serpents and now their poisoned bites were destroying the people with livid wounds; but the wise leader hangs up on a cross a serpent wrought in brass to take its force from the venom.[67]

XIII. THE LAKE OF MYRRH IN THE WILDERNESS

The people thirsted, but the pond was harsh to the taste, holding waters that were bitter in the mouth, a pool of gall. Moses the holy one says: "Get me a piece of wood. Throw it into this pool, and its bitterness will be turned to a sweet savour."[68]

XIV. THE GROVE OF ELIM IN THE WILDERNESS

The people, led by Moses, came to a place where they found six

63 Exod. 3, 4.
64 Exod. 14: 21–30.
65 Exod. 19, 32.
66 Exod. 16
67 Num. 21: 6–9.
68 Exod. 15: 23–25.

springs and again six more, with glassy water giving moisture to seventy palm-trees. This mystic grove of Elim represented the number of the apostles in the Scriptures too.[69]

XV. THE TWELVE STONES IN JORDAN

Jordan with back-flowing stream moves towards its source, leaving a dry crossing to be trodden by the people of God; witness the twelve stones which the fathers set in the river itself, prefiguring the disciples.[70]

XVI. THE HOUSE OF RAHAB THE HARLOT

Jericho has fallen and only the house of Rahab stands. The harlot who entertained the holy men—so great is the power of faith—is without fear and her house is saved; she puts out her bit of scarlet in face of the flames to catch the eye and be a token of blood.[71]

XVII. SAMSON

A lion tries to rend Samson, whose hair makes him invincible. He slays the wild beast, but from the lion's mouth flow streams of honey; and the jawbone of an ass pours forth water of itself. Foolishness overflows with water, strength with sweetness.[72]

XVIII. SAMSON

Samson catches three hundred foxes and arms them with fire, tying brands to their tails behind, and lets them loose into the Philistines' crops and burns up their corn.[73] Just so nowadays the cunning fox of heresy scatters the flames of sin over the fields.

XIX. DAVID

David was a child, the youngest of his brothers, and now in charge of Jesse's flock, tuning his harp by his father's sheepfold, which was afterwards to be for the king's pleasure. Later he makes fearful wars, and with a whizzing sling lays low Goliath.[74]

XX. THE KINGSHIP OF DAVID

The marvellous David's royal emblems shine bright,—sceptre, oil,

69 Exod. 15: 27.
70 Josh. 3: 7–17; 4.
71 Josh. 2; 6: 22–25.
72 Judges 14: 5–8; 15: 15–19.
73 Judges 15: 4–5.
74 I Kings 16: 11; 17: 48–51.

horn, diadem, purple robe and altar. They all befit Christ, the robe and crown, the rod of power, the horn of the cross, the altar, the oil.

XXI. THE BUILDING OF THE TEMPLE

Wisdom builds a temple by Solomon's obedient hands, and the queen of the South piles up a great weight of gold. The time is at hand when Christ shall build his temple in the heart of man, and Greece shall reverence it and lands not Greek enrich it.[75]

XXII. THE SONS OF THE PROPHETS

It chanced that while the sons of the prophets were cutting timber on the river's bank an axe-head was struck from its shaft and fell. The iron sank in the depths, but presently a light piece of wood thrown into the water brought the iron within reach again.[76]

XXIII. THE HEBREWS LED INTO CAPTIVITY

The people of the Hebrews, made captive by reason of their many sins, had wept over their exile by the rivers of cruel Babylon. Then being bidden to sing their native songs, they refuse, and hang their instruments of music on the branches of the bitter willow tree.[77]

XXIV. THE HOUSE OF KING HEZEKIAH

Here good Hezekiah gained the privilege of postponing his appointed day and delaying the law of death for fifteen years; and this the sun proved by returning towards his rising and bathing in light the degrees which evening had covered with its shadow.[78]

XXV. THE ANGEL GABRIEL IS SENT TO MARY

The coming of God being at hand, Gabriel comes down as a messenger from the Father's throne on high and unexpectedly enters a virgin's dwelling. "The Holy Spirit," he says, "will make thee with child, Mary, and thou shalt bear the Christ, thou holy virgin."[79]

XXVI. THE CITY OF BETHLEHEM

Holy Bethlehem is the head of the world, for it brought forth Jesus from whom the world began, himself the head and source of all begin-

[75] III Kings 5–8; 10: 1–2.
[76] IV Kings 6: 5–7.
[77] Psalm 136.
[78] IV Kings 20: 3–11.
[79] Luke 1: 26–33.

nings. This city gave birth to Christ as man, yet this Christ lived as God before the sun was made or the morning star existed.[80]

XXVII. THE GIFTS OF THE WISE MEN

Here the wise men bring costly gifts to the child Christ on the virgin's breast, of myrrh and incense and gold. The mother marvels at all the honours paid to the fruit of her pure womb, and that she has given birth to one who is both God and man and king supreme.[81]

XXVIII. THE SHEPHERDS WARNED BY THE ANGELS

The strong angelic light fills the shepherds' wakeful eyes, publishing abroad the birth of Christ from a virgin. They find Him wrapped in swaddling-clothes, and a manger was the cradle in which He lay. They rejoice with great gladness and worship his divinity.[82]

XXIX. THE BABES ARE SLAIN IN BETHLEHEM

The wicked enemy Herod slaughters countless babes, raging furiously in the search for Christ among them. The cradles reek with the milky blood of the little ones, and the mothers' loving breasts are wetted from the hot wounds.[83]

XXX. CHRIST IS BAPTISED

The Baptist, who fed on locusts and on honey from the woods and clothed himself in camel's hair, bathes his followers in the stream. He baptised Christ too, when suddenly the Spirit sent from heaven bears witness that it is He who forgives sin to the baptised who has Himself been baptised.[84]

XXXI. THE PINNACLE OF THE TEMPLE

A pinnacle stands surviving the destruction of the old temple; for the corner built with that stone which the builders rejected remains for all time, and now it is the head of the temple and the joint which holds new stones together.[85]

XXXII. WATER CHANGED INTO WINE

It chanced that people of Galilee were celebrating a union in marri-

80 Matt. 2: 6.
81 Matt. 2: 11.
82 Luke 2: 8–17.
83 Matt. 2: 16–18.
84 Matt. 3: 13–17.
85 Matt. 21: 42.

age in the presence of a company of well-wishers, and now the servants were short of wine. Christ bids them quickly fill water-pots with water, and there is poured out from them a stream of old wine unwatered.[86]

XXXIII. The Pool of Siloam

The water is a remedy for diseases; it is emitted with a gush at different times, and the cause of its flowing is unknown. Men call it Siloam; here the Saviour smeared a blind man's eyes with his spittle and bade him wash them in the water of the spring.[87]

XXXIV. The Passion of John

A dancing-girl demands a deathly fee, the head of John cut off so that she may carry it back on a plate to lay it in her impure mother's lap. The royal artiste bears the gift, her hands bespattered with righteous blood.[88]

XXXV. Christ Walks on the Sea

The Lord passes over the midst of the sea, and as He treads with his foot on the flowing waters bids his disciple come down from the rocking boat. But the mortal man's fear makes his feet sink. Christ takes him by the hand and leads him, and makes his steps firm.[89]

XXXVI. The Devil Sent into the Swine

A devil had broken his bonds of iron in the prison of a tomb; he bursts out and throws himself at Jesus' feet. But the Lord claims the man for himself and bids his enemy drive the herds of swine mad and plunge into the sea.[90]

XXXVII. The Five Loaves and Two Fishes

God broke five loaves and a pair of fish and with these fed five thousand people full with abundance. Twelve baskets are filled with the excess of broken morsels; such are the riches of the everlasting table.[91]

XXXVIII. Lazarus Raised from the Dead

A spot in Bethany was witness of a glorious deed when it saw thee,

[86] John 2: 1–10.
[87] John 5: 4; 9: 1-11.
[88] Matt. 14: 6–11.
[89] Matt. 14: 25–32.
[90] Mark 5: 1–13.
[91] Matt. 14: 16–21.

Lazarus, returned from the abode of death. The tomb is seen cleft open, its doors broken, whence the body has come back after it was mouldering in the grave.[92]

XXXIX. THE FIELD OF BLOOD

The field Aceldama, which was sold for the price of a sin unspeakable, receives bodies for burial and is covered with graves. This is the price of the blood of Christ. The unhappy Judas, hanging off the ground, draws a noose tight about his neck for his great crime.[93]

XL. THE HOUSE OF CAIAPHAS

You see the unholy house of Caiaphas the false accuser has fallen, the house in which Christ's sacred face was buffeted. This is the end that awaits sinners; their life will lie for ever buried in heaps of ruins.[94]

XLI. THE PILLAR AT WHICH CHRIST WAS SCOURGED

In this house stood the Lord bound and tied to a pillar, and submitted his back like a slave's to the scourging. This pillar, worthy of all reverence, still stands and supports a church,[95] teaching us to live in freedom from all whips.

XLII. THE SAVIOUR'S PASSION

Pierced through either side, Christ gives forth water and blood. The blood is victory, the water baptism. At this time two robbers on crosses close by on either hand are at variance; the one denies God, the other wins the crown....[96]

XLIV. THE MOUNT OF THE OLIVE GROVE

From the top of the mount where the olive trees grow Christ returned to the Father, imprinting there the footmarks[97] of peace. A liquor passing rich flows from the everlasting boughs, showing that the gift of unction has been poured on the earth.[98]

[92] John 11: 17–44.
[93] Matt. 27: 3–10.
[94] Mark 14: 53.
[95] This is a reference to the tradition that the column on which Chirst was scourged was later incorporated into the fabric of a church in Jerusalem.
[96] John 29: 34; Luke 23: 39–43. I have omitted Quatrain XLIII, which seems to be a later insertion.
[97] According to tradition Christ left a footprint on a stone of the Mount of Olives.
[98] Acts 1: 9–12.

XLV. THE PASSION OF STEPHEN

Stephen is the first to enter into the reward for blood, being dashed down under a rain of stones. But while he is bleeding amid the stones he asks Christ that the stoning may not be laid to his enemies' charge. How marvellous the love shown by the first who won the crown![99]

XLVI. THE BEAUTIFUL GATE

The gate of the Temple which men called the Beautiful still stands. It is the illustrious work of Solomon, but at that gate a greater work of Christ shone forth. For a lame man bidden by Peter's lips to rise was amazed to find his feet loosened and able to run.[100]

XLVII. PETER'S VISION

Peter dreams that a dish filled with all kinds of beasts has come down from high heaven. He refuses to eat, but the Lord bids him count all clean. He arises, and calls the unclean nations into the knowledge of the divine mysteries.[101]

XLVIII. THE CHOSEN VESSEL

Here one who was formerly a ravening wolf is clothed in a soft fleece. He who was Saul loses his sight and becomes Paul. Then he receives his vision again and is made an apostle and a teacher of the nations, having power with his lips to change crows into doves.[102]

XLIX. THE REVELATION OF JOHN

Four and twenty elders seated and resplendent with vessels and harps and each with his crown of honour are praising the Lamb that is blood-stained from the slaughter, and that alone has been able to unroll the book and undo the seven seals.[103]

[99] Acts 7: 57–59.
[100] Acts 3: 1–9.
[101] Acts 10: 11–16.
[102] Acts 9: 1–21.
[103] Apoc. 4: 4–11. The selection is reprinted by permission of the publishers and the Loeb Classical Library from Prudentius, *Lines to be Inscribed under Scenes from History,* trans. H. J. Thompson (Cambridge, Mass.: Harvard University Press, London: William Heinemann Ltd., 1953), II, 346–71.

LUXURY AND ELEGANCE: POPE HILARY'S
ORATORIES AT THE LATERAN BAPTISTERY

*Pope Hilary (461–68) added three oratories to the complex of the
Lateran Baptistery, one dedicated to St. John the Baptist, one to St. John
the Evangelist, and one to the Holy Cross. Of these the last was the most
beautiful. It was entered through a small vestibule, of which* The Book of
the Popes, *usually uncommunicative about architectonic details, gives an
interesting account. The oratories are best known from a description by
Onofrio Panvinio, a learned Roman antiquarian who saw all three of
them during the first half of the sixteenth century. The Oratory of the
Holy Cross was admired and studied by Giuliano da Sangallo,[104] Baldas-
sare Peruzzi,[105] and other sixteenth-century architects. Its fame did not
preserve it from being torn down in 1588; in altered form the two other
oratories survive.*

The Book of the Popes: A Sixth Century Description

Hilary, a Sardinian and son of Crispin, occupied the see for 6 years,
3 months, and 10 days. . . . He built three oratories on to the Baptistery of
the Basilica of Constantine, one to St. John the Baptist, one to St. John
the Evangelist, and one to the Holy Cross, all adorned with silver and
precious stones. [He gave] to St. John the Baptist a silver *confessio*[106]
weighing 100 pounds and a gold cross, [and] to St. John the Evangelist a
silver *confessio* weighing 100 pounds and a gold cross, and for both ora-
tories doors of bronze inlaid with silver.

[He gave] to the Oratory of the Holy Cross a *confessio* where he
deposited wood from the Holy Cross, a gold cross with gems weighing 20
pounds, silver doors for the *confessio* weighing 50 pounds, a gold arch
over the *confessio* weighing 4 pounds and carried by onyx columns, where
a gold lamb weighing 2 pounds stands, a gold crown before the *confessio*,
a candelabra with dolphins weighing 5 pounds, 4 gold lamps each weigh-
ing 2 pounds.

[He built] a nymphaeum[107] with a triple portico before the Oratory
of the Holy Cross, with columns of marvellous size which are called
hexato-pentaicae, and two fluted shells with fluted porphyry columns
spouting water. And in the middle there is a porphyry basin with a fluted

104 Giuliano da Sangallo (1445–1516), Florentine Renaissance architect.
105 Baldassare Peruzzi (1481–1536), Renaissance architect in Rome.
106 An altar-shrine.
107 An architectural setting for a fountain. Its description is unclear. My
translation is based on John the Deacon's parallel passage (*De eccl. lat.*, 13).

shell in its center, pouring forth water, enclosed on all sides with bronze grills and columns with gables and architraves, and adorned everywhere with mosaic work and columns of white, yellow, and porphyry marble.

[He placed] before the *confessio* of the blessed John a silver crown[108] weighing 20 pounds and a chandelier shaped like a cantharus and weighing 25 pounds.

[He gave] the same to St. John.

[He gave] to the Baptistery a gold lamp with wicks for ten lights weighing 5 pounds, three silver stags spouting water, each weighing 30 pounds, a silver lamp shaped like a pillar with dolphins weighing 60 pounds, a golden dove weighing 2 pounds.[109]

O. Panvinio: The Oratories in the Sixteenth Century

According to Anastasius the Librarian,[110] who wrote his biography, Pope Hilary, who was made bishop of Rome in 461 after the death of Leo the Great,[111] founded three oratories by the Lateran Baptistery, dedicated to St. John the Baptist, St. John the Evangelist, and the Holy Cross. He adorned all three with silver and precious stones. Two of these oratories, the ones dedicated to St. John the Baptist and St. John the Evangelist, about which I want to speak first, are in the Lateran Baptistery. The Oratory of the Holy Cross, however, stands somewhat apart. To the two oratories next to the Baptistery Pope Hilary in the beginning gave bronze doors adorned with silver. To the Oratory of St. John the Baptist, which still stands on the right side of the Baptistery, Pope Hilary, according to the Librarian, gave a silver confessio weighing 100 pounds. . . . [*Panvinio here continues to enumerate the gifts listed in the* Book of the Popes.] The oratory is a small square building. In three of its corners stands an alabaster column, but the fourth column is of marble. The ceiling, entirely covered by a very beautiful mosaic, has beneath it an elegantly stuccoed little apse. The oratory has two small windows and at its sides two other apses with paintings added at a later time. The pavement is decorated with mosaic. It can still be seen that the whole oratory was once sheathed with marble. The door is framed by pieces of an ancient and very beautiful architrave. The following verse stands on the frieze above the door: LORD, I HAVE LOVED THE BEAUTY OF THY HOUSE.[112] On the outside of the lintel is written: BISHOP HILARY TO THE

108 A circular chandelier.

109 *Vita Hilarii I*, c. 2–4 in *Liber Pontificalis*, ed. L. Duchesne (Paris: E. Thorin, 1886), I, 242–43.

110 Anastasius Bibliothecarius, ninth-century scholar, anti-pope (855) and later abbot of Santa Maria in Trastevere. He wrote the biography of Nicholas I (858–67) for the *Liber Pontificalis*. Panvinio thought that he was the author of the whole collection.

111 Leo I (440–61), Hilary's predecessor.

112 Psalm 25: 8.

HOLY PEOPLE OF GOD. Before the entrance is another marble architrave, carried by porphyry columns; they have capitals of green ophyte stone, which is also called serpentine. On the bronze doors once covered with silverwork is this inscription: BISHOP HILARY, GOD'S SERVANT, MAKES THIS OFFERING IN HONOR OF SAINT JOHN THE BAPTIST. The floor between the door of the oratory and the Lateran Fount is inlaid with mosaic.

Opposite the sanctuary of St. John the Baptist and on the left side of the Baptistery is the Oratory of St. John the Evangelist. It has been despoiled of all its ornaments and even of its marble. Pope Hilary, who founded it, adorned it with a silver *confessio* weighing 100 pounds and with a gold cross. Above its first marble doorway, which leads from the Baptistery into the vestibule of the chapel is this inscription: TO HIS LIBERATOR SAINT JOHN THE EVANGELIST FROM HILARY BISHOP AND CHRIST'S SERVANT.[113] The vestibule behind this door is small, narrow, and windowless. It leads into the church of St. Venantius. In the middle of the vestibule opposite the first door is the entrance to the Oratory of St. John the Evangelist. It is square in shape and a little larger than the other oratory. Its ceiling is vaulted and covered with a beautiful mosaic. It rests on four octagonal marble columns with Ionic capitals. The oratory has three small stuccoed apses and in them as many altars. They are empty [of relics] and consist of marble plaques which rest on fragments of porphyry columns. It is said that relics of many saints rest beneath them. The oratory was once sheathed with marble; it is now filled with bad paintings and other images. It has a marble floor.

Behind the Baptistery towards the west is the Oratory of the Holy Cross, made by the same Pope Hilary, which one enters through the new door of the Baptistery. It has in front a small open space once enclosed by a small portico, of which remain seven columns and three pilasters between the Baptistery and the oratory. The architrave over the door of the oratory rests on two fluted alabaster columns. The lintel carries the following inscription: I WILL COME INTO THY HOUSE; I WILL WORSHIP TOWARDS THY HOLY TEMPLE, IN THY FEAR.[114]

This chapel is square and has four rectangular apses. In one of them is the door, in the other three as many altars. The middle altar is old, empty, and made of stone; the ones on the sides are more recent but stand on old bases. The ceiling is vaulted and covered with a very elegant gold mosaic showing four angels who carry the Holy Cross. Above the apses and somewhat beneath the vault were once four broad windows. Three of them have been walled up; the one over the door is open. The walls

113 During a tumult at the Council of Ephesus (431–33) Hilary, who had been sent there as a papal legate, hid himself in the church of St. John the Evangelist, whom he calls his liberator in this inscription.
114 Psalm 5: 8–9.

between the windows are covered with mosaics, representing the saints Peter and Paul, John the Baptist and John the Evangelist, Lawrence and Stephen,[115] James and Philip.[116] The apses were stuccoed to the level of the frieze. The walls between the apses were sheathed with marble, with four inlaid representations of the Holy Cross. Between the four apses were as many small ancient oratories, of which the two near the entrance have collapsed, the two towards the main altar are standing. The little oratories have altars, and the left one is completely decorated with painting and stucco, but the right one is completely whitewashed, and has a marble pavement. The bronze doors are gone and the oratory has been stripped of nearly all its ornaments and marble. They have been replaced by bad paintings. For, as the Librarian informs us, Pope Hilary the founder of the oratory furnished it with many rich gifts. . . . [*a copy of the list of gifts in the* Book of the Popes *follows.*] Of all these ornaments there remains neither a trace nor a shadow.[117]

ASCETIC AND THEOLOGICAL OPPOSITION

St. Jerome: Christian Poverty

Christian emperors had given to the Church the peace and the recognition for which the early fathers had pleaded. They had also been the first to give to the Church what those same fathers had most dreaded: temples, filled with gold and silver, with images, and even with statues. St. Jerome was troubled by the discrepancy between old theory and new practice. He thought that churches were too numerous, too large, and too luxuriously and ostentatiously decorated. While bitterly critical, he seems to have been aware that the movement towards ecclesiastical pomp was irreversible, and he was careful to voice his opinion circumspectly and in private letters.

115 St. Lawrence and St. Stephen, one Roman and the other Palestinian, both martyrs and deacons, who are often represented together on Roman monuments.

116 St. Philip and St. James the son of Alphaeus, two apostles whose feasts were celebrated on the same day.

117 Onuphrius Panvinius, *De Sacrosancto Basilica, Baptisterio et Patriarchio Lateranensi*, III, 7–9, ed. Philip Lauer, *Le Palais de Latran* (Paris: Leroux, 1911), pp. 466–68.

A Letter to Paulinus of Nola

Paulinus[118] *had notified Jerome of his decision to give up his posses-*
sions and to embrace a religious life. Jerome's answer was written in 394–
396, before Paulinus had settled in Nola and embarked upon his career
as a churchbuilder.

The true temple of Christ is the believer's soul; adorn this, clothe
it, offer gifts to it, welcome Christ in it. What use are walls blazing with
jewels when Christ in His poor is in danger of perishing from hunger?
Your possessions are no longer your own but a stewardship is entrusted to
you. Remember Ananias and Sapphira[119] who from fear of the future kept
what was their own, and be careful for your part not rashly to squander
what is Christ's. Do not, that is, by an error of judgment give the prop-
erty of the poor to those who are not poor. . . .[120]

A Letter to Nepotian

This letter was written in 394 to the recently ordained nephew of a
friend. Its criticism seems to reflect a controversy between St. Jerome and
other churchmen. According to the saint, the latter busy themselves too
much with the externals of religious practice, and attempt to justify them-
selves by citing an irrelevant passage in the Old Testament, the descrip-
tion of the riches of Solomon's temple.

Many build churches nowadays; their walls and pillars of glowing
marble, their ceilings glittering with gold, their altars studded with jewels.
Yet to the choice of Christ's ministers no heed is paid. And let no one
allege against me the wealth of the temple in Judæa, its table, its lamps,
its censers, its dishes, its cups, its spoons, and the rest of its golden vessels.
If these were approved by the Lord it was at a time when the priests
had to offer victims and when the blood of sheep was the redemption of
sins. They were figures typifying things still future and were "written for
our admonition upon whom the ends of the world are come."[121] But now
our Lord by His poverty has consecrated the poverty of His house. Let us,
therefore, think of His cross and count riches to be but dirt. Why do we
admire what Christ calls "the mammon of unrighteousness"?[122] Why do

[118] For Paulinus of Nola, see above pp. 17–23.
[119] Acts 5: 1–10.
[120] St. Jerome, *Letter* 58, trans. W. H. Freemantle, G. Lewis and W. G.
Mortley, *A Select Library of Nicene and Post-Nicene Fathers of the Christian
Church,* Ser. II, VI (Oxford: James Parker and Co., 1893), 122.
[121] 1 Cor. 10: 11.
[122] Luke 16: 9.

we cherish and love what it is Peter's boast not to possess?[123] Or if we insist on keeping to the letter and find the mention of gold and wealth so pleasing, let us keep to everything else as well as the gold. Let the bishops of Christ be bound to marry wives, who must be virgins.[124] Let the best-intentioned priest be deprived of his office if he bear a scar and be disfigured.[125] Let bodily leprosy be counted worse than spots upon the soul. Let us be fruitful and multiply and replenish the earth,[126] but let us slay no lamb and celebrate no mystic passover, for where there is no temple,[127] the law forbids these acts. Let us pitch tents in the seventh month[128] and noise abroad a solemn fast with the sound of a horn.[129] But if we compare all these things as spiritual with things which are spiritual;[130] and if we allow with Paul that "the Law is spiritual"[131] and call to mind David's words: "open thou mine eyes that I may behold wondrous things out of thy law;"[132] and if on these grounds we interpret it as our Lord interprets it—He has explained the Sabbath in this way:[133] then, rejecting the superstitions of the Jews, we must also reject the gold; or, approving the gold, we must approve the Jews as well. For we must either accept them with the gold or condemn them with it.[134]

A Letter to Demetrias

This letter was written to a young Roman woman of noble family who had decided to become a nun. Jerome advises her on how to dispose of her fortune. It should be used, he says, not for the building of churches but for charities and for the support of monastic communities. It is interesting to see how Jerome distinguishes between the duties of those who, like Demetrias, choose monastic life, and those of other Christians. We have in this letter probably the first appearance of a double standard which in later medieval centuries allowed bishops and some princely abbots to build on a grand scale and lavishly patronize the arts, while many monks and theologians continued to inveigh against them.

From the time of your dedication to perpetual virginity your prop-

123 Acts 3: 6.
124 Lev. 21: 14.
125 Lev. 21: 17–23.
126 Gen. 1: 28.
127 Deut. 16: 5.
128 Lev. 23: 40–42.
129 Joel 2: 15.
130 1 Cor. 2: 13.
131 Rom. 7: 14.
132 Psalm 118: 18.
133 Matt. 12: 1–9.
134 St. Jerome, *Letter* 52, Chap. X, trans. W. H. Freemantle, G. Lewis and W. G. Mortley, *A Select Library of Nicene and Post-Nicene Fathers of the Christian Church*, Ser. II, VI (Oxford: James Parker and Company, 1893), 94.

erty is yours no longer; or rather is now first truly yours because it has come to be Christ's. Yet while your grandmother and mother are living you must deal with it according to their wishes. If, however, they die and rest in the sleep of the saints (and I know that they desire that you should survive them); when your years are riper, and your will steadier, and your resolution stronger, you will do with your money what seems best to you, or rather what the Lord shall command, knowing as you will that hereafter you will have nothing save that which you have here spent on good works. Others may build churches, may adorn their walls when built with marbles, may procure massive columns, may deck the unconscious capitals with gold and precious ornaments, may cover church doors with silver and adorn the altars with gold and gems. I do not blame those who do these things; I do not repudiate them. Everyone must follow his own judgment. And it is better to spend one's money thus than to hoard it up and brood over it. However your duty is of a different kind. It is yours to clothe Christ in the poor, to visit Him in the sick, to feed Him in the hungry, to shelter Him in the homeless, particularly such as are of the household of faith, to support communities of virgins, to take care of God's servants, of those who are poor in spirit, who serve the same Lord as you day and night, who while they are on earth live the angelic life and speak only of the praises of God. Having food and raiment they rejoice and count themselves rich. They seek for nothing more, contented if only they can persevere in their design. For as soon as they begin to seek more they are shewn to be undeserving even of those things that are needful.[135]

St. Augustine: Art and Truth

Although references to the arts are rare in the works of St. Augustine, there can be little doubt that he regarded them with apprehension. His arguments were not moral and ascetic like St. Jerome's,[136] but philosophical and psychological. In the Soliloquies *(386–387), he compared painting and sculpture to acting, observing that both contain a necessary element of illusion and that they are false in order to be true, and therefore at odds with that higher truth, "which is not self-contradictory and two-faced." St. Augustine's severe view was based on a sharp distinction between that which represents and that which is being represented. Expressed at a time when imperial and ecclesiastical propaganda tended to blur this distinction, St. Augustine's uncompromising opinion had little immediate impact, but later helped to shape the anti-Byzantine arguments of the Caroline books.[137]*

135 St. Jerome, *Letter* 130, c. 14, in *A Select Library of Nicene and Post-Nicene Fathers of the Christian Church,* Ser. II, VI, 268–69.
136 See above, pp. 37–40.
137 See above, pp. 99–103.

Reality and Illusion

Reason: It is one thing to want to be false; it is quite different to be unable to be true. So, we can group the works of men, like comedies, tragedies, farces, and other things of that type, with the works of painters and sculptors. A man in a painting cannot be true, even though he tends toward the appearance of a man, like those things which are written in the works of the comic authors. Such things do not choose to be false nor are they false, through their own desire to be so, but they are compelled by a kind of necessity to conform as much as they are able to the artist's will. On the other hand, the actor Roscius[138] was by choice a false Hecuba on the stage, though, by nature, a true man; he was by choice a true tragedian in that he fulfilled his purpose, and a false Priam because he played the part of Priam though he was not Priam. From this fact arises something remarkable, which nevertheless nobody denies is a fact.

Augustine: What is that?

Reason: What else do you think but that all these things are in some respect true precisely because they are in other respects false. To establish their truth, the only thing in their favor is that they are false in some other regard. Hence, they never succeed in being what they want or ought to be, as long as they refuse to be false. How could that man I just mentioned be a true tragedian, if he were unwilling to be a false Hector, a false Andromache, a false Hercules, and others without number? Or how would it be a true picture, if the horse in it were not false? How could it be a true image of a man in a mirror, if it were not a false man? If, therefore, in order to be something true it is to the advantage of some things that they be something false, why should we have such a dread of falsities and desire truth as if it were a great good?

Augustine: That I do not know, and I will be very much surprised if it is not because I find in these examples nothing worthy of imitation. To the end that we may be true to our nature, we should not become false by copying and likening ourselves to the nature of another as do the actors and the reflections in a mirror and the brass cows of Myron.[139] We should, instead, seek that truth which is not self-contradictory and two-faced so that it is true on one side, false on another.[140]

[138] Quintus Roscius Gallus was a famous Roman actor of the first century B. C.

[139] Myron was a famous Greek sculptor of the first half of the fifth century B. C.

[140] St. Augustine, *Soliloquies*, II, 10 (18), trans. T. F. Gilligan, O. S. A. in *Fathers of the Church*, Vol. 44 (New York: Cima Publishing Co., Inc., 1948), 401–2. Reprinted by permission of the Catholic University of America Press.

An Attack on Forgeries

Unlike Paulinus of Nola,[141] St. Augustine seems to have regarded images as of little use in religious instruction. He was aware that artists and patrons were often high-handed and even disregarded facts recorded in scripture. They depicted, for instance, Christ flanked by both Peter and Paul. In doing so they committed an anachronism which St. Augustine exposed in a passage written c. 400 and directed against authors of an apocryphal letter, purportedly written by Christ and addressed to both Peter and Paul.

Nay more, as by divine judgment, some of those who either believe, or wish to have it believed, that Christ wrote matter of that description, have even wandered so far into error as to allege that these same books bore on their front, in the form of epistolary superscription, a designation addressed to Peter and Paul. And it is quite possible that either the enemies of the name of Christ, or certain parties who thought that they might impart to this kind of execrable arts the weight of authority drawn from so glorious a name, may have written things of that nature under the name of Christ and the apostles. But in such most deceitful audacity they have been so utterly blinded as simply to have made themselves fitting objects for laughter, even with young people who as yet know Christian literature only in boyish fashion, and rank merely in the grade of readers.

For when they made up their minds to represent Christ to have written in such strain as that to His disciples, they bethought themselves of those of His followers who might best be taken for the persons to whom Christ might most readily be believed to have written, as the individuals who had kept by Him on the most familiar terms of friendship. And so Peter and Paul occurred to them, I believe, just because in many places they chanced to see these two apostles represented in pictures as both in company with Him. For Rome, in a specially honourable and solemn manner, commends the merits of Peter and of Paul, for this reason among others, namely, that they suffered [martyrdom] on the same day. Thus to fall most completely into error was the due desert of men who sought for Christ and His apostles not in the holy writings, but on painted walls. Neither is it to be wondered at, that these fiction-limners were misled by the painters. For throughout the whole period during which Christ lived in our mortal flesh in fellowship with His disciples, Paul had never become His disciple. Only after His passion, after His resurrection, after His ascension, after the mission of the Holy Spirit from

141 See above, pp. 17–19.

heaven, after many Jews had been converted and had shown marvellous faith, after the stoning of Stephen the deacon and martyr, and when Paul still bore the name of Saul, and was grievously persecuting those who had become believers in Christ, did Christ call that man [by a voice] from heaven,[142] and made him His disciple and apostle. How then, is it possible that Christ could have written those books which they wish to have it believed that He did write before His death, and which were addressed to Peter and Paul, as those among His disciples who had been most intimate with Him, seeing that up to that date Paul had not yet become a disciple of His at all?[143]

Faith and Visual Representation

The first part of St. Augustine's work On the Trinity *was written at the same time as the preceding passage. It does not mention art or artifacts, but reveals the motives behind St. Augustine's negative attitude toward them. The images about which St. Augustine speaks are mental, not visual, but they are obviously similar to the latter, because they contain, according to the Saint, visual elements which are external to the faith and deflect the human mind from contemplating what is spiritual and divine. The Augustinian doctrine, that Christian dogma defies visual representation and may actually be falsified by it, was also taken up by the author of the Caroline books[144] and by other Carolingian theologians.*

But when we believe in any corporeal things, of which we have heard or read but have not seen, our mind must represent them to itself as something with bodily features and forms, just as it occurs to our thoughts; now this image is either false or true; even if it is true, and this can happen very rarely, still we derive no profit from clinging to it by faith, but it is useful for some other purpose which is intimated by means of it. For who, upon reading or listening to the writings of Paul the Apostle, or of those which have been written about him, does not draw a picture in his mind of the countenance of the Apostle himself, and of all those whose names are there mentioned? And since in the large number of people to whom those writings are known, one represents the features and figures of those bodies in one way, and another in a different way, it is assuredly uncertain whose thoughts are closer to and more like the reality. But our faith is not busied there with the bodily countenance of those men, but only with the life that they led through the grace of God, and

142 Acts 9.
143 St. Augustine, *The Harmony of the Gospels,* I, 10, trans. S. D. F. Salmond in *A Select Library of Nicene and Post-Nicene Fathers of the Christian Church,* Ser. I, VI (Oxford: James Parker and Co., 1861), 83–84.
144 See below, pp. 99–103.

with the deeds to which that Scripture bears witness; this it is which is useful to believe, which must not be despaired of, and which must be sought.

For even the countenance of the Lord Himself in the flesh is represented differently by reason of the diversity of innumerable thoughts, even though it was only one, whichever it was. But in our faith in the Lord Jesus Christ, it is not the image which the mind forms for itself and which may perhaps be far different from what it actually was that leads to salvation, but what we think of man according to his kind. For an idea has been impressed upon human nature as if it were a law, according to which, when we see any such thing, we at once recognize it as a man or as the form of a man. Neither do we know the countenance of the Virgin Mary of whom, without contact with man or without detriment in the birth itself, He was born in a wondrous manner. Nor have we seen what were the characteristic features of the body of Lazarus, nor Bethany, nor the sepulchre, nor the stone which He ordered to be removed when He raised him from the dead, nor the new tomb hewn out of the rock from which He Himself rose, nor Mount Olivet whence He ascended to heaven; and those of us who have never seen these things do not even know whether they were as we imagine them to be; in fact we regard it as more probable that they were not so.

For if the image of some place, or of a man, or of any body whatsoever shall appear the same to our eyes as it appeared to our mind when we were thinking about it before we had seen it, we are moved with no little wonder, for such a thing rarely or hardly ever occurs; and yet we believe those things most firmly, because we reason about them in accordance with the special or general knowledge of which we are certain. For we believe that our Lord Jesus Christ was born of the Virgin called Mary. But we do not believe, and certainly we know what a virgin is, what it is to be be born, and what is a proper name. But whether that was the countenance of Mary which came to our mind when we said or recalled these things, we do not at all know nor do we believe. Here, then, it is permissible to say without violating the faith that perhaps she had such a countenance, and perhaps she did not have such a countenance; no one, however, without violating the Christian faith could say, perhaps Christ was born of a Virgin.[145]

145 St. Augustine, The Trinity, VII, 4–6 (7-9), trans. Stephen McKenna, CSS. R. *Fathers of the Church* Vol. 45 (Washington, D. C.: The Catholic University of America Press, 1963), 251–55. Reprinted by permisson of the publishers.

3

Europe
Under
Barbarian Rule

THE PROPER USE OF IMAGES

St. Augustine and St. Jerome,[1] who had been so critical of images and lavishly decorated churches, lived to see the fall of Rome in 410. It was an event whose significance was not lost on them: from the fifth century on, power in Europe fell more and more into the hands of barbarian kings. The Latin church, showered with imperial gifts during the fourth century, entered upon a period when her resources were stretched thin as a consequence of missionary expansion and barbarian invasion. From then on the building of churches and their maintenance became a difficult matter, which was often achieved only at the cost of great sacrifice and was understandably considered to be a labor worthy of saints. Under such conditions there was little occasion to reiterate St. Jerome's opinions about ecclesiastical luxury. The use of images and of large and splendidly decorated churches formed a distinctive part of Roman customs. Churchmen whose main goal was the preservation and propagation of these customs could hardly be expected to be critical. It is interesting to see how Pope Gregory[2] attacks the iconoclastic bishop of Marseille for his imprudent deviation from generally accepted habits. There were also other reasons for St. Gregory to defend the proper use of images in the church. Their usefulness for the instruction of illiterates had already been pointed out by Paulinus of Nola.[3] They were believed to be even more important in the conversion of pagans. When St. Augustine of Canterbury, Pope Gregory's envoy to Britain, went to meet King Ethelbert, he carried with him a cross and an image of the Saviour.[4]

St. Gregory the Great to Bishop Serenus of Marseille

The beginning of your letter demonstrated to such a degree your priestly benevolence that we were highly pleased by your fraternal sentiments. But its end is so different from its beginning that we wonder whether the epistle proceeded from one mind or from two. Your doubts about the [authenticity of the] letter we sent you made you seem very rash. For if you had really paid attention to our fraternal admonishments, you would not only have had no doubts, but you would have known what your priestly dignity ought to compel you to do. The former abbot Cyriacus[5] who carried our letters was of such deportment and learning as

1 See above, pp. 37–44.

2 Pope Gregory I (590–604).

3 See above, pp. 17–23.

4 St. Augustine of Canterbury landed in Kent in 597, where he was welcomed by King Ethelbert (560–616).

5 Pope Gregory's messenger.

to make it difficult to suppose that he would have dared to do what you thought, or that he could possibly have been an imposter. Your neglect of wholesome admonition has made you guilty of this doubt, in addition to being guilty of a bad action. Word has since reached us that you, gripped by blind fury, have broken the images of the saints with the excuse that they should not be adored. And indeed we heartily applaud you for keeping them from being adored, but for breaking them we reproach you. Tell us, brother, have you ever heard of any other bishop anywhere who did the like? This, if nothing else, should have given you pause. Do you despise your brothers and think that you alone are holy and wise? To adore images is one thing; to teach with their help what should be adored is another. What Scripture is to the educated, images are to the ignorant, who see through them what they must accept; they read in them what they cannot read in books. This is especially true of the pagans. And it particularly behooves you, who live among pagans, not to allow yourself to be carried away by just zeal and so give scandal to savage minds. Therefore you ought not to have broken that which was placed in the church not in order to be adored but solely in order to instruct the minds of the ignorant. It is not without reason that tradition permits the deeds of the saints to be depicted in holy places. If you had tempered your zeal with discretion, you could certainly have better achieved what you wanted, and rather than scatter the flock that was collected, you could have collected the flock that was scattered, and so have enhanced the glory of your name of pastor rather than acquired the guilty name of a disperser. But by following your own rash impulse you, as I hear, have so scandalized your flock that the larger part of it is no longer in communion with you. How will you lead wandering sheep to the Lord's fold if you are not able to keep in it those you already have? Therefore we exhort you to lay aside false pride, and immediately to do all you can to call back, with paternal love, those disaffected souls that you know to be outside the unity of your communion.

For these dispersed children of the church must be called back, and those passages of Holy Scripture should be shown to them that prohibit the adoration of man's handiwork, for it is written, "Thou shalt adore the Lord thy God, and Him only shalt thou serve."[6] But then you should add that because you saw that those painted likenesses, made for the instruction of the ignorant, so that they might understand the stories and so learn what occurred, were being adored, you were so enraged that you ordered them to be broken. And you should also tell them: "If you wish to have images in church in order to gain from them the instruction for which they were formerly made, I freely permit them to be made and placed there." And explain that it was not the sight of the story there

6 Luke 4 : 8.

related in a painted text that angered you, but the worship which had been paid to them illicitly.[7]

ITALY UNDER THE OSTROGOTHS

Among the barbarian rulers who established themselves within the boundaries of the Empire during the fifth and sixth centuries, Theodoric the Ostrogoth was the most formidable and also the most civilized. He had spent his early youth at the court of Constantinople and had later played a dominant role in the politics of Byzantium. By 488 his influence had reached a point at which the Emperor Zeno[8] thought it wise to send him and his Ostrogoths on a campaign to Italy, promising him authority over the western half of the Empire as a reward. In 493 the victorious Theodoric made Ravenna his residence. Here he built a palace, which was adorned by a mosaic depicting him on horseback and another one showing him between personifications of the cities of Rome and Ravenna. The mosaics are known through Agnellus, the ninth-century chronicler of the bishops of Ravenna. Their composition echoed imperial portraits, which often represented the Emperor between personifications of Rome and Constantinople.

Agnellus: Two Portraits of Theodoric

After Tuscia had been plundered by the Lombards, they blockaded Ticinum, which is also called Pavia,[9] where Theodoric built a palace and where I myself saw his portrait in the courtroom. It is a mosaic and shows him on horseback. A similar one was in the palace he built here [in Ravenna] on the tribunal by that triclinium[10] which is called "By the Sea" [and another one was] over the door and above the gate which is called the Chalke[11] of this city, where the main entrance to the palace was, in a place called "the Secretariat," where the church of the Saviour stands. On the gable of this building was the image of Theodoric in mosaic, holding a lance in the right hand and a shield in the left, clad in war gear. Next to his shield stands Rome, depicted in mosaic, carrying a

[7] *Sancti Gregorii Magni Epistolarum Lib. XI, Epist. 13, Patrologia latina,* ed. J. P. Migne, LXXVII (Paris: 1849), cols. 1128–30.

[8] Zeno, Roman Emperor in the East (474–91).

[9] Agnellus refers here to events which took place in 569–72.

[10] A dining room of the palace.

[11] The "Chalke" was the main entrance to the Great Palace at Constantinople.

lance and a helmet. Next to the lance stands Ravenna, depicted in mosaic, her right foot over the sea, her left foot over the earth, as if she hastened towards the king.[12]

Theodoric to Agapetus: A Request for Roman Mosaicists

Theodoric was able to draw to his court some of the most learned and accomplished men of his time, among them the philosopher Boethius and the scholar Cassiodorus, who drafted the King's letters. After Ravenna had fallen to Justinian in 540, Cassiodorus retired to Vivarium, a monastery he had founded in southern Italy. During his retirement he edited the letters he had written for Theodoric and his successors. Many of them, like the following, show Theodoric as a builder and a patron of the arts.

I am going to build a great basilica of Hercules[13] at Ravenna, for I wish my age to match preceding ones in the beauty of its buildings, as it does in the happiness of the lives of my subjects. Send me therefore skillful workers in mosaic. Send us from your city [Rome] some of your most skillful marble workers who may join together thoses pieces which have been carefully divided, and, connecting together their different veins of colors, may admirably represent their natural appearance. From art proceeds this gift which conquers nature. And thus the discolored surface of the marble is woven into the loveliest variety of pictures, the value of the work now as always being increased by the minute labor which has to be expended on the production of the beautiful.[14]

Amalasuentha to Justinian: A Request for Proconnesian Marble

After Theodoric's death Cassiodorus continued to serve the king's heirs. The following letter was written by him to Justinian[15] on behalf of Amalasuentha[16] in 535. Proconnesian marble[17] had been shipped to Ravenna ever since the city had become an imperial residence in the early fifth century. Although some unfinished marble may have been

12 Agnellus, *Liber Pontificalis*, XXIX (*Petrus* III), 15, ed. A. Testi Rasponi, *Codex Pontificalis Ecclesiae Ravennatis, Raccolta degli Storici Italiani . . . ordinata da L. A. Muratori,* new ed., (Bologna: Zannichelli, 1924), I, 227–28.

13 The Basilica of Hercules was so named either because it was dedicated to that hero or because it stood in close proximity to one of his statues.

14 Cassiodorus, *Variae,* I, 6, *The Letters of Cassiodorus. Being a Condensed Translation of the Variae Epistolae,* ed. Thomas Hodgkin (London: Henry Frowde, 1886), pp. 147–48.

15 Justinian I, Roman Emperor (527–65).

16 Amalasuentha, daughter of Theodoric and regent for her son Athalarich (526–35).

17 Proconnesos, an island in the Sea of Marmora, famous for its marble, now called Marmora.

imported, much of it was sent after being cut and still bears the marks of the workers in the Proconnesian quarries. Since Amalasuentha was murdered only a short time later, it is doubtful whether the marble was ever sent.

Delighting to receive from your Piety some of those treasures of which the heavenly bounty has made you partaker, we send the bearer of the present letter to receive those marbles and other necessaries which we formerly ordered Calogenitus[18] to collect on our behalf. All our adornments, furnished by you, redound to your glory. For it is fitting that by your assistance should shine resplendent that Roman world which the love of your Serenity renders illustrious.[19]

Theodoric to the Roman Senate: Appointment of a Custodian of Monuments

Judging by Cassiodorus' letters, Theodoric must have spent much thought and energy on the preservation of Rome. He was following a policy already adopted by Honorius,[20] who in 399 enacted a law which ordered that temples in the West should be preserved as public monuments. Its enforcement, however, presented some difficulties, especially in Rome itself, where not only the temples but also the public buildings had lost their function and invited spoliation. Theodoric therefore appointed a special official whose duties seem to have been rather like those of a modern curator, and with whom, in the following letter, he urged the senatorial nobility to collaborate.

Our care is for the whole Republic, in which, by the favour of God, we are striving to bring back all things to their former state; but especially for the City of Rome. We hear that great depredations are being committed on public property there.

It is said that the water of the aqueducts is being diverted to turn mills and water gardens—a thing which would not be suffered even in the country districts. Even in redressing this wrong we must be observant of law; and therefore if it should be found that those who are doing this can plead thirty years' prescription, they must be bought off, but the misuse must cease. If the diversion is of less ancient date, it must of course be at once stopped without compensation.

Slaves assigned by the forethought of previous rulers to the service of the aqueducts have passed under the sway of private masters.

Great weights of brass and lead, the latter very easy to steal on account of its softness, have been stripped off the public buildings. Now

18 A messenger.

19 Cassiodorus, *Variae*, X, 8, in *The Letters of Cassiodorus*, ed. Thomas Hodgkin (London: Henry Frowde, 1886), p. 423.

20 Honorius, Roman Emperor in the West (395–423).

Ionos, King of Thessaly,[21] is said to have first discovered lead, and Midas, King of Phrygia,[22] brass. How grievous that we should be handed down to posterity as neglecting two metals which they were immortalized by discovering!

Temples and other public buildings, which at the request of many we have repaired, are handed over without a thought to spoliation and ruin.

We have appointed the Spectabilis John to inquire into and set straight all these matters. You ought to have brought the matter before us yourselves: at least now, support him with the necessary compensations.[23]

Theodoric to Albinus: Urban Renewal in the Forum

One way to keep temples and deserted public buildings from being pillaged was to find new uses for them. In the following letter the King encourages the Patrician Albinus to implement such a plan, designed to protect the Forum. Private dwellings are to be constructed above a portico flanking the Forum.

Those whom the Republic has honoured should in their turn bring honour to the City. We are therefore gratified by receiving your supplication for leave to erect buildings above the Porticus Curba,[24] which being situated near the Domus Palmata[25] shuts in the Forum in a comely fashion. We like the plan. The range of private dwellings will thereby be extended. A look of cheerful newness will be given to the old walls; and the presence of residents in the building will tend to preserve it from further decay. You have our permission and encouragement to proceed, if the proposed erections do not in any way interfere with public convenience or the beauty of the City.[26]

Theodoric to Symmachus: The Restoration of Pompey's Theatre[27]

This letter was written in 510 to Symmachus, a distinguished member of the Senatorial nobility and father-in-law of Boethius, one of

21 Ion is famous as a metalworker, but not as a king. Cassiodorus may be thinking of Ionios, a legendary king of Illyricum.

22 Midas, a legendary king of Phrygia.

23 Cassiodorus, *Variae*, III, 31, *The Letters of Cassiodorus*, ed. Thomas Hodgkin (London: Henry Frowde, 1886), pp. 213–14.

24 The Porticus Curbae (some mss. say Curiae) was probably near the northwest end of the Forum.

25 The Domus Palmata was probably identical with the Secretarium Senatus.

26 Cassiodorus, *Variae*, IV, 30, in *The Letters of Cassiodorus*, ed. Thomas Hodgkin (London: Henry Frowde, 1886), pp. 249–50. Reprinted by permission of Oxford University Press.

27 Gnaeus Pompeius Magnus, Roman statesman and general (b. 106 B. C., d. 48). Dedicated in 52, the theatre built by him was the first theatre in Rome to be made of stone.

Theodoric's most prominent counsellors and officials. Here Theodoric congratulates Symmachus on his building activities and especially on his plan for the restoration of Pompey's Theater, and offers to reimburse him for the costs of the project. The description of the ruins of the theater is a stylized piece of rhetoric but conveys with remarkable success the feelings that must have been evoked by the empty and oversized remains of the past, many of which were already used as quarries or shelters by the contemporaries of Cassiodorus.

.... We agree with your advice that the fabric of the theater crumbling under its great mass should be strengthened, so that what your ancestors are known to have given as an ornament to their city may not be found to have diminished under their more virtuous progeny. What can you not dissolve, old age, having shaken such strength? It would have been easier to think that mountains had yielded than that such solidity had been shattered, since all that mass was also of solid stone so that one might think it to be a work of nature, except for the admixture of art. We could perhaps pass over these things, if we had not happened to see those great vaulted caves with their hanging rocks, their joints hidden by beautiful shapes, so that you might think them to be caverns of high mountains rather than architecture. The ancients made a place adequate for a very large crowd, so that those who had conquered the world might have a singular spectacle.[28]

PRE-CAROLINGIAN GAUL

Sidonius Apollinaris

Except for the Pagan Franks, the Germanic tribes that invaded Gaul were Arian Christians. They were on the whole tolerant, and interfered little with the orthodox beliefs of the provincial population, whose help they sought in their fight against the Franks. Such responsibilities as the administration of the Church, the support of its clergy, the care for the poor, and the building of cathedrals and monasteries were left almost entirely to those members of the senatorial aristocracy who were willing to assume the then very heavy burden of a bishop's office.

Sidonius Apollinaris was one of these public-spirited aristocrats and his career was typical of his class. Sidonius was frequently in Rome, where he served both the Emperor Avitus,[29] who was his father-in-law, and later

[28] Cassiodorus, *Variae*, IV, 51, ed. T. Mommsen, *Monumenta Germaniae Historica, Auctores Antiquissimi*, XII (Berlin: Weidmannsche Buchhandlung, 1894), 138.

[29] Avitus, Roman Emperor in the West (455–56).

the Emperor Majorian.[30] *In 468 he was Prefect of the city. On his return to Clermont-Ferrand in 468 or 470, he was made bishop. He defended the city unsuccessfully against an attack by the Visigothic King Euric*[31] *and had to resign in 474. He died in 479 and was venerated as a saint.*

The church in Lyon, for which Sidonius composed an inscription, was dedicated in 469 or 470. The inscription was flanked by two others, which adorned, according to his account, the walls by the altar. This seems to imply that Sidonius' inscription was also placed in the sanctuary. Since he calls this area the "end of the church," its "towering front," mentioned in the inscription, must mean the entrance. Like St. Peter's, the church at Lyon seems to have been oriented toward the west. It had neither transepts nor lateral oratories but was preceded by an atrium. The description of the interior is both in language and content reminiscent of Prudentius' description of St. Paul's in Rome.[32]

To Hesperius: A New Church in Lyon

What I most love in you is your love of letters,[33] and I strive to enhance the generous devotion by the highest praises I can give; your firstfruits please the better for it, and even my own work begins to rise in my esteem. For the richest reward of a man's labours is to see promising young men growing up in that discipline of letters for which he in his own day smarted under the cane. The numbers of the indifferent grow at such a rate that unless your little band can save the purity of the Latin tongue from the rust of sorry barbarisms we shall soon have to mourn its abolition and decease. All the fine flowers of diction will lose their splendour through the apathy of our people. But of that another time. My present duty is to send you what you asked, namely, any verses I might have written since we saw each other last, to compensate you for my absence. I now satisfy your desire; young though you are, your judgement is already so matured that even we seniors like to obey your wishes.

A church has recently been built at Lyons, and carried to a successful completion by the zeal of Bishop Patiens;[34] you know his holy, strenuous, and ascetic life, how by his abounding liberality and hospitable love towards the poor he erects to an equal height the temple of a spotless reputation. At his request I wrote a hurried inscription for the end of the church in triple trochaic, a metre by this time as familiar to you as it has long been to me. Hexameters by the illustrious poets Constantius[35] and

30 Majorianus, Roman Emperor in the West (457–61).

31 Euric, Visigothic king (466–84/5).

32 See above, pp. 13–15.

33 The recipient of this epistle was Hesperius, a man of letters and a friend of Sidonius Apollinaris.

34 Patiens, Bishop of Lyon (475–91).

35 Constantius (d. ca. 488), an author and cleric in Gaul, was another of Sidonius' friends.

Secundinus[36] adorn the walls by the altar; these mere shame forbids me
to copy here for you. It is with diffidence that I let my verse appear at all;
comparison of their accomplished work with the poor efforts of my lei-
sure would be too overwhelming. Just as a too beautiful bridesmaid
makes the worst escort for a bride, and a dark man looks his swarthiest
in white, so does my scrannel pipe sound common and is drowned by the
music of their nobler instruments. Holding the middle post in space and
the last in merit, my composition stands condemned as a poor thing, no
less for its faulty art than for the presumption which has set it where it is.
Their inscriptions properly outshine mine, which is but a sketchy and
fanciful production. But excuses are of little use: let the wretched reed
warble the lines demanded of me:

'O thou who here applaudest the labours of Patiens our pontiff and
father, be it thine to receive of heaven an answer to a prayer according
with thy desire. High stands the church in splendour, extending neither
to right nor left, but with towering front looking towards the equinoctial
sunrise. Within is shining light, and the gilding of the coffered ceiling
allures the sunbeams golden as itself. The whole basilica is bright with
diverse marbles, floor vaulting and windows all adorned with figures of
most various colour, and mosaic green as a blooming mead shows its
design of sapphire cubes winding through the ground of verdant glass.
The entrance is a triple portico proudly set on Aquitanian columns; a
second portico of like design closes the atrium at the farther side, and the
mid-space is flanked afar by columns numerous as forest stems. On the
one side runs the noisy highway, on the other leaps the Saône; here turns
the traveller who rides or goes afoot, here the driver of the creaking carri-
age; here the towers, bowed over the rope, raise their river-chant to Christ
till the banks re-echo Alleluia. So raise the psalm, O wayfarer and boat-
man, for here is the goal of all mankind, hither runs for all the way of
their salvation.'[37]

To Domitius: The Baths of his Villa

*When Sidonius became bishop of Clermont-Ferrand, the city had
just been given a splendid cathedral by Bishop Namatius.[38] There seems
to have been no reason for Sidonius to engage in church building. He had
built, however, as a younger man, a villa of which he gives a proud
description in a letter to his friend Domitius, whom he hopes to lure to
Clermont-Ferrand for a visit. The bath of his villa was an object of
special pride for Sidonius. Its cooling-room was modelled on a similar
structure in Bajae, a fashionable resort in the vicinity of Naples. In*

[36] Secundius, a poet who lived in Lyon, the author of a political satire.
[37] Sidonius Apollinaris, *Letter* II, 10, *The Letters of Sidonius*, ed. trans.
O. M. Dalton (Oxford: Clarendon Press, 1915), pp. 53–55. Reprinted by permis-
sion of the Clarendon Press, Oxford.
[38] Namatius, Bishop of Clermont-Ferrand (446–62).

accordance with a widespread early Christian usage, its decoration consisted of inscriptions.

.... On the south-west side are the baths, hugging the base of a wooded cliff, and when along the ridge the branches of light wood are lopped, they slide almost of themselves in falling heaps into the mouth of the furnace. At this point there stands the hot bath, and this is of the same size as the anointing-room which adjoins it, except that it has a semicircular end with a roomy bathing-tub, in which part a supply of hot water meanders sobbingly through a labyrinth of leaden pipes that pierce the wall. Within the heated chamber there is full day and such an abundance of enclosed light as forces all modest persons to feel themselves something more than naked.

Next to this the cold room spreads out; it might without impertinence challenge comparison with baths built as public undertakings. First of all the architect has given it a peaked roof of conical shape; the four faces of this erection are covered at the corners where they join by hollow tiles, between which rows of flat tiles are set, and the bath-chamber itself has its area perfectly adjusted by the nicest measurements so as to find room for as many chairs as the semicircular bath usually admits bathers, without causing the servants to get in one another's way. The architect has also set a pair of windows, one opposite the other, where the vaulting joins the wall, so as to disclose to the view of guests as they look up the cunningly-wrought coffered ceiling. The inner face of the walls is content with the plain whiteness of polished concrete. Here no disgraceful tale is exposed by the nude beauty of painted figures, for though such a tale may be a glory to art it dishonours the artist. There are no mummers absurd in features and dress counterfeiting Philistion's[39] outfit in paints of many colours. There are no athletes slipping and twisting in their blows and grips. Why, even in real life the chaste rod of the gymnasiarch promptly breaks off the bouts of such people if they get mixed up in an unseemly way! In short, there will not be found traced on those spaces anything which it would be more proper not to look at; only a few lines of verse will cause the new-comer to stop and read: these strike the happy mean, for although they inspire no longing to read them again, they can be read through without boredom. If you ask what I have to show in the way of marble, it is true that Paros, Carystos and Proconnesos, Phrygians, Numidians and Spartans have not deposited here slabs from hill-faces in many colours, nor do any stone surfaces, stained with a natural tinge among the Ethiopian crags with their purple precipices, furnish a counterfeit imitation of sprinkled bran. But although I am not enriched by the chill starkness of foreign rocks, still my buildings—call them cottages or huts as you please—have their native coolness. However, I want you to hear what we have rather than what we have not. Attached

[39] Philistion, a writer of pantomimes during the Augustan period.

to this hall is an external appendage on the east side, a *piscina* (swimming-pool), or, if you prefer the Greek word, a *baptisterium*, which holds about 20,000 *modii*.[40] Those who come out of the heat after the bath find a triple entrance thrown open to them in the centre of the wall, with separate archways. The middle supports are not pillars but columns, of the kind that high-class architects have called "purples." A stream is "enticed from the brow" of the mountain, and diverted through conduits which are carried round the outer sides of the swimming-bath; it pours its waters into the pool from six projecting pipes with representations of lions' heads: to those who enter unprepared they will give the impression of real rows of teeth, genuine wildness in the eyes and unmistakable manes upon the neck.

If the owner is surrounded here by a crowd of his own people or of visitors, so difficult is it to exchange words intelligibly, owing to the roar of the falling stream, that the company talk right into each other's ears; and so a perfectly open conversation, overpowered by this din from without, takes on an absurd air of secrecy....[41]

St. Gregory of Tours

When St. Gregory of Tours[42] wrote his History of the Franks, *conditions in Gaul had changed considerably since the time of Sidonius.[43] Clovis,[44] the Frankish king, had conquered the whole of Gaul and had at the same time embraced the Catholic religion. Frankish nobles emerged as bishops and replaced the Roman aristocrats whose generous use of their family patrimonies had sustained the Roman Church in Gaul during the preceding century. Gregory describes their buildings with admiration and nostalgia. Both the church which Perpetuus[45] constructed over the grave of St. Martin and dedicated in 470 and the church which Namatius[46] had built in Clermont-Ferrand between 446–62 were more than a hundred years old when Gregory wrote. Their late Roman splendour must have contrasted sharply with contemporary edifices.*

Fifth Century Basilicas in Tours and Clermont-Ferrand

In the city of Tours, upon the death of Eustochius[47] in the seven-

40 A modius equals approximately two gallons.

41 By permission of the publishers and of the Loeb Classical Library from Sidonius Apollinaris, *Letters*, II, 2, trans. W. B. Anderson (Cambridge, Mass.: Harvard University Press; London: William Heinemann, Ltd., 1936), I, 421–25.

42 St. Gregory, Bishop of Tours (573–94).

43 For Sidonius see above, pp. 53–57.

44 Clovis I, Frankish king (481–561), who became sole ruler of Gaul in 507.

45 St. Perpetuus, Bishop of Tours (461–91).

46 St. Namatius, Bishop of Clermont-Ferrand (446–62).

47 St. Eustochius, Bishop of Tours (444–61).

teenth year of his episcopate, Perpetuus was consecrated as fifth in succession from the blessed Martin.[48] Now when he saw the continual wonders wrought at the tomb of the saint, and observed how small was the chapel erected over him, he judged it unworthy of such miracles. He caused it to be removed, and built on the spot the great basilica which has endured until our day, standing five hundred and fifty paces from the city. It is one hundred and sixty feet long by sixty broad; its height to the ceiling is forty-five feet. It has thirty-two windows in the sanctuary and twenty in the nave. . . . Forty-one columns.[49] In the whole structure there are seventy-two windows, a hundred and twenty columns, and eight doors, three in the sanctuary, five in the nave. The great festival of the church has a threefold significance: it is at once a feast of the dedication, of the translation of the saint's body, and of his consecration as bishop. This festival you shall keep on the fourth day of July; the day of the saint's burial you shall find to fall on the eleventh of November. They who keep these celebrations in faith shall deserve the protection of the holy bishop both in this world and the next. As the ceiling of the earlier chapel was fashioned with delicate workmanship, Perpetuus deemed it unseemly that such work should perish; so he built another basilica in honour of the blessed apostles Peter and Paul, and in it he fixed the ceiling. He built many other churches, which are still standing to-day in the name of Christ.

At this time also the church of the blessed Symphorian,[50] the martyr of Autun, was built by the priest Eufronius,[51] who himself afterwards became bishop of this city. He it was who, in his great devotion, sent the marble which covers the holy sepulchre of the blessed Martin.

After the death of Bishop Rusticus,[52] the holy Namatius became in these days eighth bishop of Clermont. By his own efforts he built the church which still exists, and is deemed the older of those within the town walls. It is a hundred and fifty feet long, sixty feet broad, that is across the nave, and fifty feet high to the ceiling: it ends in a rounded apse, and has on either side walls of skilled construction; the whole building is disposed in the form of a cross. It has forty-two windows, seventy columns, and eight doors.

There is felt the dread of God, and the great brightness of His glory, and verily there often the devout are aware of a most sweet odour as of spices wafted to them. The walls of the sanctuary are adorned with a lining of many kinds of marble. The building being completed in the

48 St. Martin, Bishop of Tours (372–97), patron saint of France.

49 It has been suggested that the phrase mentioning 41 columns is incomplete, since it does not indicate whether the columns stood in the sanctuary or in the nave.

50 St. Symphorian, martyr of Autun, whose feast day is the 22nd of August.

51 St. Euphronius, Bishop of Autun (d. 490).

52 St. Rusticus, Bishop of Clermont-Ferrand (424–46).

twelfth year, the blessed bishop sent priests to the city of Bologna in Italy to bring him relics of the saints Vitalis and Agricola, crucified, as is known of all men, for the name of Christ our Lord.

The wife of Namatius built the church of the holy Stephen outside the walls. As she wished it to be adorned with paintings, she used to hold a book upon her knees, in which she read the story of deeds done of old time, and pointed out to the painters what subjects should be represented on the walls. It happened one day, as she was sitting reading in the church, that a certain poor man came in to pray. And when he saw her clad in black, for she was advanced in years, he deemed her one of the needy, and producing a piece of bread, put it in her lap, and went his way. She did not despise the gift of the poor man who did not perceive her quality, but took it and thanked him, and put it by, afterwards preferring it to her costlier food and receiving a blessing from it every day until it was all consumed.[53]

The Golden Church of Toulouse in 1633

Until 1764 Toulouse preserved a very ancient church, called "la Daurade" because of the profusion of gold mosaic in its interior. At the time of its destruction it consisted of seven sides of a regular decagon fourteen meters in diameter preceded by a western nave. The walls of the decagon were articulated by three stories of niches, whose arches rested on small columns. Some of these have survived. They vary somewhat in size; two of them, now in the Metropolitan Museum of New York, are 73 and 74-1/2 inches tall. There are three classes of capitals and some of the shafts have spiral fluting or are covered with vine scrolls. A date not later than the sixth century and possibly as early as the fifth has been assigned to them. The niches as well as the walls between them were covered with gold mosaic. The mosaics were cleaned in 1633. According to a description made at that time, each niche contained one figure, representing Christ, the Virgin, a prophet, an apostle, an angel, or a figure belonging to a scene from the infancy of Christ. The presence of such scenes indicates that the church had originally been dedicated to the Virgin. It therefore was certainly built after 423, when the Council of Ephesus proclaimed Mary to be the Mother of God.

The church is first mentioned in 585. Tradition connects it with the Visigothic kings who held court at Toulouse from 419 to 507. But since these kings were Arians, it does not seem likely that they participated in the foundation of a church dedicated to the Virgin. A date after the Frankish takeover in 507 is therefore more probable. A sixth-century date

[53] Gregory of Tours, *The History of the Franks,* edit. and trans. O. M. Dalton (Oxford: Clarendon Press, 1927), pp. 58–59. Reprinted by permission of the Clarendon Press, Oxford.

is also indicated by representations of the Virgin as an intercessor and also as a queen carrying a scepter and probably wearing a crown. The seventeenth-century description of the mosaic begins with the niches of the upper story, starting at the northwest corner and proceeding from there towards the eastern window above the main altar.

The 1st niche represents the slaughter of the innocents.[54] We see the executioner standing, and lifting the sword above his bare head, and slaying the boy he holds by the hair with his left hand. A slain child lies at his feet, and to the right the next one to be put to death is wailing. The figure stands before a golden background on a green meadow. There is no inscription.

The 2nd niche contains Herod, sitting. With a horrible and irate expression he orders the slaughter of the boys. He holds a scepter with a square top in his left hand and wears red and purple garments; he points with his right hand towards the executioner. His head is adorned by a silver circle. The word HERODIS is written on the gold background.

The 3rd niche seems to have one of the Magi who adored Christ.[55] He is either hurrying towards the crib or returning from there by another way. He has a nimbus around his head. He carries something in his hand. He certainly turns head and hand towards the crib of Christ [towards the west and right], while standing before a golden background on a green meadow. There is no inscription.

The 4th niche is occupied by a window, which contains within one arch images of St. Mary, the Christchild, and S. Anne. It is surrounded by three partridges in golden squares.

The 5th niche seems to have one of the Magi who adored Christ, like the one mentioned before, because here the figure is portrayed as wearing a bonnet, his hands are joined as if in prayer, he has long hair and wears the garb of a priest. There is no inscription.

The 6th niche contains, like the 5th, one of the Magi who adored Christ, because here the figure wears a pointed bonnet and has a grave mien. He holds his right hand before his breast and wears a multicolored cape and a garment with long sleeves, which extends from the breast to the knees and is adorned with inwoven roses and fishes. There is no inscription.

The 7th and 8th niches contain the large window at the Gospel side [the north side].

The 9th niche, though partly broken by the big cracks in the church, which were caused by the heavy weight of the vault, shows a man seated like a judge. His right arm is visible and his face is horrible and fierce.

[54] Matt. 2: 16.
[55] The niches 3–9 of the north side of the upper story contained a representation of the three Magi standing before Herod (Matt. 2: 1–8).

The rest of the figure is obscured by cracks. Close to the head is written ERO–DIS.

The 10th niche shows a standing figure, completely preserved, which is somewhat bent and agitated. The naked arms are stretched out, with hands joined; the face is turned towards heaven like someone who is praying and weeping. At his feet appears a completely preserved lamb. Close to the head of the figure is written PASTUR.[56]

The 11th and 12th niches contain the main window in the axis of the church, through which, since it is towards the east, the temple receives most of its light.

The description of the niches of the third tier turns now towards the south side of the decagon, and, beginning with the aedicula in the south-west corner of the sanctuary, moves towards the eastern window.

The 1st niche, which is opposite the niche portraying the slaughter of the innocents, contains, although without inscription, the figure of one of the Magi, ready to approach Christ with a long stride and to offer his gift, which he holds in both hands.[57]

The 2nd niche, opposite the niche with Herod, is likewise without inscription but certainly contains one of the Magi, ready to approach Christ with a long stride, and to offer his gift, which he holds in both hands. The head of this wise man has been partially destroyed by the rain of many years.

The 3rd niche is likewise without inscription but certainly contains one of the Magi, ready to approach Christ with a long stride and to offer the gift he holds in both hands to Jesus, who, seated on St. Mary the Virgin's lap, lifts his right hand in blessing.

The 4th niche contains a glass window, like the one mentioned before [on the opposite side]; this one faces the south and the cloister.

The 5th niche contains the image of blessed Mary, holding the Christchild before her breast, and steadying his holy feet with her right hand. Jesus, moreover, seems to smile at the Magi and blesses them with his right hand. The holy Virgin is veiled and wears shoes. Her vestments vary in a wonderful fashion between blue and purple. By her head is the holy and health-giving name MA–RIA.

The 6th niche shows a tall man who turns his head towards the Virgin. With his right arm, which is bare to the elbow, he points to a star. A sheep stands by his feet. The star appears on the left side. At his head is the inscription PAS–TOR.[58]

[56] The shepherd must have been part of a scene representing the appearance of the angels to the shepherds (Luke 2: 2–14).

[57] The niches 1–5 on the south side of the upper story contained a representation of the adoration of the Magi (Matt. 2: 11).

[58] The niches 6–10 of the south side of the third story contained a representation of the adoration of the shepherds (Luke 2: 16–20).

The 7th and 8th niches are by the large window on the Epistle side [the south side].

The 9th niche contains an image of the blessed Virgin Mary, with headgear and sitting on a seat resembling an episcopal throne. She wears shoes. Her right hand is held before her breasts in a majestic gesture. The left sustains a golden cross which reaches from her head to her right foot. She turns her young but venerable face towards the Christchild in the manger. By her head stands the holy name MA–RIA.

The 10th niche shows the Christchild, lying in a manger and wrapped in swaddling clothes. There the ass stands in front, turning from the Gospel side to the Epistle side [from left to right] and looking at Jesus who lies below the neck of the ox.

The description of the niches of the middle story starts at the northwest corner of the sanctuary and then moves clockwise towards the southwest corner.

The 1st niche, next to the organ and over the altar and chapel of S. Lucy, shows Esdras, who stands as if in meditation and on the left side lifts a pallium with his left hand, and holds a book with the right close to his knees. He turns slightly towards the altar. He wears sandals and has by his head the inscription ESDRAS.[59]

The 2nd niche shows Abimelech, with a silver pallium. He has the inscription ABIMELEC by his head.[60]

The 3rd niche shows Philip. His head is bare and his hands are joined before his breast. He looks reverently towards the image of the Saviour, which is some distance away. By his head is written FILIPPUS.[61]

The 4th niche shows Simon, underneath the north window. His head is bare and he looks towards the Saviour. He holds his right hand in the air and his left close to the thigh. By his head is written SIMON.

The 5th niche shows Andrew. He raises his right hand towards the Saviour, his left lifts the toga. He wears sandals and by his head is written ANDREAS.

The 6th niche shows Luke, his head covered, also turned towards the Saviour's image. He holds the right hand at the thigh. With the left he holds a rather large book before his heart. He wears sandals, he has a small beard, and he looks very old. By his head is written LUCAS.

The 7th niche shows John, who looks rather young and holds in his left hand a golden book with multicolored ornaments and on it places also his right hand. He looks towards the Saviour. He wears sandals on his bare feet. By his head is written IOHANNIS.

[59] Esdras or Ezra, one of the minor prophets.
[60] Abimelech, a king of Israel.
[61] The niches 3–8 of the northern half of the second story contained the figures of anostles and evangelists.

The 8th niche shows Peter. He is old, his head is bare and bald. He has a nimbus as do the others. He wears sandals. He holds the toga with the left hand and carries the keys. By his head is written PE–TRUS. This image is broken through the middle from head to foot, and further, because of fissures in the temple.

The 9th niche shows the angel Uriel as a young man. He is depicted in almost the same manner as the adjoining figure of Michael. By his head is written HUR–IHIL.[62]

The 10th niche shows S. Michael, with a halo, curly hair, and large wings that are open and reach the floor. In his left hand he holds a certain triple globe, which is painted in several colors. He wears a bonnet, and has sandals on his feet. By his head is written MICAHIL.

Then the 11th niche has the Saviour, holding an open book in his left hand and extending his right in blessing. The open book shows in red letters the words PAX VOBISCUM. His head is bare and from it proceed three rays. His holy hair is thick and loose and has around it the word SALVATOR. Close to his feet is the holy image which is called "The Black Virgin" and sits between the niches of the Saviour [11] and the Virgin [12] in a hollow space of the outer and elevated pyramidical structure before and over the high altar of the Daurade Church.

The 12th niche shows S. Mary next to the image of the Saviour. Her head is veiled. She looks with a lovely and devoted expression towards the Saviour's image next to her. One sees her hands but not her feet. Around her head is a radiance. By it are written these two words: SANCTA MARIA.

The 13th niche shows Gabriel in the same manner and attitude as Michael and Raphael, with curly hair, a diadem, and wings. He is youthful and carries a long staff in his left hand and three rounded and greenish globes in his right, each different from the others. By his head is written GABRIEL.

The 14th niche shows Raphael, with curly hair, a diadem, and wings. He is youthful and carries in his left hand a pilgrim's staff, which reaches from his head to his feet, and in his right hand he carries three rounded and greenish globes, each equal to and different from the others. By his head is written RAFAEL.

The 15th niche shows S. Paul, with bare head, a small beard, and a halo. He lifts his right hand as if in ecstasy; with the left he holds a large red book adorned with golden ribbons. By his head is written PAULUS.[63]

62 The niches 9–14 of the second tier were situated towards the east and contained representations of Christ, the Virgin, and two pairs of archangels.

63 The niches 15–20 of the second story, like those on the opposite side, contained figures of apostles and evangelists.

The 16th niche shows Matthew, holding his right hand and also a book with his left hand before his breast. He wears sandals over bare feet. By his head is written MATTHAEUS.

The 17th niche shows Mark, his right hand hanging by his knees, and his left holding a golden book before his breast. His face is slightly turned towards the Saviour. By his head is written MAR–CUS.

The 18th niche shows Bartholomew, his right hand raised in the air, and his left holding the toga as if he is taking a step. He wears sandals and by his head the word MARTA–LAMEUS is clearly visible.

The 19th niche shows Thomas, who looks at the Saviour's image and raises both hands towards it in admiration. This figure is under the south window and is broken in the middle from head to foot, because of the fissures in the church. At his head is written TO–MAS.

The 20th niche shows James. Looking towards the Saviour, he holds his right hand by his breast outstretched towards the faithful. The left hand is not visible. By his head is written IACOBUS.

The 21st niche shows Isaiah, whose figure, like the next one, was difficult to recognize on account of the darkness, the dirt, the distance, and the danger of a fall, but which was found entirely preserved, after it had been wiped. The figure is clad in a fine antique pallium and has at its head the inscription ESA–IAS.[64]

The 22nd niche shows Ezekiel, wearing a richly decorated pallium and standing before a golden ground on a green meadow. By his head is written ESE–CHEL.[65]

The description turns now to the last and lowest order of niches, whose mosaics were less well preserved than those in the higher tiers. The description begins at the northwest corner and proceeds clockwise towards the east and southwest. It begins with the third niche, since the space of the first two niches underneath the figures of Esdras and Abimelech had been made into a chapel.

The 3rd niche shows Jude, who is young and has a halo. From the breast to the feet his figure is entirely erased and deleted. By his head is written IU–DAS.[66]

The 4th niche shows Levi, his head turned towards the main altar. He lifts slightly his open left hand. The rest of the body is gone and erased. By his head is written LEV–VIS.

The 5th niche shows Simeon. He has a big head and large wide-

64 Isaiah, one of the major prophets.

65 Ezekiel, like Isaiah in the preceding niche, was one of the major prophets.

66 The niches 3–6 of the lowest tier contained figures of Jacob and three of his sons.

open eyes. His head is surrounded by a halo. By it is written SEM–EON. The rest of the figure is lacking.

The 6th niche, adjoining the chapel of S. Peter on the Gospel side [right or west] where the old entrance to the church formerly was, shows Jacob. He has a large head surrounded by a halo and a venerable face. The rest of the body is erased and destroyed. By his head one reads IACOB.

The 7th and 8th figures are on the arch which constitutes the chapel of St. Peter, under which was once the entrance to the church. They represent two prophets, one having the inscription ENOC[67] and the other opposite having by his head the inscription ELIAS.[68]

The 9th niche shows Isaac, who turns his head towards his father. By it is written HISAC.[69]

The 10th niche shows Abraham, an old man with a severe and grave face, a long beard, and curly hair, who bends his head towards his son, around which is written HABRAAM.

The next three niches were obscured by the main altar of the church. Only one head without an inscription remained visible.

The 14th niche shows Joel,[70] bareheaded and with the inscription NOEL. The rest of the niche is destroyed.

The 15th niche contains the doorway leading from the sacristy to the holy image [on the main altar]. Its arch contains the figures of two prophets facing each other but, after 1628, without inscriptions. One of them was Abdias, as I have seen myself. The other [inscription] I could not decipher.

The 16th niche shows Ananias, one of the youths in the fiery furnace of Babylon. He stands by the gospel [left] side of the Altar of the Nativity and turns with lifted hands towards the angel Gabriel before him. By his head is written ANNA-NIAS.[71]

The 17th niche shows the angel Gabriel, whose niche is on the epistle [right] side of the Altar of the Nativity, and who has his face turned towards the next four figures. He has wings. Sent to save the three youths, he calms the flames and sprinkles dew. By his head is written GABRIEL.

The 18th niche shows Azarias with a big bonnet, looking very

[67] Enoch, one of the patriarchs.

[68] Elijah, the prophet, like Enoch, who was represented on the other side of the arch, did not die but was translated into heaven.

[69] The niches 9 and 10 of the lower tier contained representations of the patriarchs Isaac and Abraham, the father and grandfather of Jacob.

[70] Abdias and Joel, two of the minor prophets.

[71] The niches 16–19 of the lowest tier contained a representation of the youths in the fiery furnace (Daniel 3: 22–92).

young, with curly hair, dressed from neck to knee in a tight but multi-colored and precious garment. He has both hands lifted, like a priest who greets the faithful. By his head is written AZARIAS.

The 19th niche shows Mizael, wearing a big bonnet, looking very young, with thick curly hair, wearing a tight but multicolored and preci-ous garment. He has both hands lifted. By his head is written MIZA–HEL.

The 20th niche shows Benjamin, wearing a costly pallium, young in appearance, and holding a finger of one hand against a finger of the left hand. He stands before the golden background with bare head and by it is the following inscription: BENIAMIN.[72]

The 21st niche shows Joseph, who is very young, with joined hands, bare head, clad in sandals and a splendid pallium, and turning towards his brother Benjamin. He stands before a golden background, and by his head is written IO–SEB.[73]

And in the highest region, close to the vault of the church and above the capitals of the 22 jasper columns were 22 parrots in mosaic. Between the columns were six or eight peacocks, wonderfully depicted as drinking from a vase filled with water. In the lower row of niches eight or ten busts of angels seem to invite the piety of the faithful.[74]

The Treasure of Bishop Desiderius of Auxerre

Romans and barbarians of the late antique and early medieval period shared a taste for jewelry and other ornaments made of gold, silver, and precious stones. The shimmering beauty of such objects must have satisfied an aesthetic and religious sense which, either naively or by way of philosophical speculation, was led to identify the divine with the lumi-nous. And in a time when life was perilous and currency unstable or hard to come by, there were also more practical reasons to cherish gold and silver work. It seems, in fact, that the limitations of early medieval com-merce and coinage were a necessary condition for the creation of those fabulous hoards amassed in the churches of Europe between the fourth and early eleventh centuries. These treasures were already beginning to be dispersed in the twelfth and thirteenth centuries, when an expanding economy demanded gold and silver for its coinage.

The ninth-century chronicle of the Bishops of Auxerre contains two lists of silver vessels, given to the cathedral and to the church of St. Germain of that city by Bishop Desiderius,[75] a man famous for his gen-erosity: on one occasion he is said to have freed more than two thousand

[72] Benjamin, Jacob's youngest son, one of the patriarchs.

[73] Joseph, also Jacob's son and a patriarch.

[74] *Monasticon Benedictinum*, Paris, Bibliotheque Nationale, Ms. Lat. 12680, fols. 231–35, ed. Abbé Degert in *Bulletin de la Société archéologique du midi de France* (1905), pp. 209–15. My translation is based on Degert's edition but has been corrected and completed from the manuscript.

[75] Desiderius, Bishop of Auxerre (603–21/3).

serfs. Much of the wealth he dispensed so freely may have come to him from Queen Brunhild,[76] whose kinsman he was. One of the silver vessels he gave to St. Germain certainly came out of the royal treasure and still bore the name of its previous possessor. Many of the vessels listed were adorned with mythological representations, and may have been of Roman origin. Some of them may have come from Byzantium. The fact that Byzantine silver vessels were much treasured in Merovingian Gaul is attested by Merovingian copies which also imitate the official stamps of contemporary Byzantine silverware. The "dish of medium size with four stamps on its bottom" may have been either a Byzantine piece or its copy.

The Latin text describes most of the dishes with the adjective "anacleus." Since the meaning of this word is obscure, I have omitted it in the following translation.

He [Desiderius] very splendidly decorated and enlarged the basilica of St. Stephen, his cathedral church. He added a large vault to the eastern half, marvellously decorated with gold and mosaic, similar to that which Syagrius,[77] bishop of Autun, is known to have built. Bringing the old altar there, he held a solemn dedication on the 13th day before the kalends of May,[78] and offered the following gifts: A gilded platter... weighing 50 pounds, with seven figures, a man with a bull and a Greek inscription. He also gave another similar platter... set with garnets, weighing 40½ pounds with a circle and a wreath around the center and men and beasts around the rim. Also a third platter... weighing 35 pounds, with the story of the sun and with a tree and snakes. Also a fourth platter, weighing 30 pounds, with an Ethiopian and other men. Also a gilded bowl, weighing 12 pounds and 2 ounces, with a fisher with a trident and a centaur in a seascape. Also another bowl... with circular decorations and niello work, weighing 14 pounds and 9 ounces. Also another similar bowl... with revellers weighing 13 pounds. Also another bowl... weighing 9 pounds, with a man with horns, a tree and two cupids holding small children. 4 drinking vessels... weighing 11 pounds and 2 ounces, with cupids, and beasts: one of these is gilded. He gave several dishes... one of these, decorated with niello, weighs 4 pounds, it has on it a bear, seizing a horse. Also another one... weighing 3 pounds with a lion seizing a bull. Also another one, weighing 2 pounds and 9 ounces, with a lion seizing a goat. Also another similar dish... weighing 2 pounds, with a buck with horns. Also another one, weighing 1 pound and 7 ounces, with a grazing stag. Also another one, weighing 1 pound and 9 ounces, with a leopard seizing a goat. He gave also 4 salt cellars... weighing 4 pounds. He gave also 6 deep dishes, weighing 16 pounds, and 1 deep dish of medium size... weighing 3½ pounds, with 4 stamps below and little

[76] Brunhild, Visigothic princess and Frankish queen (596–613).
[77] St. Syagrius, Bishop of Autun (*ca.* 561–*ca.* 600).
[78] April 19th.

berries around the rim. Small drinking vessels, decorated with small heads, weighing 6½ pounds. He also gave 2 decanters, weighing 4 pounds and 3 ounces. Also 3 decanters... weighing 5 pounds. He also gave 9 spoons, weighing 2½ pounds. Also one ladle, weighing 1 pound and 10 ounces, with a circular ornament in niello and a border around its rim. He also gave a mug, weighing 2 pounds, with a lion and a bull, both gilded. Also a trident, already mentioned, with the head of a lion, weighing 3 pounds. He also gave a pitcher... weighing 4½ pounds. And a waterbowl for the hands, weighing 3½ pounds. Also two gilded cans of like form weighing 5 pounds, encircled with images of men and wild beasts. He also gave a flat platter, weighing 8½ pounds, with a monogram in the middle encircled by a wheel. Also another platter, weighing 8 pounds, with a cross and two men in the center. Also a bowl... weighing 10 pounds, with 5 cupids and two winged beasts. Also another bowl... weighing 8½ pounds with a rider and a snake at his feet. Also another bowl with circular ornaments... weighing 7½ pounds, with three tall men in its center and a border of cupids and wild beasts around it. He gave also deep gilded dishes... weighing 18 pounds, with cupids and fishes. One deep gilded dish of middle size... weighing 8 pounds with sea centaurs and fishes in the center. Also 5 deep dishes ornamented with flowers, all of them alike, weighing 9½ pounds. Also a deep dish... of medium size, weighing 3 pounds, with the head of a bearded man in the center. Also a deep dish of medium size plain, weighing 2 pounds and 3 ounces with a cock in the middle. Also a deep dish... with a lip, weighing 3 pounds, with a band of cupids and wild beasts around it. Also a dish, weighing 2 pounds, with a cupid, a goat, and a tree in the middle. Also a dish... weighing 2 pounds with two cupids with lances in the center. Also a small dish, weighing 1 pound, with a wheel-like ornament in the center and a niello border. Also a salt cellar... weighing 1 pound with a man and a dog in the center. Also a shell... weighing 9 pounds, with a man and a woman in its center and a crocodile at their feet. Also a small cross-shaped salt cellar, weighing 9 ounces. Also a saucer... weighing one and a half pounds. 12 spoons, weighing 3 pounds and 2 ounces. Also 12 spoons, weighing 2 pounds and 9 ounces. Also 12 spoons, weighing 3 pounds with inscribed handles. Also 3 decanters with lips, each weighing 1 pound. And one decanter, weighing 1 pound and 1 ounce. Also a small drinking vessel, weighing 1 pound and 1 ounce. Also a jug... weighing 3 pounds with a handle with berries and the head of a man in the center. A basin for washing the hands, weighing 2 pounds and 9 ounces with a round floral decoration in the center and a man's head on the handle. Also a gilded wine cooler, weighing 2½ pounds with openings at the outside. Also another wine cooler, weighing 1 pound and 9 ounces, with a border and wild beasts in the center. Also a large sieve, weighing 1 pound, with niello work on the handle. Also a smaller sieve, weighing 2 ounces. Together 420 pounds and 7 ounces.

... He gave besides to the basilica of the Lord Germanus[79] these gifts: A silver platter, with the name Thorsomodus[80] on it; it weighs 37 pounds and shows the history of Aeneas with Greek inscriptions. Also another simple platter, weighing 3 pounds. Likewise a bowl ... weighing 13 pounds with a lion seizing a bear in the center and a border of cupids and wild beasts. Also another bowl, weighing 9½ pounds with a man and a woman and beasts at their feet. Also a dish ... weighing 5 pounds and 6 ounces, with a rider holding a snake in his hands. Also a dish ... weighing 3 pounds, with a round decoration in niello work and a wild beast in its center. He also gave 2 deep dishes, of similar shape with floral ornaments at the inside, weighing 8 pounds and 2 ounces. A pitcher ... weighing 4 pounds, with niello work on the handle and the head of a lion in the center. A washbasin weighing 3 pounds and 9 ounces, with Neptune and a trident in the center.[81]

St. Eloy of Noyon, a Merovingian Goldsmith

Goldsmiths enjoyed a privileged position among mediaeval artists. Most famous among them is St. Eloy (c. 590–660). He started his career in the workshop of Abbo of Limoges, one of the many Merovingian minters who often issued coins on their own account and signed them with their names. He was the master of Chlotar II's[82] mint in Paris and also served Dagobert I[83] as treasurer and councillor. The coins of Chlotar II which bear St. Eloy's name are remarkable for their clarity and sharpness. In 641 St. Eloy became bishop of Noyon. He died about 660 and soon afterwards was venerated as a saint. His biography, from which the following paragraph has been taken, is based on a contemporary account rewritten during the ninth century.

The treasure of St. Denis contained, until its dispersion in 1792, two pieces attributed to St. Eloy: a jade vessel, known from a reproduction of Félibien,[84] and a large cross, first mentioned as St. Eloy's in the ninth century. A small plaque of the latter still survives. It consists of a pattern of small cells, containing small garnets and emeralds, between which larger jewels were set.

The blessed man made, among other fine works, famous shrines of gold, silver, and gems for the bodies of many saints, for SS. Germanus,[85]

[79] St. Germain, Bishop of Auxerre (418–48).

[80] Thorismond, Visigothic king (451–453), one of Brunhilde's ancestors.

[81] *Gesta Pontificum Autissiodorensium*, ed. L.-M. Duru in *Bibliothèque historique de l'Yonne*, I (Paris-Auxerre: 1850), 334–37.

[82] Chlotar II, Frankish king (584–629).

[83] Dagobert I, Frankish king (623–39).

[84] Dom Félibien, French antiquary of the eighteenth century and chronicler of the Abbey of St. Denis.

[85] St. Germain, Bishop of Paris (556–76), who founded there the abbey of Saint Germain-des-Près, in which he was also buried.

Severinus,[86] Piaton,[87] Quentin,[88] Lucius,[89] Genoveva,[90] Columba,[91] Maximian,[92] Lolian, Julian[93] and many others. But especially to be noted is the shrine he fashioned for blessed Martin of Tours,[94] the cost of which was borne by King Dagobert[95] [623–39], which was of wonderful workmanship and made of gold and gems. He also fashioned the tomb of St. Brice[96], and he constructed elegantly another, above the old grave of blessed Martin. Eloy also built the tomb of the holy martyr Denis[97] in the city of Paris, and the marble baldachin over it, with a wonderful decoration of gold and gems. He also fashioned marvellously an ornament for its top and a facing for its front and also decorated the beams around the altar with gold and placed on them golden apples, rounded and adorned with gems. He also decorated with silver the lectern and the doors and the beams of the ceiling of the apse. He made as well a baldachin above the previous grave and an outer altar at the feet of the holy martyr. And he, by the king's request, put into these things so much work and so much of his own quality, that it [the mausoleum] is almost unique among the wonders of Gaul and is much admired by all even to the present day.[98]

IRELAND AND ENGLAND

Cassiodorus, Sidonius, and Gregory of Tours could not help but look nostalgically at past Roman greatness, compared to which their own period seemed to be one of decline and disintegration. For northern

[86] St. Severin (*c.* 501), buried at Château-Laudon near Meaux.

[87] St. Piat, martyr, a missionary who worked in the region around Tournai. St. Eloy is said to have found relics of St. Piat in the vicinity of Lille.

[88] St. Quentin, martyr, companion of St. Piat, whose grave is venerated in the city that bears his name. St. Eloy is said to have found relics of him along with those of St. Piat.

[89] St. Lucian, martyr, who was a missionary in the region around Beauvais, where a church dedicated to his cult has existed since the seventh century.

[90] St. Genevieve, patroness of Paris (b. *c.* 420, d. *c.* 500). The first church over her grave was built by Clovis I (481–511).

[91] St. Columba, virgin and martyr, buried and venerated in Sens.

[92] St. Maximian, martyr, one of St. Lucian's companions. See above, footnote 89.

[93] Probably St. Julian, martyr, another of St. Lucian's companions.

[94] Martin, Bishop of Tours (370/1–397), whose grave and church there became one of the religious centers of Gaul.

[95] Dagobert, Frankish king (623–639).

[96] St. Brice, Bishop of Tours (397–444).

[97] St. Denis, martyr and patron saint of France. The center of his cult, the abbey of St. Denis, north of Paris, was allegedly founded over his grave.

[98] *Vita Eligii Episcopi Novomagiensis*, X, 32, ed. W. Krusch, *Monumenta Germaniae Historica, Scriptores*, IV (Hannover-Leipzig: Hahnsche Buchhandlung, 1902), p. 688.

Europe, particularly for Ireland which had never been part of the Empire, and for England where Roman rule had had less impact than in Gaul, the same centuries were periods of extraordinary progress and expansion.

Ireland was christianized during the second half of the fifth century and possessed during the seventh and eighth centuries some of the most interesting schools of Europe, in which exegetic literature as well as poetry flourished. The Irish were no less famous for the evangelical zeal of their saints, who had been instrumental in converting Anglo-Saxons and Franks and through whose initiative Irish spirituality and monasticism had been spread to centers like Iona,[99] Lindisfarne,[100] Luxeuil[101] and Bobbio.[102] It is from Irish centers abroad such as Iona and Lindisfarne that some of the finest manuscripts of the period have been bequeathed to us.

Cogitosus: St. Bride's Church in Kildare

The Irish, fine goldsmiths and illuminators though they were, seem to have taken little interest in architecture. They built small corbelled structures of stone, but all larger buildings, such as St. Bride's[103] Church in Kildare, were almost certainly made of wood. The screen which divided the sanctuary from the nave was probably a general feature of Irish churches, in which the sanctuary does not seem to have been distinguished architecturally. The existence, on the other hand, of a longitudinal division of the nave may have been prompted by the fact that St. Bride's, the oldest Irish nunnery, was also a double monastery. Cogitosus, a monk at Kildare, described the church in his biography of the saint, written around the middle of the seventh century, about a hundred years after the saint's death.

One cannot be silent about the wonderful rebuilding of the church or about the splendor in which the bodies of the archbishop Conlaedh[104] and the blooming Virgin Bride both rest, to the right and the left of the ornate altar. They are placed in shrines, which are decorated with various adornments of gold, silver, and precious gems, with golden chandeliers hanging over them, and with diverse images, in relief as well as in painting, around them.

[99] Iona, island of the Inner Hebrides, where St. Columba founded a monastery in 563.

[100] Lindisfarne, island off the northeast coast of England, where St. Aidan, a monk from Iona, founded a monastery in 635.

[101] Luxeuil, a Roman settlement in Gaul, where St. Columban founded a monastery after 590.

[102] Bobbio, a monastery in northern Italy, founded by St. Columban in 612.

[103] St. Bride (b. 450, d. c. 523), abbess and founder of the monastery of Kildare.

[104] St. Conlaedh or Conleath (d. 520), first bishop of Kildare.

The deeds of old bring forth new things: with this I mean the church, built on spacious foundations, because of the ever increasing number of faithful men and women, rising to a jutting height, decorated with painted tablets [icons], and having within it under one roof three wide oratories divided by screens. One partition, which is decorated with paintings and covered with linen curtains, extends in the eastern part of the church from one wall to the other. This wall has two doors at each end, and through the one at the right side one goes towards the sanctuary and the altar, where the bishop with his clerics and those who are dedicated to the holy mysteries celebrates the holy sacrifice of the Lord. And through the other gate in the left side of the screen the abbess with her virgins and faithful widows enter in order to partake of the feast of Christ's body and blood.

And another screen divides the floorspace of the church into two equal parts, extending from the western wall to the transverse screen.

There are many windows in this church and one decorated door on the right side by which the priests and the men enter the church, and another door on the left side through which the nuns and the women customarily enter.

And so within this one very large basilica a multitude of people, different in order, rank, sex, and place, divided by screens, diverse in station but one in spirit, prays to God Almighty.[105]

The Venerable Bede:
Benedict Biscop's Roman Acquisitions

While the Irish were evangelizing the north of Britain, Roman missionaries had begun to enter England from the south. After the first wave of conversions the situation of the English Church deteriorated; it was reorganized in a more centralized and Roman fashion by the gifted administrators Theodore[106] and Hadrian.[107] When they came to Canterbury in 668, they were accompanied by Benedict Biscop, a Northumbrian, who had lived as a monk at Lerins in southern Gaul and who was in Rome when Theodore and Hadrian set forth. In 674 Benedict Biscop left Canterbury for his native Northumbria, where he founded twin monasteries, St. Peter's at Wearmouth and St. Paul's at Jarrow. Determined to make his houses centers of Roman influence, he was tireless in bringing to Wearmouth-Jarrow whatever he had most admired in Rome and her

105 *Sanctae Brigidae Virginis Vita a Cogitoso adornata, Patrologia latina,* ed. J. P. Migne, Vol. 72 (Paris: 1849), cols. 788–90.

106 St. Theodore, Archbishop of Canterbury (668–90), a native of Asia Minor, who was sent to Canterbury from Rome to organize the English church, a task he successfully fulfilled.

107 St. Hadrian, abbot of SS. Peter and Paul at Canterbury (later St. Augustine's), who accompanied St. Theodore on his mission to England.

churches: apostolic relics, libraries, Gregorian chant, stone churches, icons, and precious fabrics.

A witness to Benedict Biscop's classicizing taste is the famous Codex Amiatinus *written at Wearmouth-Jarrow soon after his death. It contains the oldest and one of the most authoritative of the existing versions of St. Jerome's Bible translation. It is decorated with miniatures, one of which was formerly considered to be of antique origin. Bede,[108] who wrote an account of Benedict Biscop's labours, was a monk at Wearmouth-Jarrow and one of Benedict's pupils.*

But at that same time, Cenwalh[109] being cut off by untimely death, Benedict at length turned his steps to his own people and the land wherein he was born, and came to the court of Egfrid,[110] king of the Transhumbrian region; unto him he rehearsed all the things he had done since the time that he left home in his youth; he openly shewed the zeal for religion which was kindled in him; he discovered to him all the precepts of ecclesiastical and monastical usage which he had learned at Rome or anywhere about, displaying all the divine volumes and the precious relics of the blessed apostles or martyrs of Christ, which he had brought with him; and he found such grace and favour in the eyes of the king that he forthwith bestowed upon him, out of his own estate, seventy hides of land, and bade him build a monastery there in honour of the chief pastor of the Church. The which was built, as I also mentioned in the preface, at the mouth of the river Wear toward the north, in the 674th year from the Lord's incarnation, in the second indiction, and in the 4th year of the rule of king Egfrid.

And when not more than a year had passed after the foundation of the monastery, Benedict crossed the ocean to France, where he required, procured, and brought away masons to build him a church of stone, after the Roman fashion which he always loved. And in this work, out of the affection he had for the blessed Peter in whose honour he wrought it, he shewed such zeal that within the course of one year from the time the foundations were laid, the roof was put on, and men might see the solemnities of mass celebrated therein. Further, when the work was drawing nigh to completion, he sent messengers to France, which should bring over makers of glass (a sort of craftsman till that time unknown in Britain) to glaze the windows of the church, its side-chapels and clerestory. And so it was done, and they came: and not only did they finish the work that was required of them, but also caused the English people thereby to understand and learn this manner of craft: the which without doubt was

108 The Venerable Bede (b. 673, d. 735), the greatest historian of the early medieval period.
109 Cenwalh, King of the West Saxons, who died in 572 after a troubled reign.
110 Egfrith, King of Northumbria (670–85)

worthily meet for the fastening in of church lamps, and for the manifold employments to which vessels are put. Moreover, this devout buyer, because he could not find them at home, took care to fetch from oversea all manner of things, to wit sacred vessels and vestments that were suitable to the ministry of the altar and the church.

Further, to the intent he might obtain for his church from the boundaries of Rome those ornaments also and writings which could not be found even in France, this diligent steward made a fourth journey thither (after he had well ordered his monastery according to the rule), and when he had brought it to an end, he returned laden with a more abundant gain of spiritual merchandise than before. First, because he brought home a vast number of books of every kind: Secondly, because he procured a plentiful grace of the relics of the blessed apostles and martyrs of Christ to be profitable to many English churches: Thirdly, because he introduced into his monastery the order of chanting, singing, and ministering in church according to the manner of the Roman usage, having indeed asked and obtained of pope Agatho[111] leave to bring to the English in Britain a Roman teacher for his monastery, to wit John, archchanter of the church of the blessed apostle Peter[112] and abbot of the monastery of the blessed Martin.[113] The which John coming thither, not only by the word of his lips delivered what he had learned at Rome to his scholars of ecclesiastical things, but also left good store of writings which are still preserved for the sake of his memory in the library of the said monastery. Fourthly, Benedict brought a worthy gift, namely, a letter of privilege from the venerable pope Agatho, which he obtained with the leave and consent of king Egfrid, and at his desire and request, whereby the monastery built by him was rendered wholly safe and secure continually from all assault from without. Fifthly, he brought home sacred pictures to adorn the church of the blessed apostle Peter built by him, namely, the similitude of the blessed mother of God and ever Virgin Mary, and also of the 12 apostles, with the which he might compass the central arch of the said church by means of a board running along from wall to wall; similitudes of the Gospel story for the adornment of the south wall of the church; similitudes of the visions in the Revelation of the blessed John for the ornament of the north wall in like manner, in order that all men which entered the church, even if they might not read, should either look (whatsoever way they turned) upon the gracious countenance of Christ and His saints, though it were but in a picture; or might call to mind a more lively sense of the blessing of the Lord's incarnation, or having, as it were before their eyes, the peril of the last judgment might remember more closely to examine themselves. . . .

111 Pope Agatho (678–81).
112 St. Peter's in Rome.
113 The monastery of St. Martin, near St. Peter's, whose monks performed part of the liturgy in the basilica.

But now that thus much hath been given as foretaste touching the life of the venerable Eosterwine, let us return to the course of our story. No long time after Benedict had appointed him abbot over the monastery of the blessed apostle Peter, and Ceolfrid[114] abbot over the monastery of blessed Paul, he hastened from Britain to Rome for the fifth time, and returned enriched as always with a countless number of gifts of advantage to the churches, namely, a great store indeed of sacred books, yet with the wealth, as before, of no lesser a present of sacred pictures. For at this time also he brought with him paintings of the Lord's history, with the which he might compass about the whole church of the blessed mother of God, built by him within the greater monastery;[115] he also displayed, for the adorning of the monastery and church of the blessed apostle Paul, paintings shewing the agreement of the Old and New Testaments, most cunningly ordered: for example, a picture of Isaac carrying the wood on which he was to be slain,[116] was joined (in the next space answerable above) to one of the Lord carrying the cross on which He likewise was to suffer.[117] He also set together the Son of Man lifted up on the cross[118] with the serpent lifted up by Moses in the wilderness.[119] Amongst other things he also brought home two palls all of silk of exceeding goodly workmanship, with the which he afterward purchased from king Aldfrid[120] and his counsellors (for Egfrid after his return he found had now been killed) three hides of land south of the river Wear, near the mouth.[121]

Wilfred's Hexham

Like Benedict Biscop, whom he accompanied to Rome in 654, Wilfred was a Northumbrian, and also an advocate of the Roman party. He was one of the main figures at the Synod of Whitby in 663, which led to the suppression of Irish customs. Whereas Irish bishops had often been itinerant and of less importance than abbots, Wilfred had a very Roman idea of the dignity of the episcopal office. When he went to Gaul in 664 to seek consecration by three bishops whose Roman customs were beyond doubt, he came with a retinue of 120 men, and in later years the "countless army of his followers arrayed in royal vestments and arms" became a source of disquiet to King Egfrith and his queen Irminburg.[122]

114 Ceolfrid became abbot of St. Paul's at Jarrow in 682.
115 St. Peter's at Wearmouth.
116 Gen. 22: 6–8.
117 John 19: 2.
118 Matt. 27: 57; Mark 15: 43; Luke 23: 50; John 19: 30.
119 Num. 21: 8.
120 Aldfrith, King of Northumbria (685–704)
121 Reprinted by permission of the publishers and the Loeb Classical Library from Bede, *A History of the Abbots of Wearmouth and Jarrow*, trans. J. E. King (Cambridge, Mass.: Harvard University Press; London: William Heinemann Ltd., 1954), II, 401–7, 413–15.
122 Irminburg, second wife of Egfrith, King of Northumbria (670–685).

As a builder and patron of the arts Wilfred was unrivalled in England. Of his buildings those at Hexham were most famous. They were described by Eddius Stephanus, a contemporary of Wilfred and his biographer. The main church was dedicated to St. Andrew, as was the Roman monastery founded by Pope Gregory the Great from which came the forty missionaries who accompanied St. Augustine[123] to England in 597. St. Andrew's at Hexham was built between 672 and 678. Its crypt still exists. The nave of the church, at whose size Eddius marvels, was one hundred feet long and twenty-five feet wide.

Eddius Stephanus: A Contemporary Description

So continually, in the words of the Psalmist, he drew near to God, placing in Him his hope and rendering to the Lord, who had given him all things, his dearest vows. For in Hexham, having obtained an estate from the queen, St. Aethilthryth,[124] the dedicated to God, he founded and built a house to the Lord in honour of St. Andrew the Apostle. My feeble tongue will not permit me to enlarge here upon the depth of the foundations in the earth, and its crypts of wonderfully dressed stone, and the manifold building above ground, supported by various columns and many side aisles, and adorned with walls of notable length and height, surrounded by various winding passages with spiral stairs leading up and down; for our holy bishop, being taught by the Spirit of God, thought out how to construct these buildings; nor have we heard of any other house on this side of the Alps built on such a scale. Further, Bishop Acca[125] of blessed memory, who by the grace of God is still alive, provided for this manifold building splendid ornaments of gold, silver, and precious stones; but of these and of the way he decorated the altars with purple and silk, who is sufficient to tell? Let us return to our subject.[126]

Prior Richard: Hexham in the Twelfth Century

A more detailed description of St. Andrew's is given in the twelfth-century chronicle of Prior Richard of Hexham, whose account agrees on the whole with that of Eddius. According to both writers, the church had a very complicated plan. There were galleries and oratories on different levels and upper stories were reached by winding stone stairways.

[123] St. Augustine and his companions were sent to Britain in 596 by Pope Gregory I (see above, p. 47). St. Augustine became the first archbishop of Canterbury (d. 604 or 605).

[124] St. Aethilthryth, or Etheldreda (d. 679), first wife of King Egfrith of Northumbria. The marriage was not consummated and Aethilthryth became a nun in 672.

[125] Acca, bishop of Hexham (709–32).

[126] Eddius Stephanus, *The Life of Bishop Wilfrid*, Chap. XXII, ed. trans. Bertrand Colgrave (Cambridge: Cambridge University Press, 1929), pp. 45–47. Reprinted by permission of Cambridge University Press.

The other two churches founded by Wilfred, which are mentioned in Richard's description, are St. Mary's and St. Michael's. They were begun toward the end of Wilfred's life, after a vision he had seen while lying sick in Meaux in 704. Since Wilfred died in 709 or 710, they may have been finished only after his death.

St. Wilfred, then, in the year of our Lord's Incarnation 678, in the fortieth year of his life, in the tenth year after he had been made a bishop, and in the fourth year of the reign of King Egfrith, built in that town [Hexham] a church of most elaborate and accomplished workmanship, in honor of God and St. Andrew, in requital for the benefit that had been bestowed on him through St. Andrew's intercession. For when he had first come to Rome, he had often visited that saint's church, imploring that the remission of his sins, for which he constantly prayed, should be indicated to him in the following fashion: that he should as a result of the saint's intervention be liberated from the slowness of his mind and the rusticity of his language. And without delay, through the prayers of his beloved Apostle, God's generosity bestowed such grace on his faithful servant that he knew that he had acquired the quickness of mind most suited to learning and the corresponding fluency of speech most suited to expounding what he had learned. This gift, by the salvation of innumerable souls which he gained for the Lord, he later most successfully manifested.

And so he laid the foundations of this church with great zeal, and made crypts and subterranean oratories and twisting passageways. He also erected walls of vast length and height, consisting of three different storeys and carried by straight [or square] columns variously and skillfully made. He adorned the walls and capitals of the supporting columns and the arch of the sanctuary[127] with histories and images and various figures, sculpted and protruding from the stone as well as painted, and with a delightful variety of colors and marvellous decorations. The nave of the church he surrounded on all sides with galleries and other additions, set off at different heights and with marvellous art by walls and stairwells. In and above them there were stone stairs and passageways and turning corridors, now leading up and now down. All this he devised so cunningly that it was possible for a large crowd of people to be there and to walk around the nave of the church without disturbing anyone within it. Several secluded and beautiful oratories which he constructed up high as well as further down within those aisles and galleries were dedicated to Mary the Holy Mother of God Ever Virgin, to St. Michael the Archangel, to St. John the Baptist, and to the holy apostles, martyrs, confessors, and virgins, and were furnished in a most dignified fashion. And even today some of these oratories can still be seen rising like towers or ramparts. Our poor words are unable to describe how many and what

127 Probably no longer that of Wilfred's church.

relics, and what a crowd of monks and ministers devotedly serving God, he brought together there, and with what magnificent, pious, and precious treasures of books, vestments, and all manner of furnishings and ornaments suitable for divine worship he adorned the interior of the church. The forecourt of the temple he surrounded with a thick and powerful wall. An aqueduct of hollow stone moreover ran through the middle of the village to serve the workshops. We will pass by the many and varied structures ruined by neglect and by destruction; many of their foundations can still be seen here and there. Just as the old chronicles and histories testify, among the nine monasteries that the aforesaid bishop and father and patron ruled, this one excelled all the others, as well as all other churches in England in the elegance of its arrangement and in its exquisite beauty. And in fact there was at that time nothing comparable to be found on this side of the Alps.

There are still in the same town two other churches besides. One is close to the main church and a wonderful piece of architecture. It is nearly round and built like a tower. It has wings on four sides and is dedicated to the Virgin Mary. The other church, dedicated to St. Peter the Apostle, stands somewhat further off. There is also an oratory dedicated to St. Michael, towards the north across the river Tyne and on a mountain which is close to its banks and which is called in English Erneshou and in Latin Mons Aquila.[128]

How to Paint the Apostles
in the Roman Fashion

The Roman tonsure as well as the Roman method of computing Easter were finally accepted in Ireland and in the Irish monasteries abroad during the century after the Synod of Whitby (663). The following instructions on how to represent the apostles according to the Roman manner come from the period after this reconciliation. They have survived in a collection of Irish texts, all of which antedate the end of the eighth century.

Concerning the Tonsure of the Apostles: in Roman painting the apostles are depicted in the following way:

Matthew has grey hair and a beard.
Peter is grey and has a round tonsure.
Andrew has a grey beard and the sign of the cross in his hair.

[128] *Prior Richard's History of the Church of Hexham*, Chap. III, IV, ed. James Raine, *The Priory of Hexham, its Chroniclers, Endowments, and Annals, The Publications of the Surtees Society*, XLIV (Durham: Andrews and Co., 1843), I, 10–15.

James the son of Zebedee is young, with black hair and a round tonsure.

John has long grey hair and a beard.

Philip is young, with black hair and a beard.

Bartholomew has long grey hair and a beard.

Thomas is young, with black hair and a round tonsure.

James the son of Alpheus is grey and has a beard.

Thaddeus is young and has black hair and a round tonsure.

Simon the Canaanite is young and has black hair.

The Apostles wore white albs and tunics of varied hue, honey-colored or blue or purple, which did not soil or age, nor did their footwear age or soil.[129]

[129] André Wilmart, "Effigies des Apôtres vers le début du Moyen Age," *Revue Bénédictine,* XLII (1930), p. 76.

4

The
Carolingian
Renaissance

CAROLINGIAN PALACES

Ever since the beginning of the fourth century, popes, bishops, and barbarian kings had been eager, as the case required, either to preserve the glories of Rome or to transplant them to their own time and place. What sets the Carolingian Renaissance apart is its scope and the resources of its protagonist. Charlemagne[1] controlled Gaul, Saxony, Bavaria, Hungary, the area now included in Switzerland, and large portions of Italy, including Ravenna and Rome. He was able to draw scholars and artists to his court from anywhere in Europe, and when he built his palace church at Aachen there was nothing to prevent him from using columns and capitals which were brought all the way from Rome and Ravenna. Other fixtures, such as the bronze doors and chancels in Aachen, were produced there, but with such painstaking attention to antique details that they, too, were long thought to be spoils. The chapel was dedicated in 805. It found its place in the southeast area of the palace complex, whose regular and city-like arrangement was reminiscent of late antique palaces.

Einhard, from whose Life of Charlemagne *the following passage has been taken, was in charge of the King's and later the Emperor's works. He came to Aachen shortly after 791 when he was twenty. The antique columns of the octagon were put into place in 798. It is likely that they had been procured under Einhard's supervision.*

Einhard: The Palace Church at Aachen

The Christian religion, in which he had been brought up from infancy, was held by Karl [Charlemagne] as most sacred and he worshipped in it with the greatest piety. For this reason he built at Aachen a most beautiful church, which he enriched with gold and silver and candlesticks, and also with lattices and doors of solid brass. When columns and marbles for the building could not be obtained from elsewhere, he had them brought from Rome and Ravenna.

As long as his health permitted, he was most regular in attending the church at matins and evensong, and also during the night, and at the time of the Sacrifice; and he took especial care that all the services of the church should be performed in the most fitting manner possible, frequently cautioning the sacristans not to allow anything improper or unseemly to be brought into, or left in, the building.

He provided for the church an abundance of sacred vessels of gold

[1] Charlemagne became sole ruler of the Franks in 771. He was crowned Emperor in 800 and died in 814.

and silver and priestly vestments, so that when the service was celebrated, it was not necessary even for the doorkeepers, who are the lowest order of ecclesiastics, to perform their duties in private dress. He carefully revised the order of reading and singing, being well skilled in both, though he did not read in public, nor sing, except in a low voice and only in the chorus.[2]

Ermoldus Nigellus: The Church and Palace at Ingelheim

Charlemagne had begun the construction of the palace at Ingelheim in 787; the poet Ermoldus describes it as he saw it in 825–26. Little is known of this palace of Charlemagne and Louis the Pious. There is, however, some evidence for believing that, contrary to what Ermoldus' description implies, the palace did not have a church in Carolingian times. In this case the church described by Ermoldus must have been not in the palace itself but in its vicinity. It may have been St. Remigius' at Ingelheim, which was large and prestigious enough to serve as a meeting place for synods as late as 948. The church was decorated by scenes from the Old and New Testaments, placed opposite each other on the lateral walls.

Ermoldus' poem also describes a series of frescoes which are based on Orosius'[3] History against the Pagans, to whose stories from ancient and Roman times events from Frankish history had been added. Such scenes would have been appropriate for the decoration of a large hall used for audiences and banquets. Among the very few Carolingian remains recovered at Ingelheim are parts of a structure which has been named "aula regia" by the excavators and which is believed to have served similar functions. As in the church, the frescoes were arranged on opposite walls, with the stories of a more distant and sinister past on one side and "the deeds of the fathers, who were already closer to the faith" on the other. Among them were Constantine, Theodosius the Great, Charles Martel, Pepin, and Charlemagne. Whose reign marked the transition from one to the other of these "testaments" of profane history is not clear from Ermoldus. For Orosius, whose History served as a source for the earlier events depicted in these frescoes, the crucial turning point would have been the reign of Augustus, in which Christ was born.

This place [Ingelheim] lies on the fast-flowing Rhine
where rich fields and orchards abound.
Here stands the large palace, with a hundred columns,
with many different entrances, a multitude of quarters,

2 Einhard, Life of Emperor Karl the Great, trans. William Glaister (London: George Bell and Sons, 1877), pp. 78–80.

3 Paulus Orosius, a Christian historian of the fifth century, who regarded the Roman Empire and especially the reign of Augustus as a providentially ordained preparation for the coming of Christ and the spread of His gospel.

thousands of gates and entrances, innumerable chambers
built by the skill of masters and craftsmen.
Temples dedicated to the Lord rise there, joined with metal,
with brazen gates and golden doors.
There God's great deeds and man's illustrious generations
can be reread in splendid paintings.
The left recalls how in the beginning,
placed there, as I believe, by the Lord, men inhabit you, O paradise![4]
And how the perfidious snake tempts Eve of the innocent heart,[5]
how she tempts Adam, how he touches the fruit,[6]
how, when the Lord comes by they cover themselves with fig leaves,[7]
how, because of their sin, they then labored on the soil.[8]
Out of envy over the first offering a brother murdered a brother[9]
not with a sword but with his own wretched hands.
After that the painting traces innumerable events,
according to the order and manner of the Old Testament account:
how deservedly the flood came over the whole world,[10]
how it rose higher and finally swept away all living creatures,
how the Lord in his mercy saved a few in the Ark,
also what the raven did, and your deed, O dove![11]
Thereupon the history of Abraham and his progeny are depicted,[12]
and the deeds of Joseph and his brothers and of the Pharaoh.[13]
How Moses frees the people from Egyptian servitude,[14]
How Egypt perishes and Israel wanders[15]
And the Law, given by the Lord, written on twin tablets,[16]
Water from rock,[17] quail falling down for nourishment,[18]
and the long promised foreign land which was given
as soon as Joshua appeared, a leader for his people.[19]
And then the large crowd of prophets and kings
is depicted, whose equally famous deeds shine brightly,
and the works of David[20] and the deeds of powerful Solomon,[21]
the temples built by divine effort,
then the captains of the people, who and how many,
and the most exalted priests and princes.

[4] Gen. 2.
[5] Gen. 3: 4–5.
[6] Gen. 3: 6–7.
[7] Gen. 3: 8.
[8] Gen. 3: 17–19.
[9] Gen. 4: 8.
[10] Gen. 7.
[11] Noah released a raven and a dove from the Ark. The raven was lost, but the dove returned, carrying the bough of an olive tree as a sign that the flood was over. Gen. 8: 6–11.
[12] Gen. 11–25.
[13] Gen. 27–50.
[14] Exod. 3–13.
[15] Exod. 14–18.
[16] Exod. 19–31.
[17] Exod. 15.
[18] Exod. 16.
[19] Joshua.
[20] I Kings 16; III Kings 2.
[21] III Kings 3–11.

The other side commemorates the earthly deeds of Christ
which he offered after his Father sent him down to earth,
and how first the angel descends to tell Mary,
and how Mary answers, "Behold the handmaid of the Lord,"[22]
how Christ is born, announced long before by holy Prophets,[23]
how the Lord is bundled in diapers,[24]
how the shepherds receive the divine commands of the Thunderer,[25]
and then how the Magi were worthy to behold God,[26]
how Herod rages, fearing Christ might succeed him,
and has killed the children who he thought deserved death,[27]
How Joseph fled into Egypt and brought the child back,[28]
How the child grew and obeyed his parents,[29]
How he, who came to save all those long condemned with his own
 blood,
desired to be baptized,[30]
how Christ fasted like a man,[31]
how he confounded the Tempter with his wisdom,[32]
how he then through the world taught of his Father's gentle yoke,
and mercifully gave back to the sick their former occupations,
how he even restored dead corpses to life,[33]
and how he disarmed demons and drove them far away,
how, betrayed by one of his disciples[34] and by the wild and savage
 people
God himself chose to die like a man,[35]
How, rising, he appeared to his disciples,[36]
and how he, for all to see, rose to the heavens and reigns over the
 world.[37]
These are the things with which the art of painting
and the artist's subtle hand have filled the Church.
The royal palace as well gleams with painting and sculpture,
and celebrates the great and spirited deeds of man.
The exploits of Cyrus are recounted and also the many
savage battles which were waged during the time of Ninus.[38]

22 Luke 1: 26–37.
23 Luke 1: 38.
24 Luke 2: 7.
25 Luke 2: 8–18.
26 Matt. 2: 10–11.
27 Matt. 2: 16–18.
28 Matt. 2: 13–14, 18–20.
29 Luke 3: 51–52.
30 Matt. 3; Luke 3: 20–22; Mark 1: 9–11; John 1: 29–34.
31 Matt. 4: 1–2; Mark 1: 12–13; Luke 4: 1–2.
32 Matt. 4: 3–11; Mark 1: 13; Luke 4: 3–13.
33 The Gospels tell of numerous occasions on which Christ healed the sick
and drove out evil spirits. They mention, however, only three cases in which he
raised the dead, that of Lazarus (John 11: 1–44), of Jairus' daughter (Matt. 9:
18–26; Mark 5: 22–26; Luke 8: 49–56), and of the widow's son (Luke 7: 11–16).
34 Judas. (Matt. 26: 47–50; Mark 14: 43–46; Luke 22: 47–50; John 18: 3)
35 Matt. 27; Mark 15; Luke 23; John 19.
36 Matt. 28; Mark 16: 1–18; Luke 24: 1–50; John 22–23.
37 Mark 16: 18–20; Luke 24: 50; Acts 1.
38 Ninus, mythological founder of Nineveh. Orosius, *Hist.*, I, 4.

Here you may see how the fury of a king[39] raged against a river
and how he finally avenged the death of his favorite horse.
Next to this is the wretched man triumphantly invading
a country ruled by a woman;
for this his head was thrown into a winebag filled with blood.[40]
Neither are Phalaris'[41] horrible deeds concealed,
how he with cruel art murdered miserable people,
how Pyrillus the famous goldsmith and caster of bronze
joins him and how the wretch sacrilegiously,
quickly, and with too much skill, made a brazen bull for Phalaris,
so that the merciless one may destroy the tender limbs of human
 bodies in it,
but quickly the tyrant enclosed him in the bull's belly,
and the artifact brought death to its own artifex.
One sees how Romulus and Remus laid the foundations of Rome,
how the former with his own impious hands killed his brother,[42]
how Hannibal was always involved in evil warfare,
depicting him with one eye, for he had lost one,[43]
and how Alexander[44] claimed the world through war,
how the power of Rome grew and reached the sky.
On the other side of the building we can admire the deeds of our
 forefathers,
who were much closer to the pious faith.
To the acts of the Caesars of splendid Rome
the equally admirable deeds of the Franks are added:
how Constantine[45] out of love forsakes Rome
and builds himself Constantinople;
the fortunate Theodosius[46] is depicted there
and his celebrated deeds and acts;
here Charles the First[47] the Frisians' conqueror is depicted,
and his tremendous deeds in arms;
here one sees you, Pepin,[48] as you restore law to the Aquitanians,

[39] Cyrus, king of Persia (549–29 B.C.), avenged the death of his favorite horse, which had drowned in the river Gyndus, by dividing its course into a multitude of streams. Orosius, *Hist.*, II, 6.

[40] Cyrus is said to have been killed in this fashion by Queen Thamris. Orosius, *Hist.*, II, 7.

[41] Phalaris, tyrant of Agrigentum (*c.* 570–54 B.C.), is said to have owned a brazen bull, fashioned by the goldsmith Pyrillus, in which human victims were roasted alive, among them Pyrillus himself. Orosius, *Hist.*, I, 20.

[42] Orosius, *Hist.*, II, 4.

[43] Hannibal, Carthaginian statesman and general, and Rome's most dangerous enemy (b. 247, d. 183 B.C.). Orosius refers to the fact that he had lost one eye in *Hist.* IV, 15.

[44] Alexander the Great (336–23 B.C.).

[45] Constantine the Great, Roman Emperor (306–37). After 324 Constantine resided in the East. Medieval tradition tried to suggest that he did so out of reverence for St. Peter and the Pope.

[46] Theodosius the Great, Roman Emperor (379–95).

[47] Charles Martel, grandfather of Charlemagne, came to power in 716 and ruled over the Franks, although he was not a king. He conquered Frisia in 733–34.

[48] Pepin, Charles Martel's son and Charlemagne's father, king from 754 to 768. He conquered Aquitaine in 768.

uniting them after your victory to your kingdom;
and the wise Charles shows his gracious face,
and bears rightfully on his crowned head the diadem;
here stands a Saxon warband, daring him to battle;
he fights them, masters them,[49] and draws them under his law.[50]

Leo III's Lateran Palace

*The outbreak of the iconoclastic crisis in 730 and the ensuing dis-
pute over the possession of dioceses in southern Italy and the Balkans
alienated the papacy from Byzantium. It also forced a new historical per-
spective upon the popes. They became increasingly aware of the sharp
contrast between the glory of Rome's imperial past and the mediocrity of
her provincial present. The city of Augustus and St. Peter was now situ-
ated in an outlying and exposed part of the Byzantine Empire, ruled by a
remote, unsympathetic, and heretical Emperor. It was Leo III, pope from
795 to 816, who decided to take a crucial step toward a restoration of the
Roman past when he crowned Charlemagne Emperor in St. Peter's during
mass on Christmas Day, 800, possibly without informing the Emperor of
his intentions beforehand. Leo's activities as a patron were on a princely
scale and reflected his political aims. He made lavish donations to the
churches of Rome, restored St. Paul's, and built several new churches and
oratories of his own. He also added two large triclinia or state halls to the
Lateran Palace. The older and smaller of the two, the so-called "Aula
Leonina" was in use by 799. It was an oblong hall with three apses, two
of which were situated opposite each other in the middle of the hall. A
structure of similar size and plan belonged to Charlemagne's palace in
Aachen. Leo's second state hall was built after 800. It was nearly three
times as large as the older one and had eleven apses. Both halls must have
made a great impression on Leo's contemporaries and his official biogra-
pher went out of his way to give a description of their extraordinary
shape and their decorations.*

The Book of the Popes: A Contemporary Description

He [Leo III] built in the Lateran palace a triclinium that bears his
name, richly decorated, and larger than any other triclinium. He built it
over very firm foundations and decorated it throughout with marble. He
also paved it with a variety of marble and adorned it with finely hewn
columns of porphyry and white marble, with bases and capitals and [its
doors] with jambs and lintels. He decorated the main apse and its vault

49 Charlemagne's final annexation of Saxony took place in 782.
50 Ermoldus Nigellus, *In Honorem Hludowici Imperatoris*, IV, 181–283, ed.
E. Duemmler, *Monumenta Germaniae Historica, Poetae Latini Aevi Carolini* II
(Berlin: 1884), 63–66.

with mosaic and the two other apses with paintings of different stories, likewise placed above the marble revetment.

. . . He also made in the Lateran Palace a triclinium of marvellous size decorated with an apse of mosaic, and he made ten other apses on both sides and different paintings of the apostles as they preach to the Gentiles, adjoining the basilica of Constantine. In the triclinium he also installed couches. In the center he placed a fountain in the form of a porphyry shell. He also covered the floor with multi-colored marble.[51]

O. Panvinio: The Triclinia of Leo III

When O. Panvinio, a sixteenth-century antiquarian, wrote his description of the Lateran Palace, the older and smaller of the two halls was in ruins. Its ground plan, however, and some of its mosaics were still visible. The second and larger hall, which had been used as late as 1512 to accomodate the assembly of the Lateran council called together by Julius II, was still standing with its roof and pavement intact. The inscription read by Panvinio underneath its main apse seems to indicate that the larger hall was intended for banquets. This would also explain the numerous apse-like niches on its lateral walls. Each was probably designed to hold a sigma shaped reclining couch.

As soon as one enters the Lateran Palace and climbs a flight of stairs, one sees a large hall with three apses, which in the old days was called "aula Leonina" after its founder Leo III. Its interior was covered with mosaics and marble incrustation. Of the old decoration there remains only a mosaic around the arch of the main apse . . . in which St. Peter is shown seated, while handing a banner to Charlemagne with his left hand and a pallium to Leo III, both of whom kneel before him. It contains these inscriptions: OUR HOLY LORD POPE, LEO III and also OUR LORD KING CHARLES. Under St. Peter's feet is written: HOLY PETER GIVE . . . TO POPE LEO AND VICTORY . . . TO KING CHARLES. This hall, as I said, was formerly called the smaller "Basilica Leonina" in order to distinguish it from the larger one, which is also called "The Large House." It [the smaller hall] was built adjoining the papal rooms. In it the pope used to eat with the cardinals on certain feasts, such as the second and third day of the Easter week. Public assemblies and consistories used also to be held in this place. Its roof and its pavement are destroyed; what stands are the remains of the very high walls, adorned with some precious columns.

. . . On the side of the Lateran Basilica is a door from which by marble stairs one ascends to a large and spacious hall, which today is called "The Council Room." Apart from a main apse it has ten smaller apses on

[51] *Vita Leonis III*, c. XXXIX, *Liber Pontificalis*, ed. L. Duchesne (Paris: E. Thorin, 1886), II, 3–4, 11.

both sides, a brick floor, and a wooden roof, covered with tiles. On its north side the aula is supported by several arcades and extremely heavy pillars. The main apse is decorated by mosaics, done by very inept artists, representing Christ, the Holy Virgin, the holy apostles Peter and Paul and several other saints. On the wall which precedes the apse are the twenty-four seniors and some of the ˙signed 144 thousand in the Apocalypse[52] and four angels depicted in mosaic by an unskilled artist. On the arch of the apse is this monogram: L$\overset{P}{\underset{A}{O}}$E, i.e., Leo Papa. The smaller apses all have a central window. Between the apses and the pilasters flanking them are twenty-two other windows which were restored by Julius II during the Lateran Council. At the entrance wall toward the pulpit of Boniface VIII,[53] that is, toward the north, there are six arches, three above and three beneath, carried by four supports, the two above being of porphyry. After this comes a second wall with three doorways from which one reaches the loggia of Boniface VIII. This hall we now refer to as "The Council Room" because here, as I believe, Eugene IV[54] decided to celebrate a council and here Julius recently celebrated another. Formerly it was called "The Large House" on account of its size or the "Basilica of Leo" on account of its founder, Leo III, who built and adorned it to be used by the popes.

At that time, on certain feast days such as Easter and Christmas, the Roman bishops customarily dined with a solemn ritual. The basilica was renovated by Leo IV[55] as Anastasius the Librarian[56] writes: "Leo III built from its foundations the large dining hall and endowed it with the necessary furnishings. When these had been lost on account of time and the neglect of his papal successors, Leo IV generously and swiftly restored everything that had been taken away. . . ." All this seems to be in agreement with the prayer that is written underneath the main apse: LORD, WHOSE RIGHT HAND SUSTAINED THE BLESSED PETER WALKING ON THE WATER LEST HE SHOULD SINK AND LIBERATED HIS CO-APOSTLE PAUL THREE TIMES SHIPWRECKED FROM THE DEEP SEA, MAY YOUR HOLY RIGHT HAND PROTECT THIS HOUSE AND THE FAITHFUL DINING IN IT, WHO ENJOY HERE THE GIFTS OF YOUR APOSTLE.[57]

52 Apoc. 4: 4–11; 7: 4.

53 Pope Boniface VIII (1294–1303). He added a benediction loggia on the north.

54 Pope Eugenius IV (1383–1447).

55 Pope Leo IV (847–55).

56 Panvinio quotes from Chap. VIII of the *Life of Leo IV* in the *Liber Pontificalis*. He thought this biography had been written by Anastasius Bibliothecarius. See above, p. 35, no. 110.

57 Onuphrius Panvinius, *De Sacrosancta Basilica, Baptisterio et Patriarchio Lateranensi*, IV, 3, 9, ed. Philipe Lauer, *Le Palais de Latran* (Paris: Leroux, 1911), pp. 481–82, 483–84.

J. Grimaldi: The Aula Leonina in 1617

Panvinio's description of the smaller of the two state halls built by Leo III is corroborated by a slightly later one of G. Grimaldi, another Roman antiquarian and a papal librarian. He gives a detailed account of the mosaics of the main apse, and of the surrounding wall. The principal subject of these mosaics was the mission of the apostles, a theme which also appeared in the second and larger hall which this pope built at the Lateran. The Carolingian expansion toward the east had brought many tribes under the jurisdiction of Charlemagne, tribes either still pagan or else only very superficially Christianized. Their conversion was of equal concern to Charlemagne and the Pope. The mosaic on the apsewall which showed both as servants of St. Peter was therefore a fitting counterpart for the representation of the apostolic mission in the apse. A modern copy of the mosaics now stands near the Scala Sancta on the square before the Lateran Basilica.

In the [Lateran] Palace, the Aula Leonina, built by Leo III is still visible. It has been made into a garden. Of its three apses, only the one in front stands with its mosaics intact; the others are half destroyed. In the center of the apse vault stands the Saviour on a mountain from which the four rivers of Paradise spring. He blesses with His right hand, with His ring finger and His thumb touching each other. In His left hand He holds an open book. He wears purple clothes and has five apostles on each side, of whom the one standing closest to the Saviour's right is old and carries a long cross.[58] None of the others carries an attribute. Over the Saviour's head there is, as it were, a cloud, fiery with lightning. All the figures are nimbed. Where the frieze ends, the border of the mosaic, consisting entirely of various flowers, appears. Springing from a vessel it encircles the entire arch and bends down into a second vase. In the center of this border, over the Saviour's head, is the monogram of Leo III. It is formed like this: P$\overset{\text{L}}{\underset{\text{O}}{\text{E}}}$A

A second exterior border encircles the arch, bearing the inscription cited below. At the feet of Christ and the apostles runs a frieze with an inscription. On the triangular wall left of the apse is a picture of St. Peter, Leo III and Charles the Great, described below.

On the above mentioned border, which encircles the arch, is written

... GLORY TO GOD IN THE HIGHEST: AND ON EARTH PEACE TO MEN OF GOOD WILL.[59]

[58] This was St. Peter. There were actually portraits of 11 apostles in the apse. Grimaldi's mistake in counting them also mars his further interpretation of the mosaics.

[59] Luke 2: 14.

In the frieze of the apse ... [is written] GOING THEREFORE, TEACH YE ALL NATIONS, BAPTISING THEM IN THE NAME OF THE FATHER AND THE SON AND THE HOLY GHOST. AND BEHOLD I AM WITH YOU ALL DAYS, EVEN TO THE CONSUMMATION OF THE WORLD.[60]

In the vault of the apse are the ten apostles, and the eleventh, the prince of the apostles, is in the triangle of the apse wall. This was actually the number of apostles present when Christ uttered those words, according to Matthew, Chapter 28. In the angle to the right of the apse was probably an image of St. Paul. But it is completely gone and the wall is rough. . . .

On the triangular wall to the left of the apse a mosaic has survived, showing St. Peter enthroned, dressed in chasuble and pallium, an old man with a nimbus. To his right appears Leo III, round-faced and black-haired, with the top of his head shaven, seemingly in his sixties. Around his head he has a rectangular nimbus, the sign of the living. He wears pallium and chasuble. He receives the stole, viz., the episcopal pallium, from Peter's right hand. Next to the Pope one reads the inscription: OUR MOST HOLY LORD POPE LEO. To his left kneels Charlemagne, the august emperor, receiving a tall standard from St. Peter's left hand. It shows six red roses in a blue field. Charles wears the imperial crown and the square nimbus. He wears the imperial cloak or mantle and has a sword on his side. His face is that of an old man. His chin is shaven. On the upper lip he has two twisted mustaches in the fashion of Turks or Franks. His eyes are large. At St. Peter's feet is the salutation in which Leo augurs for Charles the crown, life, and victory, as he had been acclaimed at his coronation in the basilica of St. Peter's. . . : BLESSED PETER GIVE CHARLES THE CROWN, LIFE, AND VICTORY.

Next to Charles is his name likewise written in Roman majuscules: OUR LORD KING CHARLES.

. . . This mosaic . . . which should be treasured because of its antiquity and its connection with Leo III and Charlemagne, is now exposed to the inclemency of the skies.[61]

TWO MONASTERIES

Angilbert's Centula

Angilbert was a member of Charlemagne's court, and on several occasions served as the Emperor's envoy. He was also the father of two of

[60] Matt. 28: 19.

[61] J. Grimaldi, *De aula Lateranensi*, ed. Philippe Lauer, *Le palais de Latran* (Paris: 1911), pp. 581–82.

Charlemagne's grandchildren. When he rebuilt the monastery, which had been founded in the first half of the seventh century by St. Richarius, he acted in all probability as Charlemagne's agent. He succeeded in turning it into one of the largest and most imposing monasteries of the whole medieval period. Covering a triangular area several times the size of Cluny during its heyday in the twelfth century, it was from the outset intended to house three hundred monks and one hundred pupils. Its landmarks were three churches connected by the houses for the monks. One of the two smaller churches, that dedicated to the Virgin, has been partially excavated. It consisted in part of a dodecagon fourteen meters in diameter, with an ambulatory around a polygonal inner area. The large main church had a double function. Its eastern part rose over the grave of St. Richarius; its western part sheltered the altar of the Saviour, the main altar of the church, standing in an upper story of the western ante-church whose ground floor served as an entrance to the nave which led to the grave of St. Richarius. The towerlike shape of the western ante-church was echoed by an eastern tower over the sepulchre of the saint. Both towers were flanked by smaller round ones, which gave access to galleries. With its multitude of altars and varied city-like silhouette, the main church may have been a realization of what Wilfred had attempted at Hexham.[62]

Centula's monastic influence was not very great, but as architecture it set a standard for much high medieval church building. It survived without major changes of its structure into the eleventh century, when Hariulf, the chronicler of Centula, saw and described it.

Hariulf: An Eleventh-Century Description

With great preparations, extraordinary industry, and superb lavishness, the construction of the monastery was begun and the building of the church dedicated to the Saviour and St. Richarius was completed.[63] It was among all other churches of its time the most famous. It has behind the screen toward the east a very high tower and behind the vestry toward the west another tower equal to the first. The eastern tower is close to the sepulchre of St. Richarius. The latter is arranged in such a way that the saint's altar stands above his feet and the altar of St. Peter by his head. The eastern tower with the chancel and the area around the sepulchre (buticum) is dedicated to St. Richarius. The western tower is especially dedicated to the Saviour. . . . In the pavement of the choir one sees even today marble-work so beautiful and unusual that whoever looks at it affirms the work to be incomparable. . . .

Since the old church built by St. Richarius had been dedicated to the Virgin, the venerable man Angilbert built her another one, so that

62 See above, pp. 75–78.
63 The church of St. Richarius was dedicated in 799.

the Mother of God should not appear to be less honoured. This church stands to the present day, located on the near side of the river. He also built one church for St. Benedict, the abbot, which he placed on the far side of the same river. If one surveys the place, one sees that the largest church, that of St. Richarius, lies to the north. The second, somewhat smaller one, which has been built in honor of our Lady on this side of the river, lies to the south. The third one, the smallest, lies to the east. The cloisters of the monks are laid out in a triangular fashion, one roof extending from St. Richarius' to St. Mary's, one from St. Mary's to St. Benedict's and one from St. Benedict's to St. Richarius'. This is the reason that while the buildings are joined, the middle ground under the open sky is of a triangular shape. The monastery is so arranged that, according to the rule laid down by St. Benedict, all arts and all necessary labors can be executed within its walls. The river flows through it, and turns the mill of the brothers.[64]

Angilbert: Liturgical Instructions

Although Centula did not have continuous services, as did some of the monasteries founded by Merovingian kings, its three hundred monks must have spent nearly all of their waking hours in common prayer and processions. For these Angilbert laid down a minute and elaborate schedule, whose complexity matched that of the architectural setting in which it was to be followed.

On the sequence in which the altars are to be visited: When the brethren have sung Vespers and Matins[65] at the altar of the Saviour,[66] then one choir should descend on the side of the holy Resurrection,[67] the other one on the side of the holy Ascension,[68] and having prayed there the processions should in the same fashion as before move singing towards the altars of St. John and St. Martin.[69] After having prayed they should enter from both sides through the arches in the middle of the church and pray at the holy Passion.[70] From there they should go to the altar of St.

[64] Hariulf, *Chronique de l'abbaye de Saint Riquier*, III, 3, ed. Ferdinand Lot, *Collection des textes pour servir à l'étude et à l'enseignement de l'histoire* (Paris: Picard, 1894), pp. 54–56.

[65] The evening and morning offices of the monks.

[66] The altar of the Saviour stood in the upper story of the western antechurch and the monks had to go downstairs to reach the nave.

[67] A stucco relief representing the resurrection of Christ and situated in the southern part of the church.

[68] A stucco relief representing the ascension of Christ and situated in the northern part of the church.

[69] The two processions now move eastward on both sides of the church to the altars of St. John and St. Martin.

[70] A stucco relief representing the Passion of Christ situated near the center of the church.

Richarius.[71] After praying they should divide themselves again as before and go to the altars of St. Stephen and St. Lawrence[72] and from there go singing and praying to the altar of the Holy Cross.[73] Thence they should go again to the altar of St. Maurice and through the long gallery to the church of St. Benedict,[74] as has already been described above.[75]

The Treasure of Centula in 831

A general inventory of the possessions of Centula was drawn up in 831. It contains a list of the objects in gold, silver, and other precious materials and gives an idea of the splendour with which the monastery and its main church had been ornamented.

The principal churches are three in number. The main church is dedicated to the Saviour and to St. Richarius, the second to the Virgin, the third to St. Benedict. In the main church are three altars,[76] the altar to the Saviour, the altar of St. Richarius, the altar of the Virgin. They are made out of marble, gold, silver, gems, and various kinds of stones. Over the three altars stand three canopies of gold and silver, and from them hang three crowns, one for each, made of gold and costly stones with little golden crosses and other ornaments. In the same church are three lecterns, made of marble, silver and gold. Thirty reliquaries, made of gold, silver and ivory, five large crosses and eight smaller ones, twenty-one altar knobs, three of which are gold and the others of silver. Also seven knobs which belong to standards made of silver and gold. Fifteen large candlesticks of metal with gold and silverwork, seven smaller ones. Seven circular chandeliers of silver, seven of gilded copper, six silver lamps, six lamps of gilded copper. Thirteen hanging vessels of silver, two shell shaped pendants of silver, three large ones of bronze and three small ones. Eight censers of gilded silver and one of copper. A silver fan. Sidings around the head end of the shrine of St. Richarius, and two small doors made of silver, gold and precious stones, six small doors made of gold and silver around the foot of his shrine, and six others which are similar. Before the altar of

[71] The processions have now joined and move together to the east to pray at the altar by the grave of St. Richarius.

[72] Two altars in the northern and southern portions of the church.

[73] The altar of the Holy Cross probably stood in the center of the nave.

[74] The joined processions leave the church through an entrance on its south side, and then move through a passage which had been built along the monastic building situated between the churches until they reach the church of St. Benedict, which marked the easternmost point of the triangular claustral area of Centula.

[75] *Rapport d'Angilbert sur la restoration de Saint Riquier et les offices qu'il y a instituè*, XX, Chap. XVIII, (*De circuitu orationum*), ed. Ferdinand Lot, Hariulf, *Chronique de l'abbaye de Saint Riquier, Collection de textes pour servir à l'étude et à l'enseignement de l'histoire* (Paris: Picard, 1894), pp. 305–6.

[76] Of the fourteen altars of the main church which were consecrated in 799, the inventory mentions only those three ornamented with precious metals.

the Saint stand six large copper columns with gold and silver work, carrying a beam also made of copper with gold and silver work. There are three other smaller beams around the altar, made of copper with gold and silver work. They carry seventeen arches made of gold and silver work. Underneath these arches stand seven bronze images of beasts, birds and men.... One gospel book, written in gold and its silver box set with jewels and gems.[77] Two other boxes for gospel books, of silver and gold, and a folding chair made of silver, belonging to them.[78] Four golden chalices, two large silver chalices and thirteen small ones. Two golden patens, four large silver patens and thirteen smaller ones, one brazen paten, four golden offertory vessels or chalices, sixty silver ones, and a large one of ivory with gold and silver work. One large silver bowl, four small silver bowls, one brass bowl, four knives(?) of silver, two silver pitchers with handbowls. One silver drinking vessel. One silver bucket, two of copper and metal, one with silver work. One silver can, one lead can. One ivory tablet set in gold and silver, eleven large ivory tablets, two small ones, one cypress tablet with silver work. Two silver keys, one brazen and gilded. One golden staff, fitted with silver and crystal. One crook of crystal.[79]

Ardo: St. Benedict's Aniane

Aniane was in nearly all respects the opposite of Centula. Centula was from the outset intended to shelter a very large group of monks; Aniane,[80] where St. Benedict went to live in 779–80, rose from small beginnings. Centula had been laid out with a splendid disregard for economy. The first buildings at Aniane were very simple. St. Benedict, however, like Angilbert, carefully arranged the daytime hours of his monks, with an emphasis on communal prayer that left little time for private devotion and manual work. For Centula this did not pose any problem since the monastery could fall back on the labor and productivity of 2500 laymen, who owed the abbot both payment in kind and free labor whenever he asked for it. On the other hand, Ardo, Benedict of Aniane's biographer, who lived with him as one of his monks, makes a special point of the fact that Benedict did not allow any serfs to be handed over to the monastery. Ardo likewise emphasizes how, in the beginning, the monks did every-

77 This is probably the famous gospel book which Angilbert gave to Centula. It is now in the city library of Abbeville.

78 The folding chair was probably used to exhibit the gospel during certain ceremonies.

79 Hariulf, *Chronique de l'abbaye de Saint Riquier,* III, 3, ed. Ferdinand Lot, *Collection des textes pour servir à l'étude et à l'enseignement de l'histoire* (Paris: Picard, 1894), pp. 86–88.

80 Aniane is the old name of the river Corbière in southern France (Languedoc), where Benedict established a monastic community on his own property.

thing for themselves, with the holy abbot chopping trees or helping in the kitchen. As Benedict's prestige and influence grew, the extreme austerity of the early days could not be maintained. Even after the building of a new church in 789, Aniane with its seven altars and its fine but sparse furnishings, fashioned after those described in the Old Testament, seemed to be a model of austerity when compared with Centula. Benedict gained great influence under Louis the Pious. His version of the rule of Benedict of Nursia[81] was officially approved and recommended at a synod of the Frankish church in 817. There is good reason for believing that the famous plan of St. Gall with its efficient and economic layout was based on an ideal plan for a monastery elaborated in connection with this synod.

In the meantime the number of his disciples started to increase and the fame of his piety grew, slowly at first among neighbors and then rapidly extending itself to far-away regions. Because the valley in which he first lived was very small, he began after a while to construct a new monastery outside it. And he himself either worked with the brethren or cooked meals for them and even busied himself with writing books while in the kitchen. Together with his disciples he always logged the timber with his own shoulders because there were few oxen. There was in that place, where they toiled to found a monastery, a building which they enlarged and dedicated to Mary the Holy Mother of God. From all directions came those who asked to submit themselves to Benedict's teachings, so that the construction of the monastery was quickly achieved and the place increased in wealth, since all of them contributed whatever they had. He, however, insisted on simple walls and the use of straw to cover the roofs instead of decorated walls and reddish tiles and panelled ceilings covered with paintings. And it is true that the more the number of brethren increased, the more he strove for simplicity and humility. Therefore he received whatever anybody wanted to give of his possessions to the monastery, but he refused attempts to attach servants and maids to the monastery and he did not tolerate that during his time anybody should be handed over to the monastery, but ordered them to be set free. Moreover, he did not allow the vessels which received the body of Christ to be made of silver; at first they were made of wood, later of glass, and finally he consented to having them made of brass. He refused to use a silken chasuble. If somebody gave him one as a present, he lent it immediately to others. . . .

Up to now we have spoken about the life of the holy father, how he, illumined by divine love, left the world and how he went into the country of the Goths and built a new monastery. Now, with Christ's help, we

[81] St. Benedict of Nursia (b. 480, d. 550), the founder of Monte Cassino and the first great figure of western monasticism, which was shaped by the rule he gave to his monks.

shall clearly describe how, at Charles' command, he built another monastery in the same place.

In the year 782, the fourteenth year of the reign of King Charles the Great, he began with the help of dukes and counts to construct once again another very large church in honor of our Lord the Saviour and also other new cloisters, with very many marble columns, which were located in their porticos; now he did not cover the buildings with straw but with tiles. And with such grace was that place endowed that whoever came with faith to pray for something, and did not doubt in his heart but believed, was quickly granted what he had asked. Since this church abounded with wonderful grace, we think it advisable to disclose something about its arrangement for future readers.

The venerable Father Benedict, having been prevented by pious thoughts from dedicating it to any saint, had decided, as we have already said, to dedicate this church to the Divine Trinity. In order to make this clearly visible he resolved to place underneath the main altar three steps, which were intended to signify the three persons of the Trinity. And through this ingenious arrangement he expressed in the three stone steps the three Persons, and in the one altar the unity of the Godhead. The altar itself is closed outside but hollow inside, being thereby reminiscent of the altar that Moses built in the desert.[82] In its back it has a small door, in which on appropriate days reliquaries with diverse relics of the fathers are placed. This is enough about the altar. Let us proceed to deal briefly with the furnishings of the church, and in what order and number they are arranged. All the utensils which are in that church are known to be consecrated to the number seven. There is a seven-branched candelabra beautifully fashioned of metal, from whose main stem proceed branches, spheres, and lilies, with rods and bowls shaped like almonds, made in the likeness of the one which Beseleel fashioned with great labor.[83] Before the altar hang seven most wonderful and beautiful lamps, cast with inestimable labor, which are said by experts, who desire very much to see them, to have been put together with Solomonic wisdom. An equal number of silver lamps hang in the choir; they are shaped like crowns and have all around them small cups; it is customary to fill them with oil and light them on high feastdays, so that the church by their light is refulgent all night as well as in the day. Three altars have been dedicated in the same church, one to St. Michael the archangel, another to the blessed apostles Peter and Paul, the third to the benevolent protomartyr, Stephen. In the first church, that of Mary the blessed Mother of God, St. Martin[84] and St. Benedict[85] have their altars. That church which

[82] The altar of holocaust was hollow inside, where the hearth was located (Exod. 28: 7).

[83] Exod. 27: 17–22.

[84] St. Martin, Bishop of Tours (370–97).

[85] For St. Benedict of Nursia see above, footnote 82.

stands in the graveyard is dedicated to St. John the Baptist, the greatest among those born of women, according to Christ's testimony. One should consider with what reverence and holy fear that place protected by so many princes should be regarded. The Lord Christ indeed is the prince of all princes, the king of kings and the lord of lords; the holy Mother of God Mary is believed to be the queen of all virgins; Michael is the highest of the angels; Peter and Paul are the heads of the apostles; Stephen the proto-martyr holds first rank among the witnesses; Martin is a star among bishops; Benedict is the father of all monks. And so in seven altars, in seven candlesticks, and in seven lamps the seven gifts of the Holy Spirit are represented.[86]

THE CAROLINGIAN CONTROVERSY ABOUT RELIGIOUS ART

The seventh ecumenical council was held at Nicea in 787. It condemned iconoclasm and formally sanctioned the veneration of images, a religious practice which had been common in earlier days but which had never before received such explicit official approval. The Western Church, which was only represented by two papal legates, had barely a voice in the deliberations of the council. When Pope Hadrian sent a translation of the acts to Charlemagne, a scathing reply was sent back, the so-called Caroline Books. Their basic position was Augustinian. They sharply juxtaposed truth and fiction and emphasized the gulf between the works of God and men. They also showed little confidence in images as tools of religious instruction, since, as they argued, a truth which has been transmitted in language cannot be adequately expressed in painting. The Caroline Books, however, not only reproved the Council for ascribing to images a religious role they could not fulfill, but also attacked the narrowness of the council's views on art. Whereas the Council seemed to regard the arts as willing handmaids of orthodoxy, the Caroline Books maintained that artists may treat pagan as well as Christian themes with equal skill. To stress the point, a whole catalogue of mythological subjects suitable for pictorial representation was drawn up, giving the author a welcome opportunity to flaunt his knowledge of mythology.

[86] *Ardonis sive Smaragdis Vita Benedicti Abbatis Anianensis et Indensis,* Chaps. V, XVII, ed. G. Waitz, *Monumenta Germaniae Historica, Scriptores in Folio,* XV, 1 (Hannover: Hahnsche Buchhandlung, 1887).

The Caroline Books:
A Frankish Attack on Iconodules

Truth persevering always pure and undefiled is one. Images, however, by the will of the artist seem to do many things, while they do nothing. For, since they seem to be men when they are not, to fight when they do not fight, to speak when they do not speak, to hear when they do not hear, to see when they do not see, to beckon when they do not beckon, to touch when they do not touch and other things like this, it is clear that they are artist's fictions and not that truth of which it is said: "And the truth will make you free." That they are images without sense and reason is true; that they are men, however, is false. And if someone affirms that images according to a logical trick can be called men, as, for example, "Augustine was a very great philosopher," and, "Augustine ought to be read," and "a painted Augustine stands in the church," and "Augustine is buried there," let him realize, that although all these things come from one source, that is from Augustine, he alone is the true Augustine who is called "a very great philosopher."[87] Of the others, however, one is a book, one is an image, one is a buried corpse. The principal difference between a true and a painted man is that one is true and the other false, and they have nothing in common except the name. For since he is true of whom it can be said that he is an animal, rational, mortal, capable of laughter and pain, then one must necessarily consider him false who has none of these attributes, and if he who lacks all these things is not false then neither is he who possesses all of them true...

And when somebody says: "Images are not contrary to Holy Scripture," while many things are being painted by painters about which Scripture says nothing and which can be shown to be completely false not only by learned but also by unlearned men, must one not grant, that what he says is not only extremely ridiculous but downright false? Does he not know that it is contrary to Scripture to fashion the sea as a man pouring forth a large stream of water? And is it not certainly contrary to Scripture if the earth is depicted in human form, either as arid and sterile or as overflowing with fruits? And is it not obvious that it is contrary to Scripture if one depicts rivers and streams and their confluence as men pouring water out of urns? And if the sun and the moon and the other adornments of the sky are depicted in human form, their heads crowned with rays, does not all of this run quite contrary to Holy Scripture? And if one credits each of the twelve winds with a different shape according to its strength or gives a different appearance to each of the months according to the time of the year, so that some appear naked, others half naked,

[87] The mention of St. Augustine in this example is perhaps not accidental, since the whole passage is reminiscent of a similar one in St. Augustine's *Soliloquies* (see above, p. 41).

others clad in various garments, or if one depicts the four seasons as four different figures—either verdant with flowers as spring, or scorched by the heat and loaded with grain as summer, or bent under the load of wine vats and grapes as autumn, or now freezing in the cold, now warming himself at a fire, or feeding animals or catching birds, which are exhausted by the cold, as winter—does one not recognize that these things, are contrary to Scripture, which does not contain any of them?

How is it, then, that Scripture is not contradicted by painters, who frequently follow the vain fables of the poets? They fashion sometimes events which have actually happened, but also incredible inanities on other occasions. What neither has happened nor can ever happen they depict: what is understood mystically by the philosophers, venerated superstitiously by the pagans, and rejected rightfully by the Catholics. And although all these things are contained in pagan literature they are nevertheless utterly alien to Scripture.

Is it not alien to Scripture that they paint how the three-headed Chimaera is killed by Bellerophon, although he did not overthrow a monster, as some pretend, but made the mountain habitable as others rightly understand?[88] Or is it not alien to Scripture if one pretends that Erichthonius is the son of the limping Vulcan and the earth and that he heats his iron in Mount Aetna and has his oven in Vesuvius, a mountain of Campania, which is known to burn perpetually?[89] Or is it not alien to Scripture if one paints how Scylla[90] is girded with the heads of dogs, or how Phyllis because of someone's love was changed into a tree,[91] or how Itys because of his aunt's defilement by his father and the murder his mother and his aunt committed against him was together with his parents and his aunt changed into a bird,[92] or if one paints how the Sirens[93] are in part young women and in part birds, or if one paints how Ixion deceived by Juno embraces a cloud and generates the centaurs,[94] or if one paints how Neptune with his trident governs the sea tides? Or is it not alien to Sacred Scripture if one fashions how Perseus kills the three Gorgons[95] with Minerva's help or how he flies toward Medusa backward,[96]

[88] Chimaera was a fire-breathing monster, killed by Bellerophon the grandson of Sisyphus and the rider of Pegasus. A demythologizing version of this story converts Chimaera into a volcanic mountain.

[89] Erichthonius, a mythical king of Athens and a son of Vulcan.

[90] Circe transformed Scylla into a sea monster with heads of dogs around her loins.

[91] Phyllis, a Thracian princess, was changed into an almond tree.

[92] Itys, son of Procne and of Tereus, a king of Thrace. After Tereus had raped Procne's sister Philomela, the two sisters killed Itys and served his body to Tereus as a banquet dish. All four were thereupon changed into birds.

[93] Sea nymphs, living on the southwest coast of Italy.

[94] Ixion, kind of the Lapiths.

[95] Medusa and her two sisters.

[96] Perseus approached Medusa backwards, looking at her mirror image in his shield, since she had the power to turn into stone whoever approached her directly.

or if one paints how out of Medusa's blood Pegasus is born, the winged horse that breaks open with his hoof the fountain of the Muses?[97] Or is it not contrary to Divine Scripture, that they depict Prometheus making lifeless men out of clay and the same Prometheus being lifted up among the guardians of heaven and, while he beholds the heavenly beings, touching the wheels of Phoebus with his fennel stalk,[98] stealing fire, and touching the breast of the man he had fashioned, thereby giving him life? Or is it not contrary to Sacred Scripture that they depict Tantalus, placed in a lake in Hades, his lips trembling with greed at the false water, and at fruit appearing above, hanging down by his face, and turning to ashes at a touch, furnishing him a rich sight but a poor meal?[99] Or is it not alien to Holy Scripture when the blind Phineas is depicted, and the Harpies stealing his food and fouling his meals with their excrement, those Harpies whom Zetes and Calais, the sons of the Northwind, are supposed to have driven away?[100] Or is it not contrary to Holy Scripture to paint how Admetus, the King of Greece, had to hitch a lion and a stag together to a cart with the aid of Apollo and Hercules, in order to satisfy his father-in-law[101] and enjoy marriage with Alcestis, or if Hercules is depicted as slaying Cerberus, the three-headed dog of Hell? And is it not contrary to Holy Scripture that they depict a certain hunter, named Actaeon, changed into a stag because he saw Diana bathing, and, so disguised, being devoured by the bites of his own dogs? Or is it not contrary to Divine Scripture, that they depict how Cybele[102] loved the very beautiful youth Attis and incensed by vanity and jealousy castrated him and made him a half-man? Or is it not contrary to Divine Scripture to depict Orpheus, loving Euridice and winning her as his wife with his cithar, and also Euridice, flying from Aristeus the shepherd, since she could not bear his pursuit, and being killed by a serpent she stepped on, and her husband following her, descending into Hades and accepting the rule that he should not turn around to look at her and turning around and losing her again? Or is it not alien to Divine Scripture, that Venus is represented embracing Mars, and being discovered by the Sun and caught by Vulcan and bound by him together with Mars in adamantine chains?[103] These and similar things, to us painful to recount, but to the poets and the

97 Hippocrene on Mount Helicon.

98 Prometheus stole the heavenly fire by touching the wheels of the sun god's chariot with a fennel stick.

99 Tantalus was punished in this fashion because he gave away the secrets of Jupiter's table, to which he had been admitted as a son of Jupiter.

100 Calais and his son Zetes were Argonauts. They freed Phineas, a king of Thrace who was tormented by the Harpies, monsters who were half-bird and half-woman.

101 Pelias, king of Iolcos in Thessaly and father of Alcestis, demanded that Admetus should prove himself by hitching a stag and a lion to his chariot before marrying Alcestis.

102 An earth goddess, venerated in Rome as the "Great Mother."

103 Vulcan the great smith was Venus' husband.

philosophers of the Gentiles sweet to sing and recondite to expound, and to the painters suitable for their compositions, are utterly alien to Holy Scripture. For, to be silent about other matters, if any painter dares to paint two heads on one body or one head on two bodies, or the head of one creature on the body of another, like a centaur, who has the body of a horse and the head of a man, or the Minotaur,[104] who is half bull and half man, is not this admittedly contrary to the Scriptures?

And what does it mean if one says: "Painters do not contradict Scripture," if not that they cannot paint anything that would seem opposed to Holy Scripture? In Holy Scripture, however, nothing vicious, nothing unsuitable, nothing impure, and nothing false can be found, except where Scripture records what the wicked said and did. But in painting, much that is false, wicked, foolish and unsuitable can be found, and to pass over particular examples, almost everything either possible or impossible has been depicted by learned painters. By establishing these facts we have exposed the babbling of John the priest and Eastern legate on this subject, as on others.[105] Let the prudent reader take note of how false and inane is this declaration of the same priest: "Whatever Scripture treats, painters can represent." For how can all the commands of Divine Law, given by God through Moses, like that, "Hear o Israel, the Lord thy God is one God,"[106] and other things of this sort, in which there is nothing that can be painted, be represented by painters? For is painting in its vanity able to represent all the words of the prophets in which doctrines, exhortations, arguments, considerations, warnings or other like things are contained? In them one often finds, "This says the Lord," or, "God commanded," or things similar to these which may be expressed by writers rather than by painters. For which single word of the Lord and the apostles can be represented by painters? Painters therefore have a certain ability to remind one of things that have happened. Such things, however, as are understood by reason and expressed in words can be expressed not by painters but by writers through verbal discourse. Therefore it is absurd to say, "Painters do not contradict Scripture and whatever Scripture treats, they can represent."[107]

Candidus: An Imperial Admonition
to the Abbot of Fulda

The number of churches built during the reign of Charlemagne,

104 A man-eating Cretan monster with the head of a bull and the body of a man.

105 John, the presbyter, spokesman for the iconodule position at the second Council of Nicea (787).

106 Deut. 6: 4.

107 *Caroli Magni Capitulare de Imaginibus*, I, 2; III, 13, ed. H. Bastgen, *Monumenta Germaniae Historica, Legum Sectio III, Concilia*, II, Supplement (Hannover: Hahnsche Buchhandlung, 1924), pp. 13, 151–53.

their size, and the luxury of their fittings, called for the same kind of criti-
cism which St. Jerome had once levelled against the ostentatious display
of wealth in fourth-century churches. But whereas St. Jerome had
attacked bishops and laymen rather than monks, it was now the great
monastery, with its concentration of wealth, learning, and manpower,
which was able, in a period when cities were small and few in number, to
build the largest and most conspicuous churches. Ratgar (802–817), one
of the most formidable of the abbots of Fulda and the architect of its
grandiose western church (dedicated in 819), which copied the transept
and apse of St. Peter's, so exhausted the monks and the serfs of its monas-
tery by his continuous building campaigns that the monks complained
about him to the Emperor in 812 and again in 817. They also expressed
their feeling that they were being victimized in a famous caricature,
which compared their abbot to a ferocious unicorn attacking a flock of
sheep. When Louis the Pious ratified the election of Ratgar's successor
Eigil, he exhorted him not to indulge in excessive building campaigns.
Louis' speech to Eigil was made in 818, a year after the Synod of Aachen
had decided to introduce general monastic reforms and to promulgate
the rule of St. Benedict of Aniane,[108] a far-reaching revision of the old rule
of St. Benedict of Nursia.

But you, my Father,[109] try to maintain the younger monks according
to God's will with all zeal and wisdom, so that, persevering in that holy
harmony, they may deserve to attain Him, who descended from heaven
solely in order that the world should be reconciled through Him to the
Father. Since I talk to men well versed in the Law of God, I admonish
you only in this, that you may, according to the possibilities which God
provides, turn words into deeds. Reduce to the minimum, however,
Father, immense building projects and unnecessary undertakings, which
tire the servants outside the monastery as well as the monks within, and
remember how complaints about such excesses have constantly troubled
my father's ears as well as mine. For this purpose has divine providence
called me, however unworthy, into the imperial office, to be an eye to the
blind and a foot to the lame, and a father to the poor, and to investigate
carefully causes of which I am ignorant. Therefore I cannot be silent in a
matter which touches the interests of religion. S. John Chrysostomus[110]
says of those who build martyria and decorate churches luxuriously:
"Look at those who build martyria and adorn churches and seem to do
good works. If indeed they observe the law of God also in other respects,
if the poor are gladdened by their alms, if they do not appropriate what

108 See above, p. 96.
109 The Emperor addresses the new abbot Eigil.
110 St. John Chrysostomus (b. c. 347, d. 407), a Greek Father of the
Church. The quotation ascribed to him has never been identified. It is therefore
difficult to decide where his words end and the Emperor's begin.

belongs to others either by violence or fraud, then they certainly build for God's glory. But if they do not observe the Law of God, if the poor are not gladdened by their alms, if they appropriate what belongs to others by fraud or violence, then who is so blind as not to realize that they do not build these churches in honor of God but for their own vainglory? And is it not right to say that they build martyria in which the poor, which have been martyred by them, will testify against them? The martyrs do not rejoice when they are honoured by riches gained through the tears of the poor. What justice is that, to honor the dead and rob the living, to take the blood of the wretched and offer it to God? That is not a sacrifice to God, but an attempt to make Him an accomplice in one's crimes, as if He, by freely accepting the wages of sin, should acquiesce in the sin. Do you want to build the house of God? Then give to God's poor, so that they may live, and you build him a suitable house. Indeed men live in houses but God lives in holy men. What kind of people are those, who rob men and build houses for the martyrs, who construct houses for men and wreck the houses for God? The possessions of the monastery, my Father, which are in your hands, I admonish you not to waste in a reckless and imprudent fashion, nor to give unjust orders and rules, as if you had unlimited powers. Jerome teaches you in his letter to Paulinus[111] not to squander what belongs to the poor. "What use are walls blazing with jewels when Christ in His poor is in danger of perishing from hunger?" he says, "Your possessions are no longer your own but a stewardship is entrusted to you. Remember Ananias and Sapphira."[112]

CAROLINGIAN ANTIQUARIANISM

Carolingians admired Rome's pagan past as well as its Christian present. Travelers to the city collected inscriptions from pagan and Christian monuments and followed a guidebook that mentioned both. This deepening of historical perspective was connected with the increasing rivalry between the West and Byzantium. The revival of early Christian architecture and iconography in Carolingian Rome was in part a turning away from the memories of the city's more immediate Byzantine past. When the Caroline Books insist that painting may treat classical themes as well as Christian ones, they do so in order to attack the Byzantine concept of religious images.

111 For St. Jerome's letter to Paulinus of Nola see above, p. 38.
112 Candidus, *Vita Eigilis abbatis Fuldensis*, Chap. X, ed. G. Waitz, *Monumenta Germaniae Historica, Scriptores in Folio*, XV, 1 (Hannover: Hahnsche Buchhandlung, 1887), pp. 227–28.

Theodulf of Orleans: An Antique Silver Bowl

Theodulf of Orleans was one of the most learned and influential men at the court of Charlemagne. After having served as an itinerant judge in southern France, he wrote a poem describing how a judge is bribed with rare gifts, among them a silver bowl with reliefs depicting the labors of Hercules. In his poem Theodulf lets the owner extol it, and in doing so displays his own command of mythology as well as his intimacy with the poetry of Ovid and Virgil, whose expressions he borrows throughout the description. It is likely that Theodulf was also the author of the Caroline Books, where a similar interest in classical mythology is demonstrated.

I have a beautiful and ancient vessel
which is of pure metal and not light in weight
where the crimes of Cacus can be seen in reliefs:
the decaying human heads impaled on sticks;
the boulders held by chains[113] and other traces of plunder.
The earth tinged with blood of men and sheep,
where the rage of Hercules pounded the bones of the Vulcanid[114]
and that beast belched his father's fire from his mouth.
And where Hercules with knee and foot crushed his stomach and
 groin
and shattered his smoking gullet and his face.
There you may see the bulls coming forth from the hollow rock,
frightened to be drawn back again by their tails.[115]
This is on the inside, which has a level rim
of modest width bearing small figures.
They show how the Tirinthian infant vanquished the twin ser-
 pents[116]
and note ten labors also in sequence.
But the outside part is polished smooth from frequent use and the
 old attenuated figures are disappearing.
Here the grandson of Alceus,[117] the river of Calydon, and the cen-
 taur Nessus[118]
contend for your beauty, Deianira.
The deadly robe soaked with the blood of Nessus[119]

113 Cacus had fortified his cave with boulders and chains.
114 Hercules slew Cacus, called "the Vulcanid" because he was a son of Vulcan.
115 Cacus had stolen Hercules' bulls and driven them into his cave.
116 The Tirinthian infant, Hercules, who was born in Tiryns, killed the snakes which Hera had sent to kill him in his cradle.
117 Hercules was the grandson of Alceus.
118 Hercules fought with both the river god Achelous and the centaur Nessus for Deianira.
119 The dying Nessus asked Deianira to dip a garment in his blood and use it as a love charm on Hercules. But it poisoned the hero when he donned it.

is seen and the fearful fate of the unfortunate Lichas.[120]
Also Antaeus[121] loses his life in Hercules' harsh arms
which kept him from touching the ground in his accustomed fash-
ion.[122]

Einhard to Wussin: A Query about Vitruvius

*Among the many classical authors whose works have survived in
Carolingian copies is Vitruvius.*[123] *His* Ten Books on Architecture *were
not only copied and read in Carolingian times, but studied by patrons
and possibly also by architects. Einhard,*[124] *educated at Fulda and author
of a famous biography of Charlemagne modelled on Suetonius,*[125] *was in
charge of the construction of Aachen. After 830, Einhard retired to the
monastery of Seligenstadt, where he built a church that still stands. It was
during these years that the letter to a young monk at Fulda was written,
in which Einhard asked for information on the meaning of certain terms
in Vitruvius. A now lost list of them was probably appended to the letter.
Einhard also referred to the existence of a reliquary at Fulda which imi-
tated an ancient work of architecture. He himself is known to have com-
missioned a similar reliquary, which was made of silver and reflected the
shape of a Roman triumphal arch. The passage that troubled Einhard has
also puzzled modern students of Vitruvius, since it contains an ambiguous
reference to representations in perspective, an art first developed for stage
decorations and therefore called "scenographia."*

. . . I have sent you also some obscure words and names from the
books of Vitruvius, which I have encountered up to now, so that you may
ask there about their meaning. And I think that most of them can be
explained with the help of the reliquary that Lord E.[126] made with ivory
columns after the example of ancient works. And ask also about that
which Vitruvius calls *scenographia,*[127] and whether it has something to do
with what Virgil calls *scena* in the third book of the Georgics, for he says:

120 Lichas, a servant of Hercules, brought him the garment soaked in the
poisonous blood of Nessus. When Hercules began to feel the poison, he threw
Lichas through the air on to a rock in the sea.

121 Antaeus, son of Gae the Earth Goddess, was invincible as long as his
feet touched the ground. Hercules defeated him by holding him up in the air.

122 Theodulf of Orleans, *Versus contra iudices,* 179–202, ed. E. Duemmler,
Monumenta Germaniae Historica, Poetae Latini Aevi Carolini, I (Berlin: Weid-
mannsche Buchhandlung, 1881), pp. 498–99.

123 Vitruvius, famous theorist of architecture who lived during the Augus-
tan period.

124 See above, p. 83.

125 Suetonius wrote biographies of the first twelve Roman emperors.

126 Perhaps Eigil, abbot of Fulda (818–22).

127 *De architectura,* I, 2, 2.

"Even now 'tis a joy to lead the solemn procession to the sanctuary and view the slaughter of the steers, or to watch how the scene retreats with changing front, and how the inwoven Britons raise the purple curtains.[128] Farewell."[129]

[128] Virgil, *Georgics*, III, 23–25. Einhard quotes only part of Virgil's phrase.
[129] Einhard, *Epistolae*, 57, ed. K. Hampe, *Monumenta Germaniae Historica, Epistolae Carolini aevi*, III (Berlin: Weidmannsche Buchhandlung, 1899), 138.

5

Early Romanesque

ENGLAND

Viking raids and Danish invasions destroyed most of the monasteries founded in England during the seventh and eighth centuries. In Britain by the middle of the tenth century, monastic life seems to have been practically extinct. Its reform was the work of King Edgar[1] and of Sts. Dunstan,[2] Aethelwold,[3] and Oswald,[4] all three of whom had come into contact with reformed houses such as Fleury[5] on the Continent. The monastic reform was accompanied by ambitious building activity, and soon led to a flowering of manuscript illumination, whose elegant and emotional style owed much to Carolingian sources. Since many English monasteries rewrote their records after the Norman Conquest, contemporary sources for this lively and important period are scarce. One of them is the anonymous life of St. Oswald, written shortly after his death by a monk at Ramsey in Huntingdonshire, St. Oswald's most important foundation. Of Oswald's church at Ramsey nothing remains.

St. Oswald's Church at Ramsey

Boreas the coldest wind, who is also called Northwind and who sends his awful snorts from the Thracian[6] cave, lying in a northern region, from where he usually comes, could not stop him [St. Oswald] from continuing the work he had begun. It was, as we have already said, in the ninth week of autumn when the holy man and his companions came to the said place, where he energetically looked after all its goods, replenishing the barn with wheat and other seed. Daily he strove to strengthen the tender limbs of his disciples with apostolic milk, giving them twofold nourishment so that they could chase away more freely the sickness of sloth, which leads to perdition. After the autumn had passed he did not slacken his efforts, but zealously searched for masons able to lay out the monastery in a suitable and decorous fashion, according to the right rule, with threefold triangles and compass. Afterwards he prepared cement during the whole winter and ordered stones to be gathered. And when the Swan ascended into the sign of Aries[7] at sunrise, he began to construct

[1] Edgar, English king (959–75), the royal patron of the monastic revival in England.

[2] St. Dunstan, Archbishop of Canterbury (959–88).

[3] St. Aethelwold, Bishop of Winchester (963–84).

[4] St. Oswald, Archbishop of York (972–92).

[5] Fleury, now St. Benoît sur Loire. Its famous monastery was founded in the seventh century, and at least two of the protagonists of monastic reform in England, St. Oswald and St. Aethelwold, spent some time there.

[6] Thrace, a region extending over the eastern half of the Balkan peninsula.

[7] A stellar configuration which occurs at the beginning of spring.

the foundations of the church. And since he built under the venerable sign of the cross, through which we believe ourselves to be saved, so he began to construct the buildings of this place in the form of a cross, with wings[8] towards the east, the south, and the north, and a tower in the middle. . . .[9] Afterwards he added a church to the western side of the tower, confiding greatly in the mercy of the Highest King and the protection of the holy abbot Benedict.[10]

Eadmer: The Anglo-Saxon Cathedral of Canterbury

The archepiscopal see of Canterbury was established in 597 by St. Augustine,[11] who, according to Bede, founded his cathedral in an already existing church built under Roman auspices. He restored it and dedicated it to the Saviour. Eadmer, who was brought up in Canterbury, describes its cathedral as it looked in 1067, when he was thirteen years old. Later in the same year the cathedral burned down completely and was afterwards rebuilt by Lanfranc.[12] Eadmer seems to think that the church he saw as a boy was the very same structure that had been dedicated by St. Augustine. He himself mentions, however, in other places, that it had been restored twice between 597 and 1067, once by Archbishop Cuthbert (740–60) and once by Archbishop Oda (942–58), who was a relative of St. Oswald. The rebuilding of the latter must have been rather drastic, since, according to Eadmer, the cathedral was left without a roof for three years while its walls were being built higher.

The venerable Odo had translated the body of the blessed Wilfrid archbishop of York, from Ripon[13] to Canterbury, and had worthily placed it in a more lofty receptacle, to use his own words, that is to say, in the great altar which was constructed of rough stones and mortar, close to the wall at the eastern part of the presbytery.

This was that very church (asking patience for a digression) which had been built by Romans, as Bede bears witness in his history, and which

[8] I have translated as "wings" the term "porticus," which can also mean "apse" or "aisle."

[9] The rest of the sentence is corrupt.

[10] *Vita S. Oswaldi, auctore anonymo,* Chap. IV, in *The Historians of the Church of York and its Bishops,* ed. James Raine, *Rolls Series,* LXXI, I (London: Longmans and Co., 1897), 433–34.

[11] Pope Gregory the Great's envoy to Britain, who arrived in Kent in 597. See above, p. 47.

[12] Lanfranc, Canterbury's first Norman archbishop (1070–89).

[13] Ripon, like Hexham, was founded by Wilfrid. See above, pp. 75–78. The translation of St. Wilfrid's body from Ripon to Canterbury took place about the middle of the tenth century.

was duly arranged in some parts in imitation of the church of the blessed Prince of the Apostles, Peter; in which his holy relics are exalted by the veneration of the whole world. . . .[14] Afterwards another altar was placed at a convenient distance before the aforesaid altar, and dedicated in honour of our Lord Jesus Christ, at which the Divine mysteries were daily celebrated. In this altar the blessed Elphege had solemnly deposited the head of St. Swithin, which he had brought with him when he was translated from Winchester to Canterbury, and also many relics of other saints.[15] To reach these altars, a certain crypt, which the Romans call a Confessionary, had to be ascended by means of several steps from the choir of the singers. This crypt was fabricated beneath in the likeness of the confessionary of St. Peter, the vault of which was raised so high, that the part above could only be reached by many steps. Within, this crypt had at the east an altar, in which was enclosed the head of the blessed Furseus,[16] as of old it was asserted. Moreover, the single passage (of entrance) which ran westward from the curved part of the crypt, reached from thence up to the restingplace of the blessed Dunstan,[17] which was separated from the crypt itself by a strong wall; for that most holy father was interred before the aforesaid steps at a great depth in the ground, and at the head of the saint stood the matutinal altar. Thence the choir of the singers was extended westward into the body of the church, and shut out from the multitude by a proper enclosure.

In the next place, beyond the middle of the length of the body, there were two towers which projected beyond the aisles of the church. The south tower had an altar in the midst of it, which was dedicated in honour of the blessed Pope Gregory. At the side was the principal door of the church, which, as of old by the English, so even now is called the Suthdure, and is often mentioned by this name in the law-books of the ancient kings. For all disputes from the whole kingdom, which cannot be legally referred to the king's court, or to the hundreds or counties, do in this place receive judgment. Opposite to this tower, and on the north, the other tower was built in honour of the blessed Martin, and had about it cloisters for the use of the monks. And as the first tower was devoted to legal contentions and judgments of this world, so in the second the younger brethren were instructed in the knowledge of the offices of the Church, for the different seasons and hours of the day and night.

The extremity of the church was adorned by the oratory of Mary, the blessed Mother of God; which was so constructed, that access could

[14] The Constantinian basilica of St. Peter in Rome.

[15] St. Swithin, Bishop of Winchester (852–62). His body was brought to Canterbury in 1004, when St. Alphege (Bishop of Winchester, 984–1005) was made archbishop there.

[16] St. Furseus, Irish abbot and missionary (d. 648), was buried at Peronne in Gaul.

[17] St. Dunstan, archbishop of Canterbury (960–88).

only be had to it by steps. At its eastern part, there was an altar conse-
crated to the worship of that Lady, which had within it the head of the
blessed virgin Austroberta.[18] When the priest performed the Divine mys-
teries at this altar he had his face turned to the east, towards the people
who stood below. Behind him to the west, was the pontifical chair con-
structed with handsome workmanship, and of large stones and cement;
and far removed from the Lord's table, being contiguous to the wall of
the church which embraced the entire area of the building. And this was
the plan of the church of Canterbury. These things we have shortly
described, in order that the men of the present and future generations,
when they find them mentioned in the writings of old, and perceive that
the existing things do not coincide with their narratives, may know that
all these old things have passed away, and that new ones have taken their
place. For after the innumerable vicissitudes which this church under-
went, the whole was finally consumed in our own days by fire as we have
above related.[19]

THE EMPIRE

*After the death of Louis the Pious in 840, the Carolingian Empire
deteriorated quickly. Its breakdown was hastened by the raids of Vikings,
Hungarians, and Moslems, who destroyed the cities and monasteries of
Gaul and Germany. One of the regions least affected by the general tur-
moil was Saxony, whose Duke Henry was made King of Germany in 919.
He was followed by his son Otto the Great, who was crowned Emperor by
Pope John XII in 962. The Saxon emperors had a lofty concept of their
office and comported themselves with a formality foreign to the manners
of Charlemagne. This is particularly true of Otto II,[20] who married a
Byzantine princess, and of their son Otto III,[21] and his cousin Henry II.[22]
To judge by their austere yet elegant portraits, their splendid jewels, and
their generous patronage, the new imperial family expressed the dignity
of their office with rare style. Their comportment made a deep impression
in Italy, where the imperial faction hoped for a new restoration of Roman
power and ceremonial. The description of the emperor's robes in the
Book of the Golden City of Rome, which is believed to have been written
in Rome about 1030, reproduces many dubious traditions but at least in
part seems to be based on firsthand knowledge. It records, for example,*

[18] St. Austroberta, abbess of Pavilly near Rouen (b. 630, d. 704).
[19] Eadmer, *De reliquiis S. Audoeni,* trans. R. Willis, *The Architectural
History of Canterbury Cathedral* (London: Longmans and Co., 845), pp. 9–12.
[20] Otto II, German emperor (973–83).
[21] Otto III, German emperor (983–1002).
[22] Henry II, German emperor (1002–24).

that the Emperor wore, for his coronation, cloak adorned with the signs
of the zodiac, a fact which is also known from other sources.

Imperial Robes and Insignia

We come now to the garments of the emperor and in the first place to the
cloak. The cloak is a garment which is worn sideways and which is not
sewn but held by golden clasps. The toga is round with its great fold bulg-
ing and, so to speak, overflowing. Coming from the right it is slung over
the left shoulder, as can be seen in pictures and statues, which we call
togaed statues. The Emperor and the Romans wore the toga in times of
peace but in times of war they wore the cloak. The proper measure of a
toga is six ells. The emperor's trabea[23] is a kind of toga, purple and scarlet
in color, which the emperors should wear during processions. Romulus[24]
first invented it as a garment to distinguish kings. It is called trabea
because it elevates the emperor and in past and future raises him to more
lofty heights of honour and designates him as the sole ruler of all. The
cloak of the emperor is a precious garment of scarlet, purple, and gold.
It is a garment of war and it is because of future wars that the emperor
wears it. The cloak resembles a "cyclas";[25] it is round and interwoven
with purple.

The emperor should wear a shirt of very fine and white linen with a
golden ornament. The golden border around its hem is one ell wide.

He should also have a scarlet tunic,[26] adorned with gold, gems and
precious pearls at the shoulders, around the neck, the hem and the wrists,
with 72 little bells and as many pomegranates around the hem.

The belt or girdle of the emperor should be made from gold and
precious stones, with 72 little bells, shaped like pomegranate flowers and a
subcinctorium[27] made in the same fashion. And on each end of the girdle
a golden circle adorned with precious stones and pearls, having around its
rim the motto: "Rome the head of the universe holds the reins of the orb
of the world." In the middle of the circle should be a representation of
the three regions of the world: Asia, Africa, Europe.

The dalmatic[28] of the emperor is interwoven with gold, with golden
eagles and pearls in front and back and with 365 little golden bells
attached to it.

[23] The *trabea* in late antique and medieval times was a narrow strip of
fabric, similar to the priest's stole.

[24] Romulus, the mythical founder of Rome.

[25] The *cyclas* was a state garment for women with a wide border around
its hem.

[26] The tunic hemmed with bells and pomegranates may have been model-
led on garments worn by Aaron and his sons (Exod. 28: 33; 39: 44).

[27] A strip of cloth hanging from the belt, still a part of the papal costume.

[28] The dalmatic, an overtunic reaching down to the knees, is still part of
the liturgical dress worn by the deacon and subdeacon during high mass.

The emperor's epiloricum[29] should be made with eagles and pearls in front and back.

The golden mantle of the emperor should have a golden zodiac, made from pearls and precious stones. On its fringes should sit 365 little golden bells shaped like pomegranate flowers and as many pomegranates.

He should also have golden stockings with four eagles made from pearls. The straps of the stockings should be of gold and precious stones and pearls, having 24 little golden bells made in the shape of pomegranate flowers.

The emperor's shoes should be made of gold, pearls and precious stones, on which should be fashioned eagles and lions and dragons.[30]

The pallium and the mitre of the emperor. The emperor should have a pallium around his neck, and a mitre on his head, and also a golden necklace, armbands, bracelets and rings.

... The gloves of the sole ruler should be made from the brightest gold having Romulus and Scipio[31] pictured with gold and gems and precious stones on one glove and Julius[32] and Octavian[33] on the other.[34]

Benzo of Alba to Henry IV:
The Imperial Procession

Benzo of Alba, who wrote in the second half of the eleventh century, was another Italian of the imperial faction. His description of the Emperor's coronation is tinged with nostalgia. Dedicated to Henry IV,[35] it was written at the height of the investiture controversy and before Henry's late and schismatical coronation in 1089. His description contains details which seem to be derived from the ceremonial of earlier coronations, especially Henry III's in 1046. As an ardent admirer of the Saxon emperors he may have informed himself also about the particulars of previous coronations.

The procession of the Roman emperor is celebrated in this fashion: before him is carried the holy cross with the wood of the true cross and the lance of St. Maurice. Thereafter follow the ranks of bishops, abbots, priests, and innumerable clerics. ... Then the king, clad in the long linen

[29] A garment worn above the armor.

[30] Probably an allusion to Psalm 90: 13: "And thou shalt trample under foot the lion and the dragon."

[31] Probably Scipio Africanus Maior, Roman general and statesman (b. 236, d. 184 B.C.).

[32] Gaius Julius Caesar.

[33] C. Octavius Augustus.

[34] *Graphia auree urbis Romae*, III, ed. P. E. Schramm, *Kaiser, Rom und Renovatio* (Leipzig-Berlin: G. B. Teubner, 1929), II, 68.

[35] Henry IV, German emperor (1065–1106). During his reign the investiture controversy reached its climax, and Henry, excommunicated by Pope Gregory VII, set up the antipope Clement III, who crowned him Roman Emperor in 1089.

tunic, studded with gold and gems of wonderful workmanship, awe-inspiring in golden shoes, girt with a sword, wearing the gold-embroidered cloak made of a golden fleece, the imperial garment, having his hands sheathed in linen gloves with the pontifical ring, his head glorified by the imperial diadem.

> Carrying in his left hand the golden apple which
> signifies the rule over all kingdoms,
> in his right, the imperial scepter like Julius,[36]
> Octavian[37] and Tiberius[38]
> supported on one side by the Pope and
> on the other side by the archbishop of Milan,
> with dukes, markgraves and counts on both sides, and
> rows of other princes.

No human tongue can describe like honour and glory.

Thus the emperor walks in procession.... After a short interval, the emperor changes into a green cloak with a white mitre over which sits the crown of the patricius,[39] and so he goes to vespers.[40]

Imperial Largesse

The Saxon emperors as well as their successors made rich gifts to churches and monasteries throughout the Empire and also beyond its boundaries. These gifts consisted often of goldsmith work, jewelry, illuminated manuscripts, or costly garments. They were often objects which had either been used or commissioned by the emperor. Many of them bore the imprint of imperial taste. The workshops favoured by Otto III and Henry II were much influenced by Byzantine models of the late tenth century, a period which must also have shaped the personal style of Otto II and Otto III, as well as the ceremonies of their courts. Costly, personal and distinctive, such gifts were well suited to suggest a special link of loyalty between donor and recipient.

Leo of Ostia: Henry II's Gifts
to Monte Cassino

Henry II visited Monte Cassino in 1022 in order to secure the election of an abbot favorable to the imperial party. He was successful, and in return showered the abbey with generous gifts. Among them was a

[36] Gaius Julius Caesar.

[37] C. Octavius Augustus.

[38] Tiberius, Roman Emperor (19–37), Augustus' stepson and successor.

[39] Patricius, originally a personal title, first bestowed by Constantine the Great. Charlemagne, his father, and his grandfather received the title from the Pope. It was revived by Otto III (983–1002).

[40] *Benzonis episcopi ad Henricum IV*, I, 9, ed. K. Pertz, *Monumenta Germaniae Historica, Scriptores in Folio*, XI (Hannover: Hahnsche Buchhandlung, 1854), 602.

famous Gospel Book, which still exists. Leo of Ostia, the librarian of the monastery during the second half of the eleventh century, describes it with special care.

The following morning the imperial liberality offered these gifts to the holy father Benedict: a gospel book with one side of its covering made of pure gold and set with the most precious gems, and inside, moreover, marvellously adorned with golden letters, which are called uncials,[41] and pictures. A golden chalice with its paten, set with the finest gems, pearls and enamels. A chasuble with inwoven patterns and golden borders, a stole, a maniple[42] and a belt, all with gold adornment. A cope[43] with inwoven ornaments and golden borders and also a tunic of the same fabric with golden ornaments, also a handkerchief[44] with inwoven patterns and gold ornaments. Also a mug and another drinking vessel of silver for the monks to drink from on the main feast days.[45]

Henry II's Gifts to Basel

The occasion for Henry II's gifts to Basel was the dedication of its cathedral in 1119, at which the Emperor was present. Among the gifts he made was the famous gold altar now in Paris. The cathedral of Basel remembered the donations of Henry II, canonized in 1146, as late as the sixteenth century in the lections of its pre-Tridentine breviary, which were supposed to be read on the first of July, the anniversary of the Emperor's death.

He [Henry II] set out for Basel, and there restored the bishopric devastated by the atrocious persecutions of the Huns. He commanded that the church, which for a long time had stood neglected and half in ruins, should be repaired with funds from his own treasure, and he revived its divine services and its congregation. Then he ordered that it should be consecrated in honor of the most glorious Virgin and mother of God by the venerable bishop of the place, Adalbero,[46] and by seven other bishops of neighbouring provinces. He himself was present and lavished large gifts.

He gave a golden altar, fashioned out of heavy and precious metal and covered with images in relief, and also a round silver chandelier, which is hung before the altar and, crowned with lights, vies in proud splendour with the altar front. He added a holy cross, glowing with a marvellous pattern of gems and red gold.

> [41] A large and formal book hand.
> [42] The stole and maniple were liturgical vestments consisting of narrow strips of silk worn around the neck and the left arm.
> [43] A liturgical vestment of semicircular form, closed in front.
> [44] A mappula or handkerchief.
> [45] *Chronica monasterii Casinensis auctore Leone*, II, 43, ed. W. Wattenbach, *Monumenta Germaniae Historica, Scriptores in Folio*, VII (Hannover: Hahnsche Buchhandlung, 1846), 656–57.
> [46] Adalbero, Bishop of Basel (999–1021).

And a chasuble of samite inwoven with golden eagles in which the union of art and opulence is demonstrated. He furthermore added to the beauty of the above-mentioned decorations by adorning the church with a golden censer, banners and many other sumptuous things.[47]

Raoul Glaber: Henry II's Golden Sphere

The golden sphere with which Pope Benedict VIII[48] invested Henry II during the latter's coronation in 1014 may have been the first orb ever to be made or used. It is described by Raoul Glaber, a monk in Cluny between 1131 and 1149. He certainly had firsthand knowledge of the Emperor's orb, and about the circumstances in which it was presented to Cluny, since Odilo, abbot of Cluny from 994 to 1048, to whom Glaber was close and to whom he dedicated his history, was present at Henry's coronation.

Although the imperial symbol had been fashioned in various ways, the venerable Pope Benedict, in the year of the Lord's incarnation 1014, ordered it to be made in the form of a symbolic image. He had a golden apple made which was bounded with quadrants of precious gems and a golden cross was mounted on top of it. It was shaped to resemble our earth, which indeed partakes of a certain roundness, so that whenever the ruler of the earthly empire should look at it it would be a reminder to him that he must not rule or fight in a way unworthy of his protection by the life-giving cross. And its decoration with various gems indicated that the imperial authority should be adorned with the beauty of many virtues. And when that pope, accompanied, according to tradition, by a vast multitude from the holy orders, went to meet the Emperor Henry, then he bestowed on him that imperial insignia in the presence of the whole Roman people. The latter, receiving it joyfully, and inspecting it, since he was a very sagacious man said to the Pope, "Worthy Father, you ordered this to be made and you have thereby tactfully taught how our empire ought to be governed, showing it by this emblem of our monarchy." Then holding the golden apple in his hand he added, "No one is worthier to possess and behold this gift than those who have trodden under foot the vanities of this world and follow wholeheartedly the cross of our Saviour." And he immediately sent it to the monastery of Cluny in Gaul which at that time was considered to be the most devout of all. To the same monastery he also gave many other gifts.[49]

[47] *Breviarium Basilense, In festo Henrici imperatoris,* ed. Trouillat, *Monuments de l'histoire de l'ancien évêché de Bâle,* I (Porrentruy: V. Michel, 1852), 142–43, nr. 87.

[48] Pope Benedict VIII (1012–24).

[49] Raoul Glaber, *Les cinq livres de ses histoires,* I, 5, ed. Maurice Prou, *Collection des textes pour servir à l'étude et à l'enseignement de l'histoire,* I (Paris: A. Picard, 1886), 21–22.

Adémar de Chabannes: Other Gifts to Cluny

Henry II visited Cluny in 1015, immediately after his coronation. It was probably on this occasion that he gave other parts of his regalia as well as a golden crucifix to Cluny. They were exhibited in Cluny on feast-days and carried in procession. The emperor's gifts are mentioned in the chronicle of Adémar de Chabannes, which was written before 1034.

He made these gifts to the monastery of Cluny: a golden scepter, a golden orb, a golden imperial garment, a golden crown, a golden crucifix, which together weighed a hundred pounds, along with many more gifts.[50]

The Ruodlieb: A Princely Gift

The Ruodlieb, *a versified novel about a poor knight who sets forth to win fame and riches, was probably written in southern Germany about the middle of the eleventh century. In one of its episodes a great king, in whose service Ruodlieb has distinguished himself, prepares the treasure he intends to give to Ruodlieb as a farewell present. Some of the pieces of jewelry described in this passage, like the eagle-brooch or the crescent, are similar to the so-called "Gisela-Jewels," an eleventh-century treasure which was found in Mainz in 1880. The descriptions of the* Ruodlieb *are very detailed; the mentioning of a Byzantine coin similar to a well-known type seems to indicate that the poet describes objects he had seen.*

Meanwhile the king ordered that silver vessels be made in the shape of large dishes, a cubit in circumference—not more than four, two of them flat and an equal number of them deep. When they were fitted together, they would look as if they were loaves of bread, provided they had been sprinkled on the outside with flour made of spelt. Of these vessels the king filled one with coins, which goldsmiths call bezants, so close together that he could not force in one more with a hammer. He did this so that they would not happen to move and make a noise. When Ruodlieb returned home, he would better his situation with these coins and make his lords kindly disposed toward him by his generosity so that they would give him the promised presents with a gracious mind. The other dish was divided into two sections and was filled up in this way: in one part of the dish the king placed coins made of gold and thoroughly tested in fire, to which people gave their name from the city of Byzantium. On one side of the coins was engraved the image of Christ with a Greek inscription around the edge, and on the other side appeared the power of the king. Christ

[50] Adémar de Chabannes, *Chronique,* III, 37, ed. Jules Chavannon, *Collections des textes pour servir à l'étude et à l'enseignement de l'histoire,* XX (Paris: A. Picard, 1897), 20.

was standing and placing His hand on the king whom He designated as blessed.[51] Ruodlieb was to give the coins to beloved relatives and friends, as was the custom, for the purpose of rejoicing that he was safe and had not been reduced to poverty in harsh exile but had been successful and had returned home with honor. The king placed twelve decorated bracelets on the other side of the section of the dish so stuffed with coins. Eight of them were solid, neither hollow nor filled with lead. They were provided with heads in the shape of serpents, which kissed each other but did not harm themselves in their love. Each of them bore the heavy weight of pure gold. The remaining four were bent in a circle, and each one was round like a hepatic vein and weighed a mark. The king desired that they be useful as well as beautiful. Moreover, there was added to these gifts a large brooch suitable for a queen, which had been cast in clay and had neither been made with hammers nor constructed with any craftsman's tool. It was completely solid and not at all trimmed. In the middle of the brooch was the image of a flying eagle, and in the tip of its beak was a crystal ball, in which three little birds seemed to move as if they were alive and ready to fly about. A golden ring surrounded this eagle in a circle. The brooch was so wide that it covered the breast of the wearer completely. It was wide for good reason since it had been cast from a talent of gold. The king added other brooches lighter in weight, and on each of them the splendor of many kinds of jewels was varied, as if you beheld a group of stars there. Each of these brooches weighed a fourth of a full pound and hung on a chain, which was not large but fine. He added to these a small clasp, which one could put in front and with which one could fasten his shirt every day so that it would not stand open, lest the chest be seen if it were somewhat large. Moreover, the king added a solid lune of gold, weighing one pound, on which a craftsman had brought forth his skill. On the outside and inside curves were set precious stones of all colors, which had been obtained in the month of May from sea shells which had been mixed with golden dew and then shut according to custom. There were fine globules of various types on the surface. Glass is attracted by glass, but is repelled by gold, forming knots, leaves, and little birds. At first they become rough in the flames and, full of humps, are then polished on a rough stone with saliva or water. This honorable substance is called enamel. But behind the jewels on the gleaming rim of the lune, little ornaments gave a pleasant noise by colliding with each other. The king ordered that this lune be added to the dish carefully. He then placed eight earrings into the dish. Four of them sparkled and were adorned with various precious stones, amethysts, and beryls. The four others, however, were not encircled with jewels but were lovely windings

[51] The Byzantine coins mentioned here showed Christ placing a crown on the Emperor's head.

varied with wonderful knots as if with a paintbrush one should paint glass with gold. The little ornaments and pearls jingled when the ear moved. Finally the king ordered that thirty rings be made of the best pure gold. On each of these rings he ordered that a ligure, a jacinth, and a beautiful beryl be enclosed and set. Three of them were to be given to the bride whom Ruodlieb would marry. They were not large but were fine as was becoming for women to wear. After the dishes were filled with these royal gifts and were firmly joined together with nails that had heads, the king ordered that they be covered over with a very strong glue. Flour milled with much grinding had been mixed with the glue so that it could not be scratched away nor destroyed by water.[52]

Thangmar: St. Bernward as a Patron

The Saxon emperors and kings governed to a considerable extent through the already existing machinery of episcopal administration. In so doing, they gave a first impulse to the rise of cathedral cities in Germany. They also attracted men of worldly interests to the German episcopate, whose members not only ministered as priests but also led armies, built churches and fortifications, domineered over monasteries, founded schools and guided in various ways the life of their still small but growing cities. Bernward, bishop of Hildesheim from 992 to 1022, though not among the most powerful of this group, was probably unrivalled as a patron. He had spent many years at court, first as a scribe in the imperial chancery and then as a tutor to Otto III, whom he also visited in Rome.[53] It is here that he must have seen the columns of Trajan[54] and Marcus Aurelius,[55] which served him as a model for the bronze column which was originally made for St. Michael's[56] and stands today in the Cathedral of Hildesheim. The famous bronze doors, also originally made for St. Michael's, may reflect a Roman prototype as well. Bernward's biography was written by Thangmar, who was his teacher and who stayed in Hildesheim throughout Bernward's reign. An eyewitness of the Bishop's daily life, Thangmar seems to imply that Bernward took a very active part in the production of art and architecture to adorn his episcopal see.

[52] *The Ruodlieb: The First Mediaeval Epic of Chivalry from Eleventh Century Germany*, translated from the Latin, with an introduction by Gordon B. Ford, Jr. (Leiden: E. J. Brill, 1965), fragment 5-308-391, pp. 42-45. This translation is based on the text established by G. B. Ford, Jr., *The Ruodlieb*, Linguistic Introduction, Latin Text, and Glossary, pp. 52-54. Reprinted by permission of Gordon B. Ford, Jr.

[53] Otto III established his court in Rome in 998.

[54] Trajan, Roman Emperor (98–117). The column celebrating his victory over the Dacians was put up in 113.

[55] Marcus Aurelius, Roman Emperor (161–80). His column was set up after his death.

[56] The church of the Benedictine monastery which Bernward founded outside the city.

And although he embraced ardently all liberal sciences with the fire of his vivacious genius, he also found time for the study of those less serious arts which are called mechanical. His handwriting was excellent, his painting accomplished. He excelled also in the art of casting metal and of setting precious stones, and in architecture, as afterward became evident in the many structures he built and adorned sumptuously. . . .

He studied the art of writing not so much in the monastery as in those different places from which he was able to bring together a large library of theological and philosophical codices. Painting and sculpture and casting and goldsmith work and whatever fine craft he was able to think of, he never suffered to be neglected. His interest went so far that he did not let pass by unnoticed whatever rare and beautiful piece he could find among those vessels from overseas and from Scotland, which were being brought as gifts to the royal majesty. He also attracted gifted boys to him and to the court and spent much time with them urging them to acquire by practice whatever was most needful in any art. He also taught himself the art of laying mosaic floors and how to make bricks and tiles. . . . And the old places, which had belonged to his predecessors and which he found destitute, he brightened with excellent buildings. Some of these he adorned by alternating white and red stones according to a beautiful pattern and by various mosaics. How shall I describe with what zeal he strove to ennoble our city as well as the main church, choosing to spend himself as well as his possessions for this purpose? His works are witnesses which will speak clearly to future ages about the pious devotion of his soul. He ardently desired to decorate the cathedral, and adorned with exquisite and radiant paintings the walls and the ceiling, so that one thought they were new instead of old. He also made a gospel book for the solemn processions on the high feasts, which was covered with gold and precious stones, censers of magnificent weight and value, and several chalices, one of onyx, and another fashioned by him with great diligence from a crystal. Finally there was one of gold, weighing 20 pounds, which he made for use during mass. He also hung a crown, radiant with silver and gold, in the entrance of the church and did many other things which we will pass by in order not to be boringly prolix. He also began immediately without delay to fortify our holy city with walls and towers in between and he planned the work with such prudence that in firmness and beauty there is nothing comparable to be found in Saxony to the present day. He also built a very splendid chapel outside the walls, dedicated to the Holy Cross, and placed there a part of that Cross, given him by the generosity of the Emperor Otto III, and enclosed it beautifully with gems and pure gold.[57]

[57] Thangmar, *Vita Bernwardi episcopi*, Chaps. I, VI, VIII, H. G. Pertz, ed., *Monumenta Germaniae Historica, Scriptores in Folio*, IV (Hannover: Hahnsche Buchhandlung, 1841), 758.

BURGUNDY

Raoul Glaber: Church-Building Around the Year 1000

Raoul Glaber lived during the last part of the tenth century and the first part of the eleventh. He was a monk of somewhat irregular habits who for some time went from monastery to monastery until he finally settled in St. Bénigne in Dijon. He spent the last ten years of his life in Cluny. In Dijon and Cluny he came close to the two great figures of eleventh-century monasticism in Burgundy, William of Volpiano, abbot of St. Bénigne, and Odilo of Cluny. Raoul Glaber was therefore well informed about building activities in Burgundy and also in Italy, to which William of Volpiano had many ties, and where Raoul accompanied him in 1028.

So on the threshold of the aforesaid thousandth year, some two or three years after it, it befell almost throughout the world, but especially in Italy and Gaul, that the fabrics of churches were rebuilt, although many of these were still seemly and needed no such care; but every nation of Christendom rivalled with the other, which should worship in the seemliest buildings. So it was as though the very world had shaken herself and cast off her old age, and were clothing herself everywhere in a white garment of churches. Then indeed the faithful rebuilt and bettered almost all the cathedral churches, and other monasteries dedicated to divers saints, and smaller parish churches. ... When therefore, as we have said, the whole world had been clad in new church buildings, then in the days following—that is, in the eighth year following the aforesaid thousandth after the Incarnation of our Saviour—the relics of very many saints, which had long lain hid, were revealed by divers proofs and testimonies; for these, as if to decorate this revival, revealed themselves by God's will to the eyes of the faithful, to whose minds also they brought much consolation. This revelation is known to have begun first in the city of Sens in Gaul, at the church of the blessed Stephen, ruled in those days by the archbishop Leoteric,[58] who there discovered certain marvellous relics of ancient holy things; for, among very many other things which lay hidden, he is said to have found a part of Moses' rod,[59] at the report whereof all the faithful flocked together not only from the provinces of Gaul but even from well-nigh all Italy and from countries beyond the sea; and at the same time not a few sick folk returned thence whole and sound, by

[58] Leoteric, Bishop of Sens (999–1032).
[59] For the story of Moses' rod see Exod. 4: 1–4.

the intervention of the saints. But, as most frequently befalleth, from that source whence profit springeth to men, there they are wont to rush to their ruin by the vicious impulse of covetousness; for the aforesaid city having, as we have related, waxed most wealthy by reason of the people who resorted thither through the grace of piety, its inhabitants conceived an excessive insolence in return for so great benefits. . . . At that time, moreover, that is in the ninth year after the aforesaid thousandth anniversary, the church at Jerusalem which contained the sepulchre of our Lord and Saviour was utterly overthrown at the command of the prince of Babylon.[60]

William of Volpiano's St. Bénigne

St. Bénigne of Dijon was a church of extraordinary form: a basilica with a very large crypt, five aisles and galleries joined to a multi-storied rotunda also surrounded by galleries, and with a vault containing a central skylight. Its builder was William of Volpiano, an Italian who had become a monk at Cluny in 985 and who was sent from there with twelve other monks to reform the ancient abbey of St. Bénigne at Dijon, a monastery of Merovingian foundation which had fallen into decline. The building of the new church is said to have taken fifteen years. The basilica was dedicated in 1016, the rotunda in 1018. During this period an event took place that must have made a great impression throughout the Christian world as well as at St. Bénigne. The chronicler, Raoul Glaber, an intimate of William of Volpiano, listed among the extraordinary events which marked the beginning of the Millenium the destruction of the church of the Holy Sepulchre in 1009.[61] It, too, consisted of a basilica and a rotunda, and may have been chosen, either at the beginning or at some point during the construction of St. Bénigne, to serve as its model.

The description of William's church comes from an anonymous chronicle of St. Bénigne, written in the eleventh century.

This temple was founded in the year of our Lord's incarnation 1001, in the 14th indiction on the 16th Kal. of March.[62] Its length is nearly 200 cubits,[63] its width is 53, its height will be given in an appropriate place below. The lower church, where the most holy body of St. Benignus[64] the

[60] The Church of the Holy Sepulchre was destroyed in 1009 by Caliph Hakim. It is probably to him that Raoul Glaber refers by the term "Prince of Babylon." The selection has been taken from Raoul Glaber, *Les cinque livres de ses histoires,* III, 4, trans. G. G. Coulton, *A Mediaeval Garner* (London: Constable and Co., 1910), pp. 6–8. Reprinted by permission of Constable and Company, Ltd., London.

[61] See above, footnote 60.

[62] February 14, 1001.

[63] A cubit equals eighteen inches.

[64] St. Bénigne, a second-century martyr, whose grave was found during the sixth century.

martyr is venerated, has about the same dimensions and is supported by 104 columns. It is built in the form of the letter T. Four rows of columns, arranged in groups of twelve, extend equally in length and width. The church is ten cubits high and has separate vestibules on each side. The lower church contains five altars. The first is dedicated to the honor of St. Benignus, the second in memory of St. Nicholas and all confessors, the third in veneration of St. Pascasia[65] the virgin, who is buried there, and of all virgins, the fourth in veneration of St. Ireneus and all martyrs, the fifth in honour of the holy confessors and abbots John and Sequanus and of St. Eustadius[66] the presbyter, who is buried there.

To this crypt, described just above, an oratory is joined on the east, round in shape, illuminated by the light of six windows. It is 37 cubits in diameter and 10 in height. This oratory is encircled by three rings of columns, forty-eight in number, geometrically ordered. Above rises an elegant vault over 24 columns and 32 arches, being equally apportioned among the three parts of the structure. This oratory is dedicated to St. John the Baptist, whose altar receives the light of three windows. On both sides of this church there are spiral staircases, thirty-seven steps high and adequately illuminated by a number of windows. Through them one ascends easily to the church of St. Mary, Mother of God. The latter church is supported by sixty-eight columns, and has nearly the same shape, diameter and height as the church underneath. It is illuminated by eleven glass windows. Four steps lead to the marble altar of the same Mary ever Virgin. On both sides of it are altars, of which the one on the right is dedicated to St. John the evangelist, his brother James, and St. Thomas, and the one on the left to the apostles Matthew, James and Philip.

From here again an ascent can be made through twin winding staircases, each well lit and containing 30 steps, to the church of the Holy and Indivisible Trinity. The latter, built in the shape of a crown, is also supported by thirty-six columns and is bright with light from ten windows on all sides and from an opening in the vault above. In size it is like the church below, but its height is twenty cubits. The altar of the Holy Trinity is placed where it can be seen from wherever one enters the church and from wherever one stands inside it.

From there it is possible to ascend to the highest story of the church by four staircases which face each other. Of these, two corresponding stairs lead by fifteen steps to the oratory of St. Michael. It is 33 cubits long and 10 wide and simple in shape. It has seven windows.

The other two staircases each have fifty steps leading upwards. At the ends of these staircases two ambulatories have been built above the wall. They extend for an equal distance from east to west inside as well as

[65] St. Pascasia, virgin and martyr, converted by St. Bénigne.
[66] St. Eustadius, the first abbot of St. Bénigne, 6th century.

outside the church. Here they appear as an arched passageway, there they run atop the building. A wall about 3 cubits high protects those who walk around them from falling. These ambulatories start on both sides of the church and lead under the wings through certain hidden passages to the height of the roof and then proceed on the same level, as has been said, all around and inside, until they arrive over the threshold of the western portal where they lead down by corresponding staircases of twenty steps to the entrance of the main church.

The latter is shaped like a cross. It is 128 cubits long, and as we have already said, 53 cubits wide. Its height is at least 31 cubits throughout except in the center, where it is 40. It is lit by seventy windows. It is supported by a hundred and twenty-one columns. Those over the heavy piers, of which there are forty, are arranged rectangularly. And although all seem to be crowned in the same fashion, they are not all of the same size. The church has double aisles on both sides, each with a vault. In them are four altars. On the northern side there is one altar dedicated to the Apostles St. Peter and St. Andrew. Another one is dedicated to the Apostles St. Bartholomew and Simon and Thaddeus. The altar of St. Paul is in the upper church, close to the altar of the Holy Trinity, because he was caught up to the third sky and saw the secret things of God. On the south side there is one altar dedicated to the Apostles St. Matthew and Barnabas and Luke the Evangelist, and another one dedicated to the Sts. Stephen, Lawrence and Vincent. There is another altar on the southern side of the church toward its western end which is dedicated to the Sts. Mammetis, Desiderius, Leodegarius, Sebastian and Gangolf. The altar on the other side is dedicated to the martyrs St. Polycarp, St. Andochius, St. Thirsus, St. Andeolus, St. Symphorianus, St. George, St. Christopher and the holy confessors Urban[67] and Gregory,[68] whose bodies adorn the present church. The main altar is dedicated to the martyrs Maurice and Bénigne and all saints. The right altar is dedicated to Raphael the archangel and all blessed spirits. The left is dedicated to St. Mark the evangelist and the middle altar to the Holy Cross and all saints. Before the triple altar is the entrance to the crypt and one ascends from it by fifteen steps to the upper church.

The sepulchre of the holy and glorious martyr St. Bénigne is constructed in the following way. It is a tomb, 8 cubits long and 5 wide built of rectangular stones. Its top is carried by four columns. Above it there stood in ancient times four marble columns. They formerly supported on the stone arches between them a wooden vault, 6 cubits long, 3 cubits wide, and $7\frac{1}{2}$ cubits high. This was completely covered with gold and silver and depicted in relief the stories of the Lord's nativity and passion.

[67] St. Urban, bishop of Langres (*c.* 375).
[68] St. Grégoire, bishop of Langres (509–39), founder of St. Bénigne.

It was of very fine workmanship. These very beautiful decorations of which we have just spoken were dispersed by the Lord Abbot William[69] for the relief of the poor in the time of famine. . . .

It should finally be noted in conclusion that the basilica has 371 columns, not counting those that are in the towers and the altars, 120 windows either closed or able to be closed by glass, 8 towers, 3 portals and 24 doorways.[70]

Cluny under Odilo

The great monastery of Cluny was founded on a modest scale in 910. By the middle of the twelfth century as many as 314 monasteries were dependent on Cluny, a monastic empire exceeding that of any previous medieval house. Cluny's rise to eminence coincided with the rule of its fifth abbot Odilo (994–1048). It was Odilo who rebuilt the cloisters of Cluny, replacing the old wooden structures by buildings of stone. He is said to have compared himself in jest to Augustus who "had found a wooden Rome and left a marble one." Odilo's monastic buildings are known through a description that is contained in the oldest customs of Cluny. They were either drawn up or copied for the benefit of the imperial abbey of Farfa, north of Rome, whose abbot had approached Odilo in 999 for advice on how to reform his monastery. The description of the cloisters starts with the indicative but switches later to the subjunctive case. This may indicate that certain parts of Odilo's cloisters were only planned at the time when the description was written. The church mentioned is that of Abbot Majolus,[71] Odilo's predecessor.

A Description of the Monastery

The church is 140 feet long and 43 feet high and has 160 glass windows. The chapter house is 45 feet long and 34 feet wide. It has 4 windows to the east, 3 to the north, 12 galleries to the west, each with 2 columns. The auditory is 30 feet long. The commissary is 90 feet long. The dormitory is 160 feet long and 34 feet wide. There are 97 glass windows, all the height of a man standing on tiptoe and $2\frac{1}{2}$ feet wide. The walls are 23 feet high. The latrine is 70 feet long and 23 feet wide. 45 seats have been arranged in this place and above each seat is a little window in the wall, 2 feet high and $\frac{1}{2}$ foot wide. And above the seats is a timber construction and above this construction of wood are 17 windows, 3 feet

[69] William of Volpiano, abbot of St. Bénigne (990–1031), who built the new church.

[70] *Chronicon St. Benigni Divisionensis*, ed. Abbé L. Chompton, *L'histoire de l'église de Saint Bénigne de Dijon* (Dijon: de Jobard, 1900).

[71] Majolus, abbot of Cluny (948 or 964–94).

high and 1½ feet wide. The heated room is 25 feet wide and 25 feet long. It is 75 feet from the door of the latter to the entrance of the church. The refectory is 90 feet long, 25 feet wide, with walls 23 feet high, with 8 glass windows on each side, which are 5 feet high and 3 feet wide. The kitchen for the monks is 30 feet long and 25 feet wide and so is the kitchen for the laymen. The buttery is 70 feet long and 60 feet wide. The almonry is 10 feet wide and 60 feet long, its length corresponding to the width of the buttery. The galilee[72] is 65 feet long and 2 towers stand before it and beneath them is the atrium where the laymen stand so that they do not get in the way of processions. The distance from the south door to the north door is 280 feet. The sacristy together with the tower in front of it is 58 feet long. The oratory of the Virgin is 45 feet long and 20 feet wide with walls 23 feet high. The first room of the infirmary is 27 feet wide and 23 feet long with 8 beds, and as many latrines are outside in the portico along the wall of the same building, and the cloister of the same building is 12 feet wide. The second room and the third and the fourth are arranged in the same way. The fifth, where the sick come to have their feet washed on the Sabbath and where dead brethren are enshrouded, may be smaller. The sixth cell should be arranged as the place where the servants wash the platters and other utensils. Next to the galilee a palace should be constructed 135 feet long and 30 feet wide for the reception of all those guests who come to the monastery on horseback. On one side of this house 40 beds with as many covered pillows should be prepared where as many men may rest, with 40 latrines. And on the other side 30 little beds should be made where ladies and other respectable women may rest, with 30 latrines where they may satisfy their needs undisturbed. In the middle of the palace should be placed tables like those in the refectory, where both men and women may eat. For great feasts this house should be adorned with draperies and coverings and cloths spread over the benches. In front of it there should be another house, 45 feet long and 30 feet wide, for its length should extend to the sacristy and in it should sit all the tailors and cobblers to sew and stitch what the chamberlain orders them to make. And a table should be prepared for them there that is 30 feet long and another table should be placed by it so that the width of both is 7 feet. Between that structure and the sacristy, the church, and also the galilee there should be a cemetery where laymen may be buried. From the southern gate to the northern gate on the west side a house should be constructed, 280 feet long and 25 feet wide, and stables should be made there for horses, divided into stalls. Above the stables there should be an upper story where the servants eat and sleep, and a table 80 feet long and 4 feet wide should be provided for them. And those guests who cannot be fed in the guesthouse mentioned above should eat here.

[72] A western ante-room of the church proper.

And at the entrance of this house there should be a suitable place where those men may go who arrive on foot, and they should receive free food and drink from the almoner according to their needs. At a distance of 60 feet from the refectory, at the entrance of the latrine, 12 cellars should be made and as many bathtubs, where at set times baths may be prepared for the brethren. And behind that place the house for the novices should be constructed. It should be divided into 4 rooms, the first for meditation, the second for meals, the third for sleep, and a fourth, on one side, as a latrine. Close by should be another building where goldsmiths and jewellers and glaziers may come to practice their arts. Between the bath rooms and the dwellings of the novices and the goldsmiths there should be a building 125 feet long and 25 feet wide and its length should extend all the way to the bakery. The latter together with the tower at its entrance, is 70 feet long and 20 feet wide.[73]

The ancient customs of Cluny which contain a description of the monastery also give detailed accounts of the services and processions held there. Monastic reforms during the early middle ages tended to increase the number of services, which at Cluny sometimes extended throughout the twenty-four hours of the day. The wealth of Cluny allowed its monks to withdraw almost entirely from manual labor and to dedicate themselves to prayers, processions, and worship, a form of existence enhanced by rich and complicated ecclesiastical architecture, sumptuous vestments, and precious objects for liturgical use. Of the latter those carried in procession included the golden reliquary of St. Peter and the regalia that Henry II had given to Cluny in 1015.[74]

The Procession on Palm Sunday

How the fathers should celebrate Palm Sunday.[75] On the Saturday before Palm Sunday three coverings should be placed before vespers[76] over the three altars behind the principal altar. The reliquaries of the saints should be fitted onto wooden frames so that they can be properly carried. The banners and the palm branches with flowers should be prepared so that there will be no delay in the morning. And bench covers for the choir should also be prepared. After the mass of the day has been said, the main altar should be adorned with a cover that is interwoven with gold. Every bell should ring for Vespers. . . .

After coming back into the church they should celebrate Terce,[77]

73 *Consuetudines Farfenses,* ed. Bruno Albers, *Consuetudines monasticae,* I, (Stuttgart-Wien: 1900), 137–39.
74 See above, pp. 119–20.
75 The Sunday before Easter, celebrating Christ's entry into Jerusalem.
76 The evening office of the monks.
77 A morning office, to be said during the third hour of the day.

after which the priest should go before the altar and standing at its northern corner he should bless the branches of the palms and the other trees. He should not say "The Lord be with you" and "Let us pray" at that point. But as soon as the prayer over the palms and flowers begins, and after they have been blessed, he should sprinkle blessed water on them and accepting the golden thurible he should cense the main altar first and then the palm branches. The sextons of the church should take the palms and give them one after the other to the Lord Abbot and to all the brethren standing in the choir. And while they begin to hand them out the librarian should intone the antiphon of the three youths.[78] And the librarian should take the tunics and make those younger brothers whom he has selected to carry the gospel books put them on. Then the lay brothers should take four crosses, two gold thuribles, the holy water, four candlesticks, and one of the priests should take the arm of St. Maurus[79] and three or eight priests should carry the other ornaments. Of sixteen other lay brothers two or four should carry the likeness of St. Peter with its relics and another two or four the body of St. Marcellus,[80] the pope, and two or four others the casket of St. Gregory[81] and two or four others the relics of many other holy fathers. They should go in the following order:

First about 30 servants with banners, walking two by two,
banners, banners,
the relics of many holy fathers, carried by four or two brothers,
the relics of Pope Gregory, carried by four or two brothers,
the relics of the holy Pope Marcellus, carried by four or two brothers,
St. Peter's likeness should be carried by four brothers,

a cross,		holy water,
a cross,	a crucifix	a cross,
a thurible,	the small shrine,	a thurible,
a candlestick,	a gospel book,	a candlestick
a scepter,		a scepter
the apple,[82]		the arm[83]
	a priest	

The icon[84] may be omitted on that day and it is also permitted to omit the apple and the scepters on this day on account of the weather.

After these the children follow two by two with their teachers, and afterwards other adults, namely the Priors proceeding two by two during the antiphon, having gathered together with them those who are able and

[78] "Blessed art thou O Lord." Dan. 3: 52–90.
[79] The reliquary with the arm of St. Maurus, a sixth-century disciple of St. Benedict.
[80] A reliquary with remains of Pope Marcellus (*c.* 308).
[81] Probably a reliquary with remains of Pope Gregory II (715–31).
[82] Probably the globe and scepter given by Henry II. See above, p. 130.
[83] Probably the reliquary with the arm of St. Maurus mentioned above.
[84] Probably the "likeness of St. Peter" mentioned above.

trained to sing. Last comes the Lord Abbot followed by all ranks of lay-
men. While they leave the church all the bells should be rung; the two
largest bells should continue to ring until the procession returns to the
Galilee.[85]

[85] The western part of the church. The selection has been transl. from
Consuetudines Farfenses, II, 1, ed. Bruno Albers, *Consuetudines Monasticae,* I,
(Stuttgart-Wien: 1900), 43–44.

6

High Romanesque

NEW CHURCHES AND THEIR CHRONICLERS

Leo of Ostia: Desiderius' Church
at Monte Cassino

By the end of the eleventh century, medieval writers begin to show an interest in detail when they described churches or other works of art. There was a new keenness of observation, a better knowledge of detail, and a greater clarity of expression. Most of the writings in which such descriptions occur are monastic chronicles. They are works of a scope limited enough to enable their authors, who knew intimately the houses they wrote about and had access to charts, necrologies, and traditions, to escape superficiality.

One of the earliest chronicles of this type is Leo of Ostia's Chronicle of Monte Cassino, *which was written before 1099. Its third book deals with the rebuilding of the abbey under Abbot Desiderius (1058–87), of which Leo, who entered the abbey in 1060, was an eyewitness. Desiderius sought to combine Roman and Byzantine elements in his building. The church was a basilica; like St. Peter's and other Roman churches it was preceded by an atrium; two of its inscriptions were derived from inscriptions on the triumphal arch of St. Peter's and the apse of the Lateran basilica. For the interior decoration of the church, however, for its mosaics, its altar, and its doors, Desiderius turned to Byzantium, thereby making Monte Cassino one of the main western fountainheads for the diffusion of the Byzantine influence which swept Europe during the last quarter of the eleventh century and the first half of the twelfth.*

In[1] all happiness and peacefulness, through the merits of the Holy Father Benedict,[2] God installed the venerable abbot Desiderius. He was held in such great honor by everyone around that not only all the people of modest origin, but even their princes and dukes eagerly rendered him the same obedience and ready response to his wishes that they rendered their sires or lords. Thus, not without divine inspiration, Desiderius planned the demolition of the old church and the construction of a new, more beautiful and august one. To most of our leading brethren this project seemed at that time entirely too difficult to attempt. They tried to

[1] The following passage has been taken from Leo of Ostia, *The Chronicle of Monte Cassino*, III, 18, 26–32, trans. Herbert Bloch in E. G. Holt, *Literary Sources of Art History* (Princeton: Princeton University Press, 1947), pp. 4–10. Reprinted by permission of Princeton University Press.

[2] St. Benedict of Nursia, the founder and first abbot of Monte Cassino (529–47), where he was also buried.

135

dissuade him from this intention by prayers, by reasons, and by every other possible way, believing that his entire life would be insufficient to bring such a great work to an end. But trusting in God, he was confident of God's help in everything done for God. Therefore in the ninth year of his office, in March of A.D. 1066, after having built near the hospital the not sufficiently large church of St. Peter, in which the brethren of course should assemble for divine service in the interim, he proceeded to demolish to its foundations St. Benedict's church which, because of its smallness and ugliness, was entirely out of keeping with so great a treasure and so important a congregation.

And since the old church had been built on the very top of the mountain, and had been exposed in every direction to the violent buffeting of the winds, and as it had often been hit by lightning, Desiderius decided to destroy the ridge of stone with fire and steel, to level a space sufficient for the foundations of the basilica, and to make a deep excavation where the foundations should be laid. After having given orders to those who were to execute this work with the greatest dispatch, he went to Rome. After consulting each of his best friends and generously and wisely distributing a large sum of money, he bought huge quantities of [ancient] columns, bases, epistyles, and marble of different colors. All these he brought from Rome to the port, from the Portus Romanus thence by sea to the tower at the Garigliano River, and from there with great confidence on boats to Suium. But from Suium to this place he had them transported with great effort on wagons. In order that one may admire even more the fervor and loyalty of the faithful citizens, a great number of them carried up the first column on their arms and necks from the foot of the mountain. The labor was even greater [than it would be now] for the ascent then was very steep, narrow, and difficult. Desiderius had not yet thought of making the path smoother and wider, as he did later.

Then he levelled with great difficulty the space for the entire basilica, except for the sanctuary, procured all the necessary materials, hired highly experienced workmen, and laid the foundations in the name of Jesus Christ, and started the construction of the basilica. . . .

It was one hundred and five cubits long, forty-three cubits wide, and twenty-eight cubits high.[3] On each side he erected on bases ten columns nine cubits high. In the upper part he opened rather large windows: twenty-one in the nave, six long ones and four round ones in the choir, and two in the central apse. He erected the walls of the two aisles to a height of fifteen cubits and provided each aisle with ten windows. He then started to reduce the level of the sanctuary to that of the basilica—a difference of about six cubits—but at a depth of not even three ulnae,[4]

[3] Since the measures of the basilica were 157 by 64 by 42 feet, a cubit was equivalent to about eighteen inches.

[4] *Ulna* here must mean the distance from wrist to elbow.

he suddenly found the venerable tomb of St. Benedict. He expressed the opinion to his brethren and to other men of good judgment that he should not venture to change the tomb in the least, and in order that no one could snatch away anything from so great a treasure, he re-covered the tomb where it was with precious stones and above it, running north and south at right angles to the axis of the basilica, he built a sepulcher of Parian marble five cubits long—a wonderful work. By this device, the sanctuary remained in great eminence, so much so that one has to descend from its pavement to that of the basilica by eight steps under the large arch which is, of course, above the sanctuary. In the main apse, toward the east, he erected an altar to St. John the Baptist, in the same place where St. Benedict had built an oratory in honor of this saint. In the south apse he erected an altar to the Mother of God and in the north apse an altar to St. Gregory. Beside this [north] apse, he built a house with two rooms for housing the treasure of the church service. This house is usually called the sacristy; and he connected this house with a similar one in which the ministrants of the altar should prepare themselves. As he had taken away not a small part of his house to create space for the basilica, he made the same house which connected with the sacristy wider and more beautiful than the former one. On the side of it, near the aisle of the main church, he built a short [narrow] but very beautiful chapel with a curved wall to St. Nicholas. Between this chapel and the very front of the basilica he constructed in the same type of work, a venerable oratory to St. Bartholomew. At the front, near the portal of the main church, he erected an admirable campanile of large square stones.

Before the church he also built the atrium, which we call in the Roman fashion, "paradise." It was seventy-seven and a half cubits long, fifty-seven and a half cubits wide, and fifteen and a half cubits high, with four columns on square bases at each end and eight columns at each side. On its south side he installed below the pavement of the atrium a large vaulted cistern of the same length. Before the entrance to the basilica, he constructed five arches, which we call "cross-vaults," and five before the entrance to the atrium as well. At each of the two corners of the west wing of the atrium he built a beautiful chapel in the form of a tower: the right in honor of the Archangel Michael, and the left one in honor of the prince of apostles, St. Peter. Their interior is accessible by five steps from the atrium. Since the ascent to the church was very difficult and steep, he made an excavation sixty-six cubits square and seven cubits deep in the mountain itself outside the vestibule of the atrium and the two tower chapels, and built there the twenty-four marble steps thirty-six cubits wide by which one ascends to the vestibule of the atrium.

Meanwhile he sent envoys to Constantinople to hire artists who were experts in the art of laying mosaics and pavements. The [mosaicists] were to decorate the apse, the arch, and the vestibule of the main basilica; the others, to lay the pavement of the whole church with various kinds of

stones. The degree of perfection which was attained in these arts by the masters whom Desiderius had hired can be seen in their works. One would believe that the figures in the mosaics were alive and that in the marble of the pavement flowers of every color bloomed in wonderful variety. And since *magistra Latinitas* had left uncultivated the practice of these arts for more than five hundred years and, through the efforts of this man, with the inspiration and help of God, promised to regain it in our time, the abbot in his wisdom decided that a great number of young monks in the monastery should be thoroughly initiated in these arts in order that their knowledge might not again be lost in Italy. And the most eager artists selected from his monks he trained not only in these arts but in all the arts which employ silver, bronze, iron, glass, ivory, wood, alabaster, and stone. But about that in another place; now we shall describe how he decorated and finally consecrated the basilica.

He covered the whole basilica, the choir, and both aisles as well as the vestibule with roofs of lead. The apse and the major arch he faced with mosaic. He ordered the following verses to be written in large letters on the arch:

> In order that under Thy Leadership the just may be able to reach
> and take possession of the heavenly home,
> Father Desiderius founded here this hall for Thee.[5]

In the apse, under the feet of St. John the Baptist and St. John the Apostle, he ordered the following verses to be written:

> This house is like Mount Sinai which brought forth sacred laws.
> As the Law demonstrates what was once promulgated here.
> The Law went out from here which leads the minds from the depths
> and having become known everywhere, it gave light through the
> times of the age.[6]

He filled all the windows of the nave and the choir with plates made of lead and glass and connected with iron; those in the sidewalls of both aisles he made of mica, but of similar gracefulness. After having installed below the timber work the ceiling admirably decorated with various colors and designs, he had all the walls painted a beautiful variety of colors. He laid the pavements of the entire church including its annexes, the oratories of Sts. Nicholas and Bartholomew, and his own house with an admirable number of cut stones hitherto quite unknown in these parts—particularly the pavement near the altars and in the choir. The steps leading to the altar were incrusted with precious marbles. The front of the choir which he built in the center of the basilica, he fenced with four marble plates, one was red, one green, and the remaining plates

[5] These verses copy and modify the Constantinian inscription on the triumphal arch of St. Peter's in Rome.

[6] These verses paraphrase an inscription which decorated the apse of the Lateran basilica.

around the choir were white. He further decorated the arches above the entrance and the vestibule of the church with beautiful mosaics. He had the whole façade of the basilica plastered from the arches to the pavement. Also he had the outside of the arches covered with mosaic and the verses of the poet Marcus[7] inscribed there in golden letters. He ordered the remaining three wings of the atrium painted outside and inside with various scenes from the Old and New Testament, and all the wings paved with marble. Moreover, he covered them with ceilings and brick roofs. The vestibule of the atrium with its two towers was paved, painted and covered in the same way.

After all this had been completed, with God's help and through His grace, within five years, Desiderius resolved to dedicate the basilica with the greatest solemnity and with an immense festival for eternal memory. He petitioned and devoutly invited Pope Alexander II[8] to come to the dedication. When he found the Pope eager and willing, he also invited the latter's archdeacon, Hildebrand,[9] the other cardinals, and the Roman bishops. . . .[10] On the first day of October of A.D. 1071 . . . the basilica of St. Benedict with its five altars was dedicated by the most reverend and angelic Pope himself. The altar in honor of the Virgin in the southern part was dedicated by John, Bishop of Tusculum,[11] the altar in honor of St. Gregory in the northern part was dedicated by Hubald, the Bishop of Sabina,[12] and that in honor of St. Nicholas was dedicated by Erasmus, Bishop of Segni. . . .[13]

After the dedication of the church it may be fitting to report Desiderius' other contributions to its decoration. . . . He sent one of the brethren to the imperial city [Constantinople] with a letter to the emperor and thirty-six pounds of gold, and had made there a golden antependium decorated with beautiful gems and enamels. In these enamels he had represented some stories from the New Testament and almost all the miracles of St. Benedict.

The Emperor Romanos IV Diogenes[14] received our brother very honorably and treated him and all his companions honorably and reverently as long as they stayed, and he granted him all possible facilities for whatever he wished to have executed. He had made four barriers of bronze to be placed before the altar, between the choir and the sanctuary; also a beam of bronze with fifty candlesticks in which, on the principal holidays, as many candles were to be stuck; and thirty-six lamps which

7 Marcus, a pupil of St. Benedict.
8 Pope Alexander II (1061–73).
9 Hildebrand was chancellor of Alexander II and became his successor as Pope Gregory VII (1073–85). He died in Monte Cassino.
10 The passage is followed by a guest list and a description of the festivities.
11 John, cardinal-bishop of Tusculum (1071–1112).
12 Hubald, cardinal-bishop of Sabina (1066–68).
13 Erasmus, bishop of Segni (1059–71).
14 Romanos IV Diogenes, Roman Emperor in the East (1068–71).

hung down on bronze hooks from the beam. This beam of bronze was supported by arms and handles of bronze. It was connected with [or: put in] a wooden beam which was beautifully made and decorated with gold and purple at Desiderius' order. It was placed upon six columns of silver —each four and a half cubits high and weighing eight pounds—in front of the choir. He had six round icons hung under the beam. Above it he had set thirteen square ones of equal size and weight, ten of which the above-mentioned brother had made of solid silver and gilded in Constantinople. Each of them weighed twelve or fourteen pounds. The round icons had only a silver frame and were painted by [one with] Greek experience in colors and figures. Three other square icons were made of the same metal, size, and way at the order of Desiderius by his own artists. Another round icon covered on both sides with embossed and gilded silver, and surrounded by silver buds on the outside was sent to St. Benedict from Constantinople at that time by a noble. Later on Desiderius had a similar one made and both were suspended in the ciborium of the altar. Moreover, Desiderius had made and gilded another beam of silver weighing about sixty pounds. This was placed under the major arch before the altar on four silver, partially gilded, columns, each five cubits high and weighing ten pounds. He also had made two large silver crosses, each weighing thirty pounds, on which the images were of beautiful embossed work. These he put on marble bases between the columns and below the above-mentioned beam. The three other sides of the major altar he faced with chased and gilded silver . . . each weighing eighty-six pounds. The sides of the other three altars are decorated on three sides with old plates. For the ciborium of the altar he had made four beams with the outer sides likewise covered with embossed, gilded silver, while he had the inner sides decorated with plates and colors. Two of the beams are six cubits long and weigh twenty pounds. The other two beams are four and a half cubits long and weigh twelve pounds. He also had made six large candlesticks of chased silver plates, three cubits high and each weighing five or six pounds. On the principal holidays they were to be placed in a straight line before the altar and lighted with great torches. He also had made a wooden pulpit for reading and singing, far more excellent and eminent than the former one. It has six steps. Out of a beautiful pulpit he made a most beautiful one [decorated] with various purple colors and gold plates. In front of it he set up on a base of porphyry a partially gilded silver column, six cubits high. Upon it is placed the huge candle, the blessing of which is solemnly celebrated on Easter Sunday. He had made in the form of a huge crown of silver a chandelier, twenty cubits in circumference and weighing about one hundred pounds, with twelve projecting towers and thirty-six lamps hanging from it. From a heavy chain of seven gilded balls, he suspended the chandelier outside the choir in front of the cross.

While visiting Amalfi, Desiderius saw the bronze doors of the cathe-

dral of Amalfi and as he liked them very much, he soon sent the measures of the doors of the old church of Monte Cassino to Constantinople with the order to make those now existing. As he had not yet resolved to renew the basilica, the doors are for this reason so short as they have remained until now.

Gervase of Canterbury: The Cathedral of Lanfranc and Anselm

The ancient cathedral of Canterbury of which Eadmer has left a description,[15] burned, together with its monastery, in the year after the Norman conquest. Lanfranc, the first Norman archbishop of Canterbury (1070–89), was forced, at the beginning of his episcopate, to build a new cathedral and a new monastery. In view of Norman prowess in matters of architecture, this may have been a welcome opportunity for the Archbishop. The nave of Lanfranc's church stood until the end of the fourteenth century. Lanfranc's choir however, was already torn down under his successor St. Anselm (1093–1109), to be replaced by a more splendid and ornate structure. This new choir burned in 1174 and was replaced by the still standing Gothic one. Gervase of Canterbury, a twelfth-century chronicler with a unique taste and understanding for architecture, has given an account of both Lanfranc's nave and the choir added to it during the episcopate of St. Anselm. When Gervase wrote, he had the nave before his eyes, whereas the choir, destroyed by fire in 1174, had to be described from memory.

I will first describe the work of Lanfranc; beginning from the great tower, not because the whole of this church has been destroyed, but because part of it has been altered. The tower, raised upon great pillars ..., is placed in the midst of the church, like the centre in the middle of a circle. It had on its apex a gilt cherub. On the west of the tower is the nave or *aula* of the church, supported on either side upon eight pillars. Two lofty towers with gilded pinnacles terminate this nave or aula. A gilded crown[16] hangs in the midst of the church. A screen with a pulpit separated in a manner the aforesaid tower from the nave, and had in the middle, and on the side towards the nave, the altar of the holy cross. Above the pulpit, and placed across the church, was the beam, which sustained a great cross, two cherubim, and the images of St. Mary, and St. John the Apostle. In the north aisle was the oratory and altar of St. Mary. In this nave, as above related, we for five years endured banishment.[17] The aforesaid great tower had a cross[18] extending to each side, to the

15 See above, pp. 112–14.
16 A circular chandelier.
17 After the fire of 1174, which destroyed the choir.
18 Gervase calls the whole of the transept as well as each of its wings a "cross."

south as well as to the north, each of which had in the midst a strong pillar; this pillar sustained a vault which proceeded from the walls on three of its sides; the plan of one was exactly the same as that of the other. The south cross was employed to carry the organ upon the vault. Above and beneath the vault was an apse, extended towards the east. In the lower part was the altar of St. Michael, in the upper part the altar of All Saints. Before the altar of St. Michael to the south was buried Archbishop Feologild.[19] On the north the holy virgin Siburgis,[20] who for her sanctity was buried in the church by St. Dunstan.[21]

Between this apse and the choir the space is divided into two, that is, for the few steps by which the crypt is gained, and for the many steps by which the upper parts of the church are reached. The north cross similarly had two apses. In the upper one is the altar of St. Blasius, in the lower that of St. Benedict. In this lower one, to the right of the entrance, was buried Archbishop William,[22] who with great glory dedicated the church of Christ which I am describing. He also founded the church of St. Martin for monks of Dover. To the left lies the predecessor of William, Archbishop Radulf. . . .[23] In the same apse, before the altar on the right, lies Archbishop Egelnoth,[24] and to the left Vulfelm.[25] Behind the altar to the right Adelm,[26] to the left Chelnoth.[27] And thus is the aforesaid apse graced. Between this apse and the choir the space is divided into two, that is, for the steps which descend to the crypt, and for the steps which serve those who ascend to the eastern parts of the church.

Between this space and the aforesaid apse is a solid wall, before which that glorious companion of martyrs, and guest of the Apostles, the holy Thomas,[28] fell in the body by the swords of raging men, but transmitted his unconquered soul to heaven to be straightway crowned with the glory and honour of the eternal kingdom. This place of martyrdom is opposite to the door of the cloister by which those four notaries of the devil entered that they might stamp the seal of the genuine prerogative of the martyr between the anvil and hammer, that is, that they might adorn the head of St. Thomas, prostrate between the pavement and their swords, with the stamp of the Most High, the chaplet of martyrdom.

The pillar which stood in the midst of this cross, as well as the vault which rested on it, were taken down in process of time out of respect for

[19] Feologild or Fleogild, Archbishop of Canterbury (832).
[20] I have been unable to identify St. Siburgis.
[21] St. Dunstan, archbishop of Canterbury (960–88).
[22] William of Corbeil, archbishop of Canterbury (1123–36).
[23] Ralph d'Escures, archbishop of Canterbury (1114–22).
[24] Egelnoth, archbishop of Canterbury (1020–38).
[25] Wulfhelm, archbishop of Canterbury (923–42).
[26] Aethelhelm, archbishop of Canterbury (914–23).
[27] Ceolnoth, archbishop of Canterbury (833–70).
[28] St. Thomas Becket, archbishop of Canterbury (1162–70). He was murdered in Canterbury Cathedral by four courtiers of Henry II.

the martyr, that the altar, elevated on the place of the martyrdom, might be seen from a greater distance. Around and at the height of the aforesaid vault a passage was constructed from which draperies and curtains might be suspended. From the cross to the tower, and from the tower to the choir many steps ascended. There was a descent from the tower into the south cross by a new entrance. Also a descent from the tower to the nave through two doors. Thus much for the church of Lanfranc. Now let us describe the choir, lest the memory thereof be utterly lost.

I have described, as shortly as I might, the church constructed by Archbishop Lanfranc; that is, the nave, crosses, towers, and their appurtenances. Still the actual sight of them will explain them as much more rapidly as it will effectually.

You must know however, good reader, that I never saw the choir of Lanfranc, neither have I been able to meet with any description of it. Eadmer, indeed, describes the old church, which before the time of Lanfranc was constructed after the Roman manner.[29] Also he mentions, but does not describe, the work of Lanfranc which succeeded this old church, and the choir of Conrad[30] constructed in the time of St. Anselm. Now, therefore, that this choir of Conrad, so gloriously completed, has been in our own days miserably consumed by fire; my poor and simple pen shall attempt its description, lest the memory of so great a man and so noble a work be utterly lost. And although my purpose is not to describe the mere arrangement of stones, yet it is impossible clearly to shew the places of the Saints and of their repose, which are in various parts of the church, without first describing the building itself in which they were arranged, under the inspection and with the assistance of their historian Eadmer. Let us begin therefore with the aforesaid great tower, which, as already explained, is placed in the midst of the whole church, and proceed eastward. The eastern pillars of the tower projected as a solid wall, and were formed each into a round semi-pillar. Hence in line and order were nine pillars on each side of the choir, nearly equidistant from each other; after these six in a circuit were arranged circularly, that is, from the ninth on the south side to the ninth on the north, of which the two extreme ones were united by the same one arch. Upon these pillars, as well those in the straight line as those in the circuit, arches were turned from pillar to pillar; above these the solid wall was set with small blank windows. This wall, bounding the choir, met the corresponding one at the head of the church in that circuit of pillars. Above the wall was the passage which is called triforium, and the upper windows. This was the termination upwards of the interior wall. Upon it rested the roof and a

[29] See above, pp. 112–14.
[30] Conrad was prior of the cathedral monastery during the episcopate of St. Anselm, archbishop of Canterbury (1093–1109).

ceiling decorated with excellent painting. At the bases of the pillars there was a wall built of marble slabs, which, surrounding the choir and presbytery, divided the body of the church from its sides, which are called aisles.

This wall inclosed the choir of the monks, the presbytery, the great Altar dedicated in the name of Jesus Christ, the altar of St. Dunstan,[31] and the altar of St. Elfege,[32] with their holy bodies.

Above the wall, in the circuit behind and opposite to the altar, was the patriarchal seat formed out of a single stone, in which, according to the custom of the Church on high festivals, the archbishops were wont to sit during the solemnities of the mass, until the consecration of the Sacrament; they then descended to the Altar of Christ by eight steps.

From the choir to the presbytery there were three steps; from the pavement of the presbytery to the altar three steps; but to the patriarchal seat eight steps. At the eastern horns of the altar were two wooden columns, gracefully ornamented with gold and silver, and sustaining a great beam, the extremities of which rested upon the capitals of two of the pillars. This beam, carried across the church above the altar, and decorated with gold, sustained a representation of Christ enthroned and the images of St. Dunstan and of St. Elfege, together with seven chests, covered with gold and silver, and filled with the relics of divers saints. Between the columns there stood a gilded cross, of which the cross itself was surrounded by sixty transparent crystals. In the crypt, under this altar of Christ, stood the altar of the holy Virgin Mary, to whose honor the entire crypt was dedicated. Which crypt occupied precisely the same space and compass in length and breadth as did the choir above it. In the midst of the choir hung a gilded corona carrying four and twenty wax lights. This was the fashion of the choir and presbytery. But the exterior wall of the aisles was as follows. Beginning from the martyrium of St. Thomas, that is to say from the cross of Lanfranc, and proceeding towards the east as far as the upper cross, the wall contained three windows and no more. Opposite to the fifth pillar of the choir, the wall received an arch from it, and turning towards the north it formed the north cross. The breadth of this cross extended from the fifth to the seventh pillar. For the wall proceeding northwards from the seventh pillar as from the fifth, and making two apses, completed the cross of the eastern part. In its southern apse was the altar of St. Stephen, under which, in the crypt, was the altar of St. Nicholas. In the northern apse was the altar of St. Martin; and under it, in the crypt, the altar of St. Mary Magdalene. At the altar of St. Martin two archbishops were laid, to the right Vulfred,[33] to the left Living;[34] and

31 See above, note 21.
32 St. Elfege or Alphege, archbishop of Canterbury (1005–1012).
33 Wulfred, archbishop of Canterbury (805–32).
34 Lyfing, archbishop of Canterbury (1013–20).

similarly at the altar of St. Stephen, to the left Athelard,[35] and to the right the venerable Cuthbert.[36]

He it was who, being endowed with great wisdom, procured for Christ Church the right of free sepulture. For the bodies not only of the archbishops, but of all who died in the city, were wont, from the time of St. Augustine,[37] to be carried to the church of the Apostles Peter and Paul, without the city, and there buried. For in those days it was said that the city was for the living and not for the dead. But the blessed Cuthbert was grieved to think that after death he must be separated from his church and his children, that in life were the delights of his affection. Wherefore he sought and obtained from Rome the right of free burial for Christ Church. He was the first who, by the will of God, the authority of the high pontiff, and the permission of the king of England, was buried in Christ Church, and so also were all his successors, save one alone named Jambert.[38]

From this apse of St. Stephen, the aforesaid wall proceeding eastward had a window opposite to the side of the great Altar. Next after came a lofty tower, placed as it were outside the said wall, which was called the tower of St. Andrew because of the altar of St. Andrew which was therein, below which, in the crypt, was the altar of the Innocents. From this tower the wall proceeding, slightly curved and opening into a window, reached a chapel, which was extended towards the east at the front of the church, and opposite to the high seat of the archbishop. But as there are many things to be said of the interior of this chapel, it will be better to pause before its entrance until the south wall with its appurtenances has been traced up to the same point. This south wall, beginning from the apse of St. Michael in the cross of Lanfranc, reaches the upper cross after three windows. This cross at its eastern side, like the other, had two apses. In the southern apse was the altar of St. Gregory, where two holy archbishops were deposited; to the south St. Bregwin,[39] to the north St. Plegemund,[40] underneath in the crypt was the altar of St. Audoen, archbishop of Rouen. In the other apse was the altar of St. John the Evangelist, where two archbishops reposed; to the right Ethelgar;[41] to the left Elfric;[42] underneath in the crypt was the altar of St. Paulinus, where Archbishop Siric[43] was buried. Before the altar of St. Audoen and nearly in the middle of the floor was the altar of St. Katherine. The wall pro-

[35] Aethelard, archbishop of Canterbury (793–805).
[36] Cuthbeorht, archbishop of Canterbury (740–60).
[37] St. Augustine of Canterbury. See above, pp. 47, 112.
[38] Jaenbeorht, archbishop of Canterbury (765–92).
[39] Breguwine, archbishop of Canterbury (761–64).
[40] St. Plegemund, archbishop of Canterbury (890–914).
[41] Aethelgar, archbishop of Canterbury (988–90).
[42] Aelfric, archbishop of Canterbury (995–1005).
[43] Sigeric Serio, archbishop of Canterbury (990–94).

ceeding from the above cross had a window opposite to the great Altar, and next a lofty tower, in which was the altar of the Apostles Peter and Paul.

But St. Anselm[44] having been translated there and placed behind the altar gave his name to the altar and to the tower. From this tower the wall proceeding for a short space and opening into a window in its curve, arrived at the aforesaid chapel of the Holy Trinity, which was placed at the front of the church. An arch springing from each wall, that is, from the south and from the north, completed the circuit.

The chapel placed outside the wall but joined to it and extended towards the east, had the altar of the Holy Trinity, where the blessed martyr Thomas celebrated his first mass on the day of his consecration. In this chapel, before and after his exile, he was wont to celebrate mass, to hear service, and frequently to pray. Behind the altar there lay two archbishops, to the right St. Odo,[45] to the left St. Wilfrid, archbishop of York;[46] to the south, close to the wall, the venerable Archbishop Lanfranc and to the north Theodbald.[47] In the crypt beneath, there were two altars, on the south that of St. Augustine, the apostle of the English, and on the north that of St. John Baptist. Close to the south wall Archbishop Ethelred[48] was deposited, and Eadsin[49] against the north wall.

In the middle of this chapel there stood a column which sustained arches and a vault, that came from all sides. At the base of this column, on the eastern side, . . . was the place where the blessed martyr Thomas was buried, on the day after his martyrdom. . . .

And now the description, as concise as I could make it, of the church which we are going to pull down, has brought us to the tomb of the martyr, which was at the end of the church; let therefore the church and the description come to an end together; for although this description has already extended itself to a greater length than was proposed, yet many things have been carefully omitted for the sake of brevity. Who could write all the turnings, and windings, and appendages of such and so great a church as this was? Leaving out, therefore, all that is not absolutely necessary, let us boldly prepare for the destruction of this old work and the marvellous building of the new, and let us see what our master William[50] has been doing in the meanwhile.[51]

44 St. Anselm, archbishop of Canterbury (1093–1109).
45 St. Oda, archbishop of Canterbury (942–58).
46 See above, pp. 75–78.
47 Theobald of Bec, archbishop of Canterbury (1139–61).
48 Aethelred, archbishop of Canterbury (870–89).
49 Eadsige, archbishop of Canterbury (1038–50).
50 William of Sens, the first architect of the Gothic choir of Canterbury Cathedral.
51 Chronica Gervasi monachi Cantuarensis, I, trans. R. Willis in *The Architectural History of Canterbury Cathedral* (London: Longmans and Co., 1845), pp. 34–47.

PILGRIMS AND TRAVELERS

A Guide to Santiago di Compostela

An early medieval legend locates the grave of the Apostle St. James the Elder at Compostela. The fame of the site grew as Catholic successes in the reconquest of Moslem Spain multiplied. Santiago's popularity reached its peak during the middle years of the twelfth century. It was at about this time that an anonymous French author wrote a guide for pilgrims, informing them about the roads leading to Compostela, enumerating sights and sanctuaries, and providing information about roads, dangerous crossings, food, and the character of the local people. The last book of the guide contains a description of the great church at Compostela, which mentions sculpture and towers no longer extant.

Written between 1137 and 1173, this description is similar to the accounts of Leo of Ostia and Gervase of Canterbury in its clarity and its concern with detail. It is also interesting to see with what admiration the author referred to the two architects of the church. He had obviously known and talked with architects and also tried to use some of their technical expressions.

THE DIMENSIONS OF THE CHURCH

Now the basilica of S. James is in length fifty-three times a man's stature,[52] measuring from the western doorway to the altar of the Saviour, in width, thirty-nine times, measuring from the Door of the Franks to the south portal. The interior height is fourteen times a man's stature.

It is not worth anyone's while to know what the external length and height are.

The church has nine aisles on the lower level, and six on the upper, also a principal apsidal chapel, namely that containing the altar of the Saviour, and a sanctuary with ambulatory; a nave and two transepts; and it has eight small apsidal chapels, each with an altar.

Six of the nine aisles we speak of as small, and three as great. The first principal aisle stretches from the west portal to the four middle piers which dominate the church, and it has a lesser aisle to the right and to the left. There are two other naves in the two transepts, of which the first extends from the Door of the Franks to the four piers of the crossing, and the second from these same piers to the south portal; both have two lesser lateral aisles. These three principal naves reach to the vault of the church,

[52] A "man's stature" seems to have been the equivalent of five and a half feet.

and the six lesser aisles only to the middle of the piers. Each of the great arms measures eleven and a half times a man's stature in breadth. We call a man's stature just eight palms.

There are twenty-nine piers in the great nave, fourteen to the right hand, and as many to the left, and one comes between the two inner portals, . . . standing between the arches. In the naves of the transept of the church, from the Door of the Franks to the south portal, there are twenty-six piers, twelve at the right hand and as many at the left; two of them, placed within before the doors, stand between the arches and portals.

In the apse of the church, besides, there are eight single columns about the altar of the Blessed James.

The six aisles which are above in the upper story of the church are the same in length and width as the corresponding aisles below. On one side the walls bound them, and on the other, the piers rising from the lower part of the great naves and pairs of shafts of the kind called semi-cylindrical[53] by the masons. There are as many piers in the lower part of the church as in the naves above; and as many as are the arches below, so many are they in the galleries above. But in the gallery passages there are, between successive piers, in each case, two of the shafts called by the masons cylindrical columns.

In the church there is indeed not a single crack, nor any damage to be found; it is wonderfully built, large, spacious, well-lighted; of fitting size, harmonious in width, length, and height; held to be admirable and beautiful in execution. And furthermore it is built with two stories like a regal palace. For he who visits the galleries, if sad when he ascends, once he has seen the preëminent beauty of this temple, is rejoiced and filled with gladness.

THE WINDOWS

The glazed windows in the basilica proper number sixty-three, and in each and every chapel surrounding the choir there are three. In the vault of the basilica about the altar of the Blessed James which is in the apse there are five windows from which the altar of the Apostle receives a good light. In the galleries above are windows to the number of forty-three.

THE LESSER PORTALS

The church has, in addition to seven small entrances, three principal portals: one which faces the west, the main portal; another to the south, and still another to the north. In each portal there are two doorways, and in each doorway, two doors. The first of the minor portals is

53 The Latin text gives here a technical term, *medie cindrie,* whose meaning is uncertain.

called that of S. Mary; the second, of the Via Sacra; the third, of S. Pelagius; the fourth, that of the Chapter; the fifth, the Stoneyard Portal; the sixth likewise, Stoneyard Portal; the seventh, the Grammar School Portal, which also communicates with the dwelling of the archbishop.

THE FOUNTAIN OF ST. JAMES[54]

When we of Gallic nation wish to enter the apostolic basilica, we go in on the northern side. Before the entrance is situated, near the street, the hospice for poor pilgrims of Santiago; and beyond the street there is a sort of park with nine descending steps, the Paradise. At the foot of the steps of this Paradise there is a remarkable fountain, the like of which is not to be found in the whole world. This fountain has three stone steps at its base, upon which rests a very handsome hollow round stone conch, like a platter or basin; so large, I judge, that fifteen men could bathe in it. In the centre of it is set a bronze column of seven pieces fitted together, large in the lower part and suitably tall; from the top of it project four lions, out of whose mouths flow jets of water for the refreshment of the pilgrims of the Blessed James and the townspeople. The streams, after they issue from the lions' mouths, fall at once into the basin below, and, passing through an opening in the basin itself, are drained off under ground. Thus it is impossible to see whence the water comes or whither it goes. This water is sweet, nourishing, healthful, clear, excellent; warm in winter, cool in summer. On the column referred to above is inscribed, in two lines, round about beneath the lions' paws, the following:

✠I Bernard, Treasurer of the Blessed James, brought this water
hither and built this present work
For the good of my soul and those of my parents.
3 Ides of April, in the Era 1160.[55]

THE PARADISE OF THE CITY

Beyond the fountain is the Paradise, as we have said, with a pavement of cut stone. In it are sold little shells, the signs of the Blessed James, that is to say; wine-flasks, deerskin pouches, purses, shoe-latchets, belts; all kinds of medicinal herbs, and other drugs; and many other things are offered there for sale. There are money-changers, hotel-keepers, and other merchants in the Street of the Franks. The Paradise is about a stone's throw in length on each side.

THE NORTH PORTAL[56]

And beyond this Paradise is the north portal, the Door of the

[54] This fountain was destroyed during the fifteenth century.
[55] By our reckoning, April 11, 1122.
[56] This portal no longer exists, having been replaced during the eighteenth century. Some of its sculptures were then used to decorate the south facade.

Franks, of the basilica of St. James, with two entrances, which have the following beautiful sculptured decoration. Outside at each opening there are six columns, some of marble, others of stone: three to the right and three to the left: six, that is to say, at one entrance, and six at the other; and so there are twelve columns. Above the shaft between the two portals, on the outer side, there is let into the wall the seated figure of Our Lord in Majesty; with His right hand He gives benediction, and in His left He holds a book. And round about His throne are the Four Evangelists, as if supporting the throne. At His right is carved Paradise, with another figure of the Lord reproving Adam and Eve for their sin;[57] He appears also to the left, driving them forth from Paradise.[58] And round about are sculptured a multitude of images of saints, animals, men, angels, women, flowers, and other created things whose nature and quality we cannot relate because of their great number. But over the doorway to the left as we enter the basilica—within the arch, that is—is carved the Annunciation of the Blessed Virgin Mary; there, too, the Angel Gabriel addresses her.[59] To the left above the doors of the entrance at the side, the months of the year and many other beautiful works are represented in sculpture. Here are, also, two great fierce lions extending out from the wall, one to the right and one to the left, who continually look down as if keeping their eyes upon the doors.

On the upper part of the jambs are four apostles, each holding a book in his left hand, and with his raised right hand giving a benediction to those entering the basilica. On the left-hand portal are Peter at the right and Paul at the left; on the right-hand portal are the Apostle St. John at the right and the Blessed James at the left. Above the head of each Saint is carved the head of a bull, corbeled out from the jamb.

THE SOUTH PORTAL

The South Portal has two entrances, as we have said, with four door-valves. At the right door on the exterior, that is, in the first band above the doors, the Betrayal of Our Lord[60] is wonderfully carved. There He is bound to the pillar by the hands of the Jews; here he is flagellated,[61] there Pilate sits enthroned, as if judging Him.[62] And above, on the other band, is sculptured the Blessed Mary, Mother of Our Lord, with her Child, in Bethlehem, and the three Kings who are come to visit the Boy and the Mother, offering Him three gifts; and the star also is carved there, and the angel warning the Kings not to return to Herod.[63] On the jambs

57 Gen. 3: 9–19.
58 Gen. 3: 23–24.
59 Luke 1: 26–38.
60 Matt. 26: 47–55; Luke 22: 47–53.
61 Matt. 27: 27–31; Mark 15: 16–20; John 19: 1–6.
62 Matt. 27, Mark 15, Luke 23, John 18.
63 Matt. 2: 10–18.

of this doorway are two apostles like warders of the doors, one to the right and one to the left.

Similarly there are two other apostles placed at the other doorway, to the left; on the jambs, that is to say.[64] And in the first band of this doorway, above the doors, that is, is carved the Temptation of Our Lord. There are before the Lord hideous angels like spectres setting Him upon the pinnacle of the Temple; others offer Him stones, urging Him to make bread of them; others spread out before Him the kingdoms of the world, pretending that they will give them to Him if He will fall down and worship them—thus may it not be! But there are also others, white or good angels, behind His back, and still other angels above with censers, ministering unto Him.[65]

On this same portal, there are four lions, one to the right of one doorway, and another by the other doorway. Above the middle shaft between the two doorways are two ferocious lions, one of which holds his hind-quarters against the hind-quarters of the other. There are eleven columns on this same portal—at the right-hand door, five, and at the left-hand door, five; and an eleventh which comes between the two doorways, separating the arches. And these columns, some of marble, others of stone, are marvellously carved with images of flowers, men, birds, and animals. The marble columns here are of white marble.

Nor ought we to forget the female figure set near the Temptation of Our Lord: she holds in her hands the rotting head of her lover, cut off by her husband, who forces her to kiss it twice each day. What a great and admirable judgment upon an adulterous woman, which should be recounted to everyone!

Above the four doors the upper zone, near the triforium level of the church, is beautifully resplendent with an admirable band of figures sculptured on slabs of white marble. There is a standing figure of the Lord, and St. Peter holding the keys in his hands is at His left, while the Blessed James is at his right between two cypress trees; next him stands St. John his brother, while at the right and left are apostles and others. The wall above and below, on the right side and on the left, is most excellently sculptured with flowers, men and saints, beasts, birds, fish, and other works, which are beyond the possible limits of our recital. But it might be said that there are four angels above the archivolts, each with a trumpet, announcing the Day of Judgment.

THE WEST PORTAL[66]

The West Portal, with two doorways, in beauty, size, and in the

64 The four jamb-figures are actually St. Andrew, Moses, a bishop, and a woman standing over a lion.

65 Matt. 4: 1–11; Luke 4: 2–13.

66 The west portal no longer exists, having been replaced during the later twelfth century by the "Puerta della Gloria."

works upon it, excels the other portals. It is greater and handsomer, and more wonderfully carved than the others; it is provided with a great number of steps of approach; it is adorned by various marble columns and decorated with many kinds of creatures and in various ways; it is sculptured with images of men, women, beasts, birds, saints, angels, flowers, and works of divers kinds, so many that they cannot be included in our description. In the upper part, however, is a wonderful carving of the Lord's Transfiguration as it occurred on Mount Tabor. Our Lord is represented there in a white cloud, His face shining like the sun, His garments refulgent like snow, the Father above speaking to Him; and Moses and Elias who appeared with Him, telling Our Lord of His decease which was to be accomplished in Jerusalem. The Blessed James is there, as are Peter and John, to whom, before any others, the Lord revealed His transfiguration.[67]

THE TOWERS OF THE CHURCH

There are to be nine towers on the church—two over the portal by the fountain,[68] two over the South Portal, two over the West Portal, one over each of the winding stairways,[69] and a larger one over the crossing in the middle of the basilica.

The splendid basilica of the Blessed James is gorgeous with these and other very beautiful works. It is all built of very strong, living stone, brown, and very hard. Within it has various paintings, and without it is roofed in the best manner with lead and tiles. But of these things we have mentioned, some are already entirely finished and others are yet to be completed.

THE ALTARS OF THE BASILICA

The basilica has its altars arranged in the following order. First, adjoining the Door of the Franks, which is on the left side, comes the altar of St. Nicolas; next, the altar of the holy Cross; then in the ambulatory, that is, the altar of St. Fides, the virgin, then the altar of the Apostle and Evangelist St. John, the brother of St. James; next comes the altar of the Saviour in the principal absidiole; then the altar of the Apostle St. Peter, then the altar of St. Andrew, then the altar of the Bishop St. Martin; then comes the altar of the Baptist St. John.

Between the altar of St. James and that of the Saviour stands the altar of St. Mary Magdalene, where the pilgrims' morning masses are sung.

Above in the galleries there are customarily three altars, of which

[67] Matt. 17: 1–6; Mark 9: 1–7; Luke 9: 29–37.
[68] The north portal.
[69] In the angles between nave and transept.

the principal one is that of the Archangel St. Michael; there is another altar, to the right, dedicated to St. Benedict, and still another dedicated to the Apostle St. Paul and the Bishop St. Nicholas to the left, where also the archbishop's chapel customarily is.

THE BODY AND THE ALTAR OF ST. JAMES

But as we have thus far described the church, now we must consider the venerable apostolic altar. Within the said venerable basilica, the revered body of the Blessed James lies under the high altar raised in his honor, enclosed by a marble sarcophagus, in state, as the tradition has it, in a very fine arched sepulchre of wonderful workmanship and fitting size. That the body is immovable is well known from the testimony of Theodomir,[70] Bishop of this city, who found it in time past, and was unable to stir it from its place. So let the folk beyond the mountains blush when they claim to have any part of it, or relics of him. For the entire body of the Apostle is there; it is brightened by heavenly jewels; it is graced with unfailing odors, fragrant and divine; it is embellished by the splendor of celestial lights, and unceasingly honored by angelic adoration.

Above the sepulchre of St. James is a small altar which his disciples made, tradition has it, and which, for love of the Apostle and his disciples, no one has since wished to destroy. And above this is a large and admirable altar five palms high, twelve long, and seven wide. I have with my own hands thus measured it. There is also a small altar made of three pieces of stone under this great altar, which is closed at the back and on the right and left sides, but open in front so that the old altar can clearly be seen when the silver altar frontal is removed.

And if anyone should wish to send a covering or altar-cloth for the apostolic altar, he should make it nine palms in width and twenty-one in length.[71] And if any one for love of God and the Apostle should send an antependium to cover the altar in front, let him see that it is made seven palms wide and thirteen long.

THE SILVER FRONTAL

The frontal before the altar is gloriously wrought of gold and silver. In the centre of it is sculptured the Lord's Throne; there the Four and Twenty Elders are, placed as the Blessed John, brother of St. James, saw them in his Apocalypse—twelve to the right and as many to the left, round about, holding zithers and golden phials of sweet spices in their hands.[72] In the midst of the Throne sits the Lord in Majesty, holding the

[70] Theodomir, bishop of Iria (800–843).
[71] The palm is equivalent to about eight inches.
[72] Apoc. 4: 4; 7: 11.

Book of Life in His left hand, and giving blessing with His right. Around His Throne are the Four Evangelists, as if holding up the Throne. The Twelve Apostles are placed at His right and His left, three at the right in the first, and three in the upper register; similarly there are at the left, three in the first, the lower register, and three in the upper. There are very finely wrought flowers in the border round about and very lovely columns between the apostles. This fitting and beautiful frontal has this inscription in verse on the upper part:

DIEGO II[73] BISHOP OF THE SEE OF SANTIAGO MADE THIS FRONTAL IN THE FIFTH YEAR OF HIS EPISCOPATE. EIGHTY-FIVE MARKS OF THE SILVER CAME FROM THE TREASURY OF SANTIAGO; and below, this inscription: ALFONSO[74] WAS KING, AND RAIMUNDO HIS SON-IN-LAW WAS DUKE WHEN THE BEFORE MENTIONED BISHOP FINISHED THE WORK.

THE CIBORIUM OF THE APOSTOLIC ALTAR

The canopy which covers this venerable altar is marvellously wrought inside and out with paintings and representations of various kinds. It is square, well proportioned in height and width, and carried on four columns. On the inside, in the lowest register, are certain special Virtues which St. Paul mentions,[75] represented as women, eight in number. There are two at each corner. And above their heads are standing angels, holding in their raised hands a throne, which is at the crown of the vault. On the throne is the Lamb of God holding a cross with His foot. There are as many angels as Virtues.

Outside, in the first register, are four angels, who announce the Resurrection of Judgment Day with blaring trumpets. Two are in the front, and two behind in the other face at the rear. Similarly placed there are four prophets, Moses and Abraham on the left-hand side, and Isaac and Jacob on the right, each one holding in his hand a scroll with his prophecy.

The Twelve Apostles are seated round about in a row above, with the Blessed James in the middle of the façade or front face, his left hand holding a book, his right hand making the sign of benediction. At his right is another apostle, and at his left, still another, in the same register. Similarly, there are three other apostles on the right side of the ciborium, three on the left, and likewise three at the back.

On the covering above are seated four angels, as if guarding the altar, while at the four angles where this roofing begins are carved the Four Evangelists in their own likeness.

The ciborium is painted on the inner parts; its exterior is sculptured as well as painted.

73 Diego II (Gelmirez), bishop of Santiago (1100–1139).
74 Alfonso I, king of Aragon (1104–34).
75 Phil. 4: 4–8.

At its summit is built a kind of three-arched top stage, in which is carved the Divine Trinity. In the first arch, which faces the west, stands the Person of the Father; in the second, which faces between south and east, the Person of the Son; and in the third, which faces north, the Person of the Holy Spirit. Again, above this upper stage there is a shining silver ball, on which a precious cross is set.

THE THREE LAMPS

Before the altar of the Blessed James three large silver lamps are suspended for the honor of Christ and the Apostle. That in the middle is very great in size, and is marvellously wrought in the shape of a mortar, with seven receptacles, each with a light, recalling the Seven Gifts of the Holy Spirit. These receptacles are never filled with anything but balsam, myrtle, whale, or olive oil. The receptacle in the middle is larger than the rest, and each of the receptacles round about it has the images of two apostles sculptured on the outside. May the soul of King Alfonso[76] of Aragon, who is said to have given it to St. James, rest in eternal peace.

THE DIGNITY OF THE CHURCH OF ST. JAMES AND OF ITS CANONS

As a rule, no one celebrates mass at the altar of the Blessed James unless he be a bishop, archbishop, or pope, or a cardinal of this church.[77] There are by custom seven cardinals in the church who celebrate the divine office at the altar, constituted and conceded by many popes in former days, and confirmed besides by our lord Pope Calixtus.[78] For love of the Apostle, no one should diminish the dignity which by good custom the basilica of the Blessed James enjoys.

THE MASONS OF THE CHURCH, AND THE FINE QUALITY OF ITS CONSTRUCTION

The master-masons who first labored at the building of the basilica of the Blessed James were named Bernard the elder, a builder of genius, and Robert, who, with about fifty other masons, worked assiduously at it under the very faithful administration of Lord Wicartus, the Canon Lord Seferedus, and the Abbot Lord Gundesindus in the reign of Alfonso,[79] King of Spain, and under the Bishop Lord Diego I,[80] a strenuous militant churchman and noble man. The church was begun in the Era 1116....[81]

[76] Alfonso I, king of Aragon (1104–34).

[77] The *cardinals of this church* were cardinals in name only. The title had been conferred on seven members of the chapter of Santiago by Pope Paschal II in 1104.

[78] Pope Calixtus II (1119–24).

[79] Alfonso VI, king of Asturias, Leon, and Castile (1065–1109).

[80] Diego I (Pelaez), bishop of Santiago (1071–88).

[81] By our reckoning, A.D. 1078. Several contradictory chronological equivalents follow, which are probably later interpolations.

From the year in which the first stone was laid in its foundations until that in which the last stone was put into place, forty-four years elapsed.[82]

And this church, from the time it was begun until the present day, has flourished in the glory of the miracles of the Blessed James. In it health is bestowed on the sick, sight returned to the blind; the tongue of the mute is unloosed; hearing is restored to the deaf, normal carriage afforded the lame, relief conceded the possessed; and what is better, the prayers of faithful people are heard, vows are fulfilled, the bonds of sin are broken; to the stricken the skies are opened; to the grieving, consolation is given; and all foreign nations from all the earth's climes troop thither, bearing with them gifts of praise to the Lord.

THE DIGNITY OF THE CHURCH OF SANTIAGO

Nor is it to be forgotten that for love and honor of the Apostle, the blessed Pope Calixtus (worthy of good memory) translated and gave to the Basilica and City of Santiago the archepiscopal dignity of the City of Mérida, which has been a metropolis in the land of the Saracens. And for this he ordained and confirmed Diego,[83] a most noble man, to be the first archbishop of the Apostolic See of Compostela. This same Diego was previously bishop of Santiago.[84]

Benedict the Canon: The Marvels of Rome

This famous guide book was written about 1140 by Benedict, a canon of St. Peter's, who also compiled a voluminous manual on church administration for Celestine II, pope from 1143–44. The marvels dealt mainly with the pagan monuments of the city but also with some Christian ones, and the ease with which the author moves from one to the other is especially striking in his tale about the foundation and rededication of the Pantheon. There he draws an astounding parallel between the pagan Great Mother Cybele and the Virgin Mary. Such tolerance was made possible by the fact that paganism was not an urgent issue during the twelfth century. It was also suggested by a new and fervent Roman patriotism, which gladly adopted a glorious pagan past in order to enhance a Christian present. The Mirabilia *were much read during the later Middle Ages and the early Renaissance. Their text saw many revisions and editions, the last of which dates from 1415.*

Hear now to what intent the horses of marble were made bare, and

82 The church must therefore have been finished in 1122.

83 Diego II (Gelmirez), bishop of Compostela (1100–1139).

84 Liber Sancti Jacobi, V, 3–19, trans. by Kenneth John Conant. Reprinted by permission of the publishers from Kenneth John Conant, *The Early Architectural History of the Cathedral of Santiago de Compostela* (Cambridge, Mass.: Harvard University Press, 1936) pp. 49–58.

the men beside them naked,[85] and what story they tell, and what is the reason why there sitteth before the horses a certain woman encompassed with serpents, and having a shell before her.[86]

In the time of the emperor Tiberius[87] there came to Rome two young men that were philosophers, named Praxiteles and Phidias,[88] whom the emperor, observing them to be of so much wisdom, kept nigh unto himself in his palace; . . . and they said: Whatsoever thou, most mighty emperor, shalt devise in thy chamber by day or night, albeit we be absent, we will tell it thee every word. If ye shall do that ye say, said the emperor, I will give you what thing soever ye shall desire. They answered and said, We ask no money, but only a memorial of us. And when the next day was come, they showed unto the emperor in order whatsoever he had thought of in that night. Therefore he made them the memorial that he had promised, to wit, the naked horses, which trample on the earth, that is upon the mighty princes of the world that rule over the men of this world; and there shall come a full mighty king, which shall mount the horses, that is, upon the might of the princes of this world. Meanwhile there be the two men half naked, which stand by the horses, and with arms raised on high and bent fingers tell the things that are to be; and as they be naked, so is all worldly knowledge naked and open to their minds. The woman encompassed with serpents, that sitteth with a shell before her, signifieth the Church, encompassed with many rolls of scriptures, to whom he that desireth to go, may not, but if he be first washed in that shell, that is to say, except he be baptized.

In the times of the Consuls and Senators, the prefect Agrippa,[89] with four legions of soldiers, subjugated to the Roman senate the Suevians, Saxons, and other western nations. Upon whose return the bell of the image of the kingdom of the Persians, that was in the Capitol, rang. For in the temple of Jupiter and Moneta in the Capitol was an image of every kingdom of the world, with a bell about his neck, and as soon as the bell sounded, they knew that the country was rebellious.[90] The priest therefore that was on watch in his week, hearing the sound of the bell, shewed the same to the Senators; and the Senators did lay the ordering of this war upon the prefect Agrippa. He denying that he was of ability to undergo so great a charge, was at length constrained, and asked leave to take counsel for three days. During which term, upon one night, out of too much

85 The statues of the Dioscuri, which stood in the Baths of Constantine until the end of the sixteenth century, are now in the Piazza del Quirinale.

86 Possibly a statue of Hygieia from the nearby temple of Serapis.

87 Tiberius, Roman Emperor (17–37 A.D.).

88 The Dioscuri stand even today on bases with inscriptions containing the names of Praxiteles and Phidias.

89 Marcus Vipsanius Agrippa (63–12 B.C.) built the first Pantheon. His name appears on the frieze of the pronaos of the present structure, which was built by the Emperor Hadrian (117–38 A.D.).

90 The legend of the bells is probably of Carolingian origin.

thinking he fell asleep, and there appeared to him a woman, who said unto him: What does thou, Agrippa? forsooth, thou art in great thought; and he answered unto her: Madam, I am. She said, Comfort thee, and promise me, if thou shalt win the victory, to make me a temple such as I show unto thee. And he said, I will make it. And she showed him in the vision a temple made after that fashion. And he said: Madam, who art thou? And she said, I am Cybele, the mother of the gods: bear libations to Neptune, which is a mighty god, that he help thee; and make this temple to be dedicated to my worship and Neptune's, because we will be with thee, and thou shalt prevail. Agrippa then arose with gladness, and rehearsed in the Senate all these sayings; and he went, with a great array of ships and with five legions, and overcame the Persians, and put them under a yearly tribute to the Roman Senate. And when he returned to Rome, he built this temple, and made it to be dedicated to the honour of Cybele, mother of the gods, and of Neptune, god of the sea, and of all the gods, and he gave to this temple the name of Pantheon. And in honour of the same Cybele he made a gilded image, which he set upon the top of the temple above the opening, and covered it with a magnifical roof of gilded brass.

After many ages pope Boniface,[91] in the time of Phocas,[92] a Christian emperor, seeing that so marvellous temple, dedicated in honour of Cybele, mother of the gods, before the which Christian men were ofttimes stricken of devils, prayed the emperor to grant him this temple, that as in the Calends of November it was dedicated to Cybele, mother of the gods, so in the Calends of November he might consecrate it to the blessed Mary, ever-virgin, that is the mother of all saints.[93] This Cæsar granted unto him; and the pope, with the whole Roman people, in the day of the Calends of November did dedicate it; and ordained that upon that day the Roman pontiff should sing mass there, and the people take the body and blood of our Lord as on Christmas day; and that on the same day all saints with their mother, Mary ever-virgin, and the heavenly spirits should have festival.[94]

Master Gregory: Pagan Antiquities

Master Gregory, the author of a small booklet on the antiquities of Rome, was an Englishman who visited the city about the middle of the twelfth century. His account is entirely devoted to pagan monuments,

[91] Pope Boniface IV (608–15).
[92] Phocas, Roman Emperor (602–10).
[93] Boniface IV dedicated the Pantheon to the Virgin and all saints on May 13, 609 or 610. Later Gregory III (731–41) shifted the feast of consecration to November 1st.
[94] From the oldest version of the *Mirabilia*, Chaps. XII, XVI, trans. Fr. Morgan Nichols, *The Marvels of Rome* (London: Ellis and Elvey; Rome: Spithoever, 1889), pp. 39–41, 46–49.

*and he expresses his admiration for them as well as for Rome in a very
personal way. His involvement with antique beauty and greatness has no
ideological overtones. There are no stories which transform deities into
moral heroes, goddesses into saints, or pagan statues into symbolic repre-
sentations of the Church as in Benedict's* Marvels of Rome.[95] *On the
contrary, it is quite clear that Master Gregory did not share Benedict's
easy confidence in the continuity of Roman history. He repeats several
times the charge that Pope Gregory the Great*[96] *was responsible for break-
ing the statues of the city, and when he refers to the follies of Chris-
tian pilgrims, his tone comes very close to contempt. Master Gregory, of
course, was an Englishman, and so had little reason to exalt the Rome of
his own day and thereby blur the shape of a great past, whose beauty he
so keenly felt.*

The sight of the whole city is I think most wonderful, where there
is such a multitude of towers, so great a number of palaces, as none can
count. When first I saw the city from the far-off hill, I was overwhelmed,
and remembered Caesar's view of it when, having conquered the Gauls
and flown across the Alps, he exclaimed greatly,

> wondering . . . at the walls of Rome,
> "Were you, abode of gods, abandoned by men
> Whom no war forced to flee? What city then
> Will find defenders? The gods be thanked . . ."[97]

And a little later:

> Coward hands gave up the city which might have contained the
> human race assembled.[98]

And, calling upon Rome, he named her

> sacred as any god.[99]

This beauty passing understanding I long admired, and I thanked
God who, though great in his manifestations throughout the earth, yet
has magnified there the works of man with immeasurable beauty. For
even if Rome falls into complete ruin, nothing that is intact can be com-
pared to it. As has been said,

> Nothing can equal Rome, Rome even in ruins:
> Your ruins themselves speak loud your former greatness.[100]

The ruin of Rome shows clearly, I think, that all temporal things
are near their end, especially when the centre of all worldly things, Rome,
daily languishes and decays. . . .

[95] See above, pp. 157–58.
[96] Pope Gregory I (590–604).
[97] Lucan, *Bellum civile*, III, 90–93.
[98] *Ibid.*, I, 511–14.
[99] *Ibid.*, I, 199.
[100] The first lines of "Par tibi, Roma", a famous mediaeval poem in
praise of Rome, written by Hildebert of Lavardin, archbishop of Tours (1125–33).

Now I shall subjoin a few words about the marble statues, almost all of which were either destroyed or disfigured by St. Gregory.[101] I shall refer first to one of them because of its extraordinary beauty.

This statue was dedicated by the Romans to Venus in that guise in which, as it is said in the story, she showed herself naked to Paris with Juno and Pallas in the rash competition. The rash judge, observing her, says

In our judgment Venus conquers both.[102]

This statue is made of Parian marble with such marvelous and inexplicable art that it seems rather a living being than a statue, for her nudity seems to blush, and her face to be suffused with red, and those who look close seem to see the blood warming the snowy face. On account of the admirable figure and I know not what magic charm it held, I was impelled to revisit this statue three times, though it was two miles distant from my inn.

The Pantheon. I pass over the Pantheon briefly because it was once the image of all the gods, that is the demons. This building is now a church dedicated in honor of all the saints and called Sancta Maria Rotunda, properly from the first and larger part, although it is the church of all saints. This building has a spacious portico sustained by marble columns of great and wonderful height. Before it are baths and other vessels of porphyry, and lions and other statues of the same marble endure to our time. I measured the width of this building, which is 266 feet. Its roof was once all gilded, but the measureless greed and the . . . vile thirst for gold . . . of the Roman people scraped off the gold and disfigured the temple of their gods. For the insatiable greed of men who have thirsted and who thirst after gold has withheld and withholds their hands from no crime.

The triumphal arch of Augustus.[103] Near this temple is the triumphal arch of Augustus Caesar, on which I found this inscription: THE ROMAN PEOPLE BUILT THIS MONUMENT IN HONOR OF THE RETURN TO ROMAN RULE, AND THE RECOVERY FOR THE STATE BY AUGUSTUS, OF A CONQUERED WORLD. This is to say, it is a perpetual monument to posterity of great victories and triumphs. This arch is also marble, and is multiple; on it on wide projecting bases are raised statues of generals or of those killed when fighting valiantly or of those otherwise memorable in battle. Among them the statue of Augustus of larger size than the others excels also by its wonderful sculptural art, presenting his triumph and his victory over the enemy. Moreover, everywhere on the arch the army is carved, and everywhere detested war, so that when you look closely, you think you see

101 Pope Gregory I, 590–604.
102 Ovid, *Ars amatoria*, I, 248.
103 The triumphal arch of Augustus stood at the southeast side of the Roman Forum.

actual battle. There the battle of Actium is admirably shown, where Caesar, victorious beyond all his hopes, pursues Cleopatra in flight in her galley, and where Cleopatra is led captive, and again where the proud queen, shown in Parian marble, the asps at her breast, languishes in death.

From this war Caesar Augustus brought back highest honor, in this fashion he celebrated his triumph. Four white horses drew a golden chariot in which he sat garbed in a toga woven of gold and gems. And before him were led in long line captive kings, rulers, and generals, hands bound behind their backs, and innumerable glorious trophies. His wars and his vigorous deeds were recounted in the languages of all the peoples who made up Rome, and the people read and sang songs in honor of his triumph. Moreover, his victory was carved on tablets so that those who could not hear his praise should see it. So with solemn song and inexpressible joy the people led him even to the Tarpeian rock on the Capitol, where he exhibited his arms, both those he had used in battle and those which he had captured from the enemy, and hung them up under the dome as token of a great victory. And there the senate and senators and Roman people gave him the last province, so that the report of his triumph and the praise of his great victory might enlighten the world.

These events as I have here described them are in all respects shown in the sculptures on the arch.

I also saw many other triumphal arches, which are much like this one in workmanship and art, and may therefore be taken as described. Each one of them pictures a victorious war and the great deeds of the victor and so represents to this present day the great glory of former times.

The Pyramids, tombs of the mighty. Now I shall add something about the pyramids. These tombs of the mighty are of great size and height, pointed at the top, semi-conic in shape. The first which I saw is that of Romulus,[104] standing before the Tower of Crescentius[105] . . . near St. Peter's. The pilgrims utter this lie about it: they say it was the grain-heap of the apostle Peter; when Nero seized it for himself, it was turned into a hill of stone of the same size. This story is folly, in which the pilgrims abound. Each pyramid contains a marble vessel, which is sculptured on all sides, enclosed within it, in which the corpse is laid.

The Pyramid of Augustus.[106] I also saw the pyramid of Augustus near the Porta Latina, built of square stones fastened with iron so that no degree of age has yet been able to tear out one stone.

[104] A pyramidical tomb, which was called *Meta Romuli* during the Middle Ages, existed until the 15th century in the vicinity of Castel Sant'Angelo.

[105] The mausoleum of Hadrian, today's Castel Sant'Angelo.

[106] Since the mausoleum of Augustus lies in another part of the city, it is likely that Master Gregory speaks here of the pyramid of C. Cestius, which was called the *Meta Remi* during the Middle Ages because of its similarity to the *Meta Romuli*. See above, footnote 104.

There are many pyramids in Rome, but the one worthy of greatest admiration is the pyramid of Julius Caesar, which is made of one complete block of porphyry. It is truly remarkable how a mass of such great height could have been cut, or been raised, or remained standing, for its height they say is 250 feet. At the top is poised a bronze sphere in which the bones and ashes of Julius Caesar are buried.[107] From this remarkable pyramid comes the saying:

If this is but one stone, say what skill raised it;
If there are many stones, say where they join.

... This pyramid is called by the pilgrims St. Peter's needle, and with great effort they crawl under it where it is supported by four bronze lions. And they lyingly say that they are saved from sin and do genuine penance if they can crawl under the stone.[108]

Benjamin of Tudela: Baghdad and Babylon

Twelfth-century travelers looked with fresh eyes at familiar places like Canterbury and Rome. But they had an unprecedented opportunity to look at new places as well. This was provided by the great wave of western European expansion in the eleventh century. Sicily and a large part of Moslem Spain were conquered, and the Latin Kingdom of Jerusalem was founded. In a time when knights, merchants, and artists moved in large numbers between Europe and the Near East, few people can have traveled further than Benjamin of Tudela, a rabbi who left his city in northern Spain during the middle of the twelfth century in order to visit Jewish communities in Europe and in the Near and Middle East. He went as far as Baghdad, where he saw the ruins of Babylon and visited the tomb of Ezekiel.

In Bagdad there are twenty-eight Jewish Synagogues, situated either in the city itself or in Al-Karkh on the other side of the Tigris; for the river divides the metropolis into two parts. The great synagogue of the Head of the Captivity[109] has columns of marble of various colours overlaid with silver and gold, and on these columns are sentences of the Psalms in golden letters. And in front of the ark are about ten steps of marble; on the topmost step are the seats of the Head of the Captivity

107 The obelisk described here is probably the Vatican obelisk which stands today before St. Peter's, since Gregory later refers to it as *St. Peter's needle.*

108 *Master Gregory's Book on the Marvels Which Were Once at Rome or Are Still There,* Chaps. I, XII, XXI–XXIII, XXVII–XXIX, trans. George B. Parks, *The English Traveller to Italy,* I (Roma: Edizioni di Storia e Letteratura, 1954), 254–55, 260–61, 263–64, 266–67. Reprinted by permission of Edizioni di Storia e Letteratura.

109 Exilarch, head of the Babylonian Jewry, a hereditary dignity wth princely privileges.

and of the Princes of the House of David. The city of Bagdad is twenty miles in circumference, situated in a land of palms, gardens and plantations, the like of which is not to be found in the whole land of Shinar. People come thither with merchandise from all lands. Wise men live there, philosophers who know all manner of wisdom, and magicians expert in all manner of witchcraft.

Thence it is two days to Gazigan which is called Resen. It is a large city containing about 5,000 Jews. In the midst of it is the Synagogue of Rabbah—a large one. He is buried close to the Synagogue, and beneath his sepulchre is a cave where twelve of his pupils are buried.

Thence it is a day's journey to Babylon, which is the Babel of old. The ruins thereof are thirty miles in extent. The ruins of the palace of Nebuchadnezzar[110] are still to be seen there, but people are afraid to enter them on account of the serpents and scorpions. Near at hand, within a distance of a mile, there dwell 3,000 Israelites who pray in the Synagogue of the Pavilion of Daniel, which is ancient and was erected by Daniel. It is built of hewn stones and bricks. Between the Synagogue and the Palace of Nebuchadnezzar is the furnace into which were thrown Hananiah, Mishael, and Azariah,[111] and the site of it lies in a valley known unto all.

Thence it is five parasangs to Hillah, where there are 10,000 Israelites and four Synagogues: that of R. Meir, who lies buried before it; the Synagogue of Mar Keshisha, who is buried in front of it; also the Synagogue of Rab Zeiri, the son of Chama, and the Synagogue of R. Mari; the Jews pray there every day.

Thence it is four miles to the Tower of Babel,[112] which the generation whose language was confounded built of the bricks called Agur. The length of its foundation is about two miles, the breadth of the tower is about forty cubits, and the length thereof two hundred cubits. At every ten cubits' distance there are slopes which go round the tower by which one can ascend to the top. One can see from there a view twenty miles in extent, as the land is level. There fell fire from heaven into the midst of the tower which split it to its very depths.

Thence it is half a day to Kaphri, where there are about 200 Jews. Here is the Synagogue of R. Isaac Napcha, who is buried in front of it. Thence it is three parasangs to the Synagogue of Ezekiel, the prophet of blessed memory, which is by the river Euphrates. It is fronted by sixty turrets, and between each turret there is a minor Synagogue, and in the court of the Synagogue is the ark, and at the back of the Synagogue is the sepulchre of Ezekiel.[113] It is surmounted by a large cupola, and it is a very

110 Nebuchadnezzar, King of Babylon (605–562 B.C.). He conquered Jerusalem in 598 and led the Jews into captivity.

111 Dan. 3: 12–100.

112 The ziggurat of Borsippa, an ancient city fifteen miles from Babylon, seems to have been destroyed by spontaneous combustion.

113 The prophet Ezechiel was one of the captives and died in Babylon.

handsome structure. It was built of old by King Jeconiah, king of Judah,[114] and the 35,000 Jews who came with him, when Evil-merodach[115] brought him forth out of prison. This place is by the river Chebar on the one side, and by the river Euphrates on the other, and the names of Jeconiah and those that accompanied him are engraved on the wall: Jeconiah at the top, and Ezekiel at the bottom. This place is held sacred by Israel as a lesser sanctuary unto this day, and people come from a distance to pray there from the time of the New Year until the Day of Atonement. The Israelites have great rejoicings on these occasions. Thither also come the Head of the Captivity, and the Heads of the Academies from Bagdad. Their camp occupies a space of about two miles, and Arab merchants come there as well. A great gathering like a fair takes place, which is called Fera, and they bring forth a scroll of the Law written on parchment by Ezekiel the Prophet, and read from it on the Day of Atonement. A lamp burns day and night over the sepulchre of Ezekiel; the light thereof has been kept burning from the day that he lighted it himself, and they continually renew the wick thereof, and replenish the oil unto the present day. A large house belonging to the sanctuary is filled with books, some of them from the time of the first temple, and some from the time of the second temple, and he who has no sons consecrates his books to its use. The Jews that come thither to pray from the land of Persia and Media bring the money which their countrymen have offered to the Synagogue of Ezekiel the Prophet. The Synagogue owns property, lands and villages, which belonged to King Jeconiah, and when Mohammed came he confirmed all these rights to the Synagogue of Ezekiel. Distinguished Mohammedans also come hither to pray, so great is their love for Ezekiel the Prophet; and they call it Bar (Dar) Melicha (the Dwelling of Beauty). All the Arabs come there to pray.[116]

ART AND THEOLOGY

Gilbert Crispin: Scripture and Images

The old controversy between puritans and patrons of art, which had subsided during the tenth and eleventh centuries, was fought with new

114 Jeconiah, king of Israel (562) was defeated by Nebuchadnezzar, who kept him a prisoner for 37 years.

115 Evil-Merodach, Nebuchadnezzar's son, released Jeconiah from his captivity.

116 *The Itinerary of Benjamin of Tudela*, chaps. LXIV–LXVIII, trans. M. N. Adler (London, Henry Frowde, 1907), 42–45.

intensity during the first half of the twelfth century. Romanesque art, with its exuberant taste for the grandiose and exotic, was too conspicuous a presence to be overlooked. Since the two most famous Benedictine monasteries of this period, Monte Cassino and Cluny, were also centers of art, it seems only natural that many of the defenders of religious art were Benedictines. This is also true of Gilbert Crispin, who was abbot of Westminster from 1085 to 1117. His dialogue between a Jew and a Christian was probably based on an actual encounter. Written between 1093 and 1096, it was dedicated to the author's close friend St. Anselm, whose humane spirit seems to be reflected in the relative urbanity of the exchange. The dialogue was much read and imitated. Some of Gilbert's arguments are quite conventional: his distinction of different modes of worship goes back to the second Council of Nicaea (787). And when he hopes to invalidate the injunction of Exodus 20: 4 by quoting from Exodus 25: 8–9, he advances an argument that had already been rejected by St. Jerome.[117] New and interesting however, is what he has to say about the relationship of images and Scripture. He avoids the juxtaposition of what is obviously incompatible and distinguishes between the text and the content of Scripture. Where the latter consists of things seen, it may be transcribed into images, as the words of Scripture are transcribed into writing. Although Gilbert Crispin does not spell out the implications of his arguments, one sees easily that he ascribes an important religious function to images, which under certain conditions may express the contents of Scripture in a more adequate fashion than words.

The Jew: . . . Let the Christians be confounded, since they too adore graven images and delight in their idols: For indeed you depict your own God sometimes miserably hanging nailed to the arms of a cross and this horrible sight you adore. And by the cross you depict the sun as the half-figure of a boy, who is terrified (I don't know of what) and the fleeing moon as the half figure of a mournful girl, hiding herself behind the horn of her light. Sometimes, moreover, you depict God sitting on a lofty throne blessing with an outstretched hand, and around him, as if it were a sign of great dignity, an eagle, a man, a bull-calf and a lion. These effigies the Christians carve out, make, and paint, wherever they can, and wherever they can they adore and worship them: a thing absolutely forbidden by the Law the Lord gave. For in Exodus it is written: "Thou shalt not make to thyself a graven thing, nor the likeness of anything that is in heaven above or in the earth beneath, nor of those things that are in the waters under the earth. Thou shalt not adore them nor serve them."[118] The Law thus prohibits all graven images and menaces him who shall make them with a terrible judgement.

117 See above, pp. 38–39.
118 Exod. 20: 4.

The Christian: If the Law ever so damns all graven images, then Moses sinned who depicted similitudes and carved them; nay God sinned who ordered him to depict and carve them. Because in Exodus the Lord prescribed thus: "And they shall make me a sanctuary. . . . According to all the likeness of the tabernacle which I will shew thee, and of all the vessels for the service thereof."[119] And a little below: "Thou shalt make also a plate of the purest gold: wherein thou shalt grave with engraver's work: Holy to the Lord."[120] And: "And thou shalt take two onyx stones: and shalt grave on them the names of the children of Israel with the work of an engraver and the graving of a jeweller."[121] Behold how similitudes are made and how God orders them to be made. Behold how sculpture is made for the Lord in stones of onyx and gold. In the book of Kings, moreover, one reads about the building of the Lord's temple: "And all the walls of the temple round about he carved with divers figures and carvings: and he made in them cherubim and palm trees and divers representations, as it were, standing out and coming forth from the wall. He made also a molten sea of ten cubits from brim to brim. And it stood upon twelve oxen.[122] And a little below: "And he made in the oracle two cherubim of olive tree, of ten cubits in height."[123] And also: "And the priests brought in the ark of the covenant of the Lord into its place, into the oracle of the temple into the Holy of Holies under the wings of the cherubims."[124] Behold how openly scripture enumerates pictures and graven images, not condemning but approving those which existed in the Lord's temple. And God himself made known that he approved of all those things which had been made: "And the priests," it is written, "could not stand to minister because of the cloud: for the glory of the Lord had filled the house of the Lord."[125] The Prophet Isaias said: "In the year that king Ozias died I saw the Lord sitting upon a throne high and elevated. Upon it stood the seraphim: the one had six wings, and the other had six wings."[126] About those four images of living creatures, which you have mentioned with unjustified derision, the prophet Ezechiel has spoken thus: "And as for the likeness of their faces: there was the face of a man, and the face of a lion on the right side of all the four, and the face of an ox on the left side of all the four, and the face of an eagle over all the four."[127] What therefore Isaiah saw, said and wrote, what Ezechiel saw, said and wrote, it is fitting that these things should after them be

119 Exod. 25: 8–9.
120 Exod. 28: 36.
121 Exod. 28: 9, 11.
122 III Kings 6: 29; 7: 23, 25.
123 III Kings 6: 23.
124 III Kings 8: 6.
125 III Kings 8: 11.
126 Isa. 6: 1.
127 Ezek. 1: 10.

written and said and inscribed into that other language of images. Because just as letters in some fashion may become figures and signs of words, so scriptural matters may likewise appear as likenesses and signs in painting. What else need I say? Let us finish our discourse and arrive at the conclusion of the question that has been proposed. God prohibits the making of graven images and yet as we read graven images have been made on the Lord's command. The word of the Law therefore ought to be interpreted with discretion, and indeed when the Lawgiver says: "Thou shalt not make to thyself a graven thing, et cetera,"[128] he also gives the reason: "Thou shalt not adore them nor serve them."[129] Excluding therefore the idolatry of false worship, images were made by the Jews and can also be made by us. In God's honor we make pictures, in God's honor we make carvings, in God's honor we also make graven images. But we do not adore them or worship them as if they were divine. For even the cross itself, which we call holy, we regard as wood and not as God and we hold that in itself and by itself it holds no virtue. And after it has been sanctified by the priest's blessing in the memory of the Lord's passion we still receive, tend and venerate it not with divine worship but with the worship of due veneration, as is said in the Psalm: "Adore his footstool, for it is holy."[130] . . . When therefore a Christian adores the cross then he adores in the cross with divine worship the passion of Christ because it is the passion of a man joined to God in personal unity, and with the worship of due veneration he adores the image of the cross, the carved likeness of the Lord's passion.[131]

Rupert of Deutz: Divine Grace and Artistic Skill

Rupert of Deutz, who died in 1129 or 1135, was, like Gilbert Crispin, a Benedictine. In a passage appended to his commentary on Exodus, he claimed that the artist's talent is a special gift of God and ought to be employed accordingly, that is, without undue interest in material rewards. The Church, which, throughout the early middle ages, had been able to command and attract artistic talent without much competition had various reasons to give new thought to the problems of religious art at a moment when lay artists became more and more important. They had families and households to maintain and demanded an adequate reward. In such a situation it was not only generous but also expedient to elevate the artist to a special status, thereby implying that he had also a special debt to repay.

128 Exod. 20: 4.
129 Exod. 20: 5.
130 Psalms 98: 5.
131 Gilbert Crispin, *Disputatio Iudei et Christiani*, ed. B. Blumenkranz, *Stromata Patristica et Mediaevalis*, III (Utrecht: In Aedibus Spectrum, 1956), 65–68.

Here we end our treatise on the book of Exodus, because the things which were said and done concerning the construction of the temple we have already dealt with according to our ability at an earlier point. However, this we think should not be omitted, which Moses told the children of Israel: "Behold the Lord hath called by name Beseleel, the son of Uri, the son of Hur, from the tribe of Juda, and hath filled him with the spirit of God, with wisdom and understanding. Oliab also, the son of Achisamech, of the tribe of Dan. Both of them hath he instructed with wisdom, to do carpenters' work, and tapestry, and embroidery."[132] Beseleel is also taken to mean "The Lord's shadow" because by his name he signifies, as has been said, the tabernacle, because he made it a shadow, that is a type, of the heavenly tabernacle. Oliab is also taken to mean "The Father is my protection," and signifies by this name that the protection of the Lord and his tabernacle may be hoped for as a reward by those who serve him. And since scripture says with divine authority that "the Lord called them by name" and "both of them hath he instructed with wisdom," who could doubt that these as well as all other arts of this sort are gifts from God? In like manner, in whatever man such useful and licit arts are found, they ought to be cherished, and skilled craftsmen ought to be admonished lest they devote divine skill to the pursuit of gain, for their talents are not their own, but bestowed on them by their creator, and that which he has given he will also require.[133]

St. Bernard to William of St. Thierry: Ascetic Reaction

A new and sharpened sense of the incompatibility of secular and religious concerns was the cause as well as a result of the investiture controversy, which reached its critical phase between 1075 and 1122. A wave of puritanism led to the foundation of stricter monastic orders like the Carthusians, Cistercians, and Praemonstratensians. From their ranks came the ascetics of the twelfth century to whom the luxuriousness, the sensuality and the paganism of contemporary art seemed scandalous. The writings of these critics are often influenced by St. Jerome,[134] and one of them, the Carthusian Guiges de Châtel,[135] edited the letters of St. Jerome. The most eloquent among the enemies of romanesque art was St. Bernard of Clairvaux, whose critique is also the most perceptive.

But these are small things; I will pass on to matters greater in themselves, yet seeming smaller because they are more usual. I say naught of the vast height of your churches, their immoderate length, their super-

132 Exod. 35: 30–31.
133 Rupert of Deutz, *In Exodum*, IV, 44, ed. Migne, *Patrologia latina*, CLXVII (Paris, 1862), col. 744.
134 See above, pp. 37–40.
135 Guiges de Châtel, prior of the Grand Chartreuse (1110–37).

fluous breadth, the costly polishings, the curious carvings and paintings
which attract the worshipper's gaze and hinder his attention, and seem to
me in some sort a revival of the ancient Jewish rites. Let this pass, how-
ever: say that this is done for God's honour. But I, as a monk, ask of my
brother monks as the pagan[136] [poet Persius] asked of his fellow-pagans:
"Tell me, O Pontiffs" quoth he, "what doeth this gold in the sanc-
tuary?"[137] So say I, "Tell me, ye poor men" for I break the verse to keep
the sense, "tell me, ye poor if, indeed, ye be poor, what doeth this gold in
your sanctuary?" And indeed the bishops have an excuse which monks
have not; for we know that they, being debtors both to the wise and the
unwise, and unable to excite the devotion of carnal folk by spiritual
things, do so by bodily adornments. But we who have now come forth
from the people; we who have left all the precious and beautiful things
of the world for Christ's sake; who have counted but dung, that we may
win Christ, all things fair to see or soothing to hear, sweet to smell,
delightful to taste, or pleasant to touch—in a word, all bodily delights—
whose devotion, pray, do we monks intend to excite by these things? What
profit, I say, do we expect therefrom? The admiration of fools, or the
oblations of the simple? Or, since we are scattered among the nations,
have we perchance learnt their works and do we yet serve their graven
images? To speak plainly, doth the root of all this lie in covetousness,
which is idolatry, and do we seek not profit, but a gift? If thou askest:
"How?" I say: "In a strange fashion." For money is so artfully scattered
that it may multiply; it is expended that it may give increase, and prodi-
gality giveth birth to plenty: for at the very sight of these costly yet mar-
vellous vanities men are more kindled to offer gifts than to pray. Thus
wealth is drawn up by ropes of wealth, thus money bringeth money; for
I know not how it is that, wheresoever more abundant wealth is seen,
there do men offer more freely. Their eyes are feasted with relics cased in
gold, and their purse-strings are loosed. They are shown a most comely
image of some saint, whom they think all the more saintly that he is the
more gaudily painted. Men run to kiss him, and are invited to give; there
is more admiration for his comeliness than veneration for his sanctity.
Hence the church is adorned with gemmed crowns of light—nay, with
lustres like cartwheels, girt all round with lamps, but no less brilliant
with the precious that stud them. Moreover we see candelabra
standing like trees of massive bronze, fashioned with marvellous subtlety
of art, and glistening no less brightly with gems than with the lights they
carry. What, think you, is the purpose of all this? The compunction of
penitents, or the admiration of beholders? O vanity of vanities, yet no
more vain than insane! The church is resplendent in her walls, beggarly

136 Persius Flaccus, a Stoic poet (34–62 A.D.).
137 Persius, *Saturae* II, 71–72.

in her poor; she clothes her stones in gold, and leaves her sons naked; the rich man's eye is fed at the expense of the indigent. The curious find their delight here, yet the needy find no relief. Do we not revere at least the images of the Saints, which swarm even in the inlaid pavement whereon we tread? Men spit oftentimes in an Angel's face; often, again, the countenance of some Saint is ground under the heel of a passer-by. And if he spare not these sacred images, why not even the fair colours? Why dost thou make that so fair which will soon be made so foul? Why lavish bright hues upon that which must needs be trodden under foot? What avail these comely forms in places where they are defiled with customary dust? And, lastly, what are such things as these to you poor men, you monks, you spiritual folk? Unless perchance here also ye may answer the poet's question in the words of the Psalmist: "Lord, I have loved the habitation of Thy House, and the place where Thine honour dwelleth."[138] I grant it, then, let us suffer even this to be done in the church; for, though it be harmful to vain and covetous folk, yet not so to the simple and devout. But in the cloister, under the eyes of the Brethren who read there, what profit is there in those ridiculous monsters, in that marvellous and deformed comeliness, that comely deformity? To what purpose are those unclean apes, those fierce lions, those monstrous centaurs, those half-men, those striped tigers, those fighting knights, those hunters winding their horns? Many bodies are there seen under one head, or again, many heads to a single body. Here is a four-footed beast with a serpent's tail; there, a fish with a beast's head. Here again the forepart of a horse trails half a goat behind it, or a horned beast bears the hinder quarters of a horse. In short, so many and so marvellous are the varieties of divers shapes on every hand, that we are more tempted to read in the marble than in our books, and to spend the whole day in wondering at these things rather than in meditating the law of God. For God's sake, if men are not ashamed of these follies, why at least do they not shrink from the expense?[139]

ARTISTS AND PATRONS

An Exchange of Letters

The abbot Wibald of Stavelot was a prominent politician who

[138] Psalm 25: 8.

[139] Bernard of Clairvaux, *Letter to William of St. Thierry*, trans. G. G. Coulton, *A. Mediaeval Garner* (London: Constable and Co., 1910), pp. 70–72. Reprinted by permission of Constable and Co., Ltd.

served three emperors, Lothair II,[140] *Conrad III,*[141] *and Frederick Barba-rossa.*[142] *He traveled widely and went twice as an envoy to Constantinople, where he died in 1158. He was also a famous patron of the arts. His cor-respondent may have been Godefroi de Claire, a goldsmith who worked, like Wibald, for the emperors Lothair II and Conrad III. Godefroi also shared Wibald's taste for travel, which led him as far as Sidon. He later returned to Huy where he died as a canon in 1175. The letters show the abbot urging the goldsmith to deliver his work and the goldsmith de-manding his pay. To say that patron and artist treat each other as equals in these letters would probably be an exaggeration. Each, however, seems to assess his own position as well as that of his opponent carefully: the abbot finds it necessary to temper his imperious demand with politeness, while the goldsmith allows himself only an undertone of mockery. It is obvious that both men esteem each other, but that neither is willing to give an inch of what he considers to be his right or his prerogative.*

Abbot Wibald to the Goldsmith G.

Brother Wibald to his beloved son G. the goldsmith greeting and blessing.

Men of your profession are often wont not to fulfill their promises, since they accept more work than they are able to perform, greed being the root of all evil. But your noble talent and your willing and celebrated hand avoid all suspicion of deceit. May good faith guide your craft, may honesty accompany your work, may your promises be fulfilled in time. And we believe that you should be reminded of your binding promises, especially since no suspicion of fraud and falseness can reside in the home of such a distinguished talent. Why then do we say these things? Namely that you may zealously concentrate on the work we have ordered you to do and not in the meantime accept another commission which might hinder the completion of ours. Know, that our desire is impatient and pressing and that we want quickly that which we want. As Seneca says in his *De beneficiis*: "He gives twice who gives quickly."[143] Later we intend to write you at more length about the care and management of your household, the government of your family and the supervision and dis-cipline of your wife.

The Goldsmith G. to Abbot Wibald

To Lord Wibald by the grace of God abbot of Stavelot and Corbie his G. sends greetings and due reverence.

140 Lothair II, German Emperor (1125–37).
141 Conrad III, German Emperor (1138–52).
142 Frederick I, German Emperor (1152–90).
143 A medieval proverb, here ascribed to Seneca who expresses a similar thought in *De Beneficiis*, II, 1–4.

I have received both joyfully and obediently the admonitions bestowed on me by your benevolence from the treasury of your wisdom, admonitions which certainly were as acceptable for the gravity of their content as for the authority of the sender. And so I have committed to memory and, as it were, locked away your council that my craft should be guided by good faith, that my labor should be performed with honesty, that my commitments should be fulfilled. But it is not always in the power of him who promises to fulfill his promises. Often you, to whom the promise has been made are the cause why its fulfillment is omitted or delayed. And so if it is true that you are as you say impatient in desire and wish what you wish at once, hasten that I may be swift in doing your work. For I hurry and will hurry unless necessity brings delay. My purse, however, is empty: none indeed of those I have served has treated me in such fashion. And he who according to your promise was to bring light to my wife has rather brought darkness, since while raising expectations of a reward he delayed the reward itself. Therefore, in as much as human need after famine rejoices in repletion, be mindful of necessity, give quickly that you may give twice and you will find me faithful, constant, wholly devoted to your work. Farewell.

Remind yourself how much time there is between the 1st of May and the feast of S. Margaret[144] and between the latter and the feast of S. Lambert.[145] A word to the wise is sufficient.[146]

Theophilus: The Decoration of a Chalice

Theophilus' treatise on the various arts was written during the first quarter of the twelfth century. Its author, a man of considerable intellectual power and expert knowledge, seems to have had some connections with Cologne and may have been a goldsmith. Whether or not he was Roger of Helmarshausen,[147] as has been suggested, we do not know. Compared to the short and often muddled recipes collected by other mediaeval artists, Theophilus' treatise is a completely new departure. Written in long paragraphs, it describes the making of a particular artifact step by step from the preparation of the workshop to the finishing touch. The amount of planning and forethought which should go into the artist's work is admirably understood and explained. Such planning eventually allowed a division of labor, the use of preparatory drawings, and a careful estimate of a project's aesthetic effect.

144 July 20.
145 April 14.
146 Epistolae Wibaldis abbatis, Epistolae C, CI ad a. 1148, ed. Migne, *Patrologia latina* (Paris, 1854), col. 1193–94.
147 A goldsmith who worked in Paderborn around 1100.

. . . After doing this, take a flat thin piece of gold and fit it to the upper rim of the bowl. Measure this piece so that it extends from one handle around to the other; its width should equal the size of the stones you want to set on it. Now, as you arrange the stones in their place, distribute them in such a way that first there stands a stone with four pearls placed at its corners, then an enamel, next to it another stone with its pearls, then another enamel; arrange it all so that stones will always stand next to the handles. Build up the settings for the stones and the grounds and also the settings in which the enamels are to be placed, and solder as above. Do the same on [the strip for] the other side of the bowl. If you want to put gems and pearls in the middle of the body, do it in the same way. After doing this fit [the settings and grounds] together and solder them like the handles.

After this in each of the settings in which enamels are to be put you should fit in place a single flat thin piece of gold. When they have been carefully fitted, take them out and with a measure and rule cut up into pieces a strip of somewhat thicker gold and bend them around the rim of each setting, twice, so that there is a narrow space running all around between the small strips. This space is called the border of the enamel. Then using the same measure and rule cut strips of the thinnest possible gold; out of these bend and shape with tweezers whatever work you want to make in enamel, whether circles or scrollwork or little flowers or birds or animals or figures. Arrange the pieces delicately and carefully, each in its proper place, and secure them with moistened flour over the coals. When you have completed one plaque, solder it, taking the greatest care that the delicate work and the thin gold do not become separated or melt. Do this two or three times until each piece firmly adheres.

When you have built up and soldered all the [plaques for] the enamels in this way, take all the kinds of glass you have prepared for this work and breaking off a little from each piece put all the fragments at the same time on a single sheet of copper, each fragment, however, by itself. Then put it into the fire and build up coals around and above it. Then while you are blowing observe carefully whether the fragments melt evenly; if so, use them all; but if any fragment is more resistant, lay aside by itself the stock that it represents. Now take all the pieces of tested glass and put them one at a time in the fire and when each one becomes red-hot throw it into a copper pot containing water and it will immediately burst into tiny fragments. Quickly crush these fragments with a pestle until they are fine. Wash them and put them in a clean shell and cover with a linen cloth. Prepare each color separately in this way.

After doing this, take one of the soldered gold plaques and stick it with wax in two places onto a flat smooth board. Take a goose quill, cut as finely as for writing, but with a longer and unsplit point, and with it draw up [some of] whichever glass color you want, which should be moist.

With a long, slender, fine-pointed copper tool scrape the color delicately off the point of the quill and fill in whatever little flower you wish with as much as you want. Replace any of it that is left over in its own little pot and cover it. Do the same with each of the colors until one plaque is filled. Then take away the wax to which it was stuck, and put the plaque on a flat thin iron tray which should have a short handle. Cover this with another piece of iron, which should be concave like a small bowl and should be finely perforated all over with [punched] holes that are smooth and wide on the inside while on the outside they are narrower and jagged and serve to keep off any ashes that happen to fall on it. This cover should also have a small ring in the middle on top, by means of which it may be put on and lifted off.

After doing this, heap up big, long pieces of charcoal and burn them strongly. Make a place among them and smooth it with a wooden mallet so that the iron tray may be lifted into it with tongs by its handle. Cover it and carefully set it in position; then build up charcoal on all sides around and above it, take the bellows with both hands and blow from all sides until the coals blaze evenly. You should also have a whole wing of a goose or some other large bird, which should be fully spread and tied to a stick; fan [the coals] with this and blow vigorously on every side until you see between the coals that the holes in the cover are completely red-hot inside. Then cease blowing. After waiting about half an hour uncover it gradually until you have removed all the coals. Again wait until the holes of the cover grow black inside; then lift the tray out by its handle and, keeping it covered, put it in a corner behind the furnace until it is completely cold. Now open it and take out the enamel and wash it. Fill it again and melt as before. Continue in this way until everything is melted and it is evenly filled throughout. Build up the remaining pieces in the same way.

After doing this take a piece of wax the length of half a thumb. Fit the enamel in this so that on every side there is wax by which to hold it. Rub the enamel carefully on a flat smooth piece of sandstone with water until the gold [cloisons] appear evenly everywhere. Next, rub it for a very long time on a hard, smooth hone until it acquires clarity. Moisten the same hone with saliva and rub on it a potsherd of the kind that are found broken from ancient pots, until the saliva becomes thick and reddish; then smear it on a flat smooth lead plate and rub the enamel gently on it until the colors become translucent and clear. Again rub the sherd on the hone with saliva and smear it on a goatskin fastened to a flat smooth wooden board. Polish the enamel on this until it is completely brilliant, so much so that if half of it becomes wet while the other half remains dry, no one can tell which is the dry part and which is the wet.

Then cast the gold from which you should shape the foot with its knop . . . in the middle of the knop and round the rim of the foot arrange a border with stones and enamels as above. Also, when you have shaped

the paten to the size and shape you want, make a border with the same kind of work round its rim, in the same way. Also make a gold fistula in the same way and manner as the silver one above. Also ornament crosses, missal covers, and reliquaries with similar work using stones, pearls, and enamels.[148]

Heraclius: The Colors and Arts of the Romans

Heraclius' versified treatise on the colors and the arts of the Romans was already in existence when Theophilus wrote. Its author lived proba-bly during the later half of the eleventh century. His collection consists of a number of short recipes, many of which contain fantastic ingredients or call for strange procedures. Heraclius' technical knowledge does not compare with the expertise of Theophilus. On another level, however, Heraclius' approach is equally interesting. The idea of versifying the treatise, thereby adopting a literary form typical of treatises on the liberal arts, was extraordinary and indicates the author's belief in the theoretical dignity of his subject. Some of the more fanciful recipes were transcribed from Pliny. They were not so much signs of technological backwardness as of classical erudition. Heraclius not only read ancient texts but studied ancient objects, as his description of gold glass shows.

I have described, brother, various flowers for your use, as I best could. I have added to the flowers the arts which relate to, and are proper for writing; to which, if you pay attention, you will find them true in practice. I indeed write nothing to you, which I have not first tried myself. The greatness of intellect, for which the Roman people was once so emi-nent, has faded, and the care of the wise senate has perished. Who can now investigate these arts? Who is now able to show us what these arti-ficers, powerful by their immense intellect, discovered for themselves? He who, by his powerful virtue, holds the keys of the mind, divides the pious hearts of men among various arts.

The Romans made themselves phials of glass, artfully varied with gold, very precious, to which I gave great pains and attention, and had my mind's eye fixed upon them day and night, that I might thus attain the art by which the phials shone so bright; I at length discovered what I will explain to you, my dearest friend. I found gold-leaf carefully inclosed between the double glass. When I had often knowingly looked at it, being more and more troubled about it, I obtained some phials shining with clear glass, which I anointed with the fatness of gum with a paint-brush. Having done this, I began to lay leaf-gold upon them, and when they were dry I engraved birds and men and lions upon them, as I thought

[148] Theophilus, *On Divers Arts*, III, 53–56, trans. John G. Hawthorne and Cyril Stanley Smith (Chicago: University of Chicago Press, 1963), pp. 125–28. By permission of the authors and of the University of Chicago Press.

proper. Having done this, I placed over them glass made thin with fire by skilful blowing. After they had felt the heat thoroughly, the thinned glass adhered properly to the phials.

Whoever wishes to cut with iron the precious stones in which the kings of the Roman city who anciently held the arts in high estimation much delighted, upon gold, let him learn the discovery which I made with profound thought, for it is very precious. I procured urine, with the fresh blood of a huge he-goat, fed for a short time upon ivy, which being done, I cut the gems in the warm blood, as directed by Pliny,[149] the author who wrote upon the arts which the Roman people put to proof, and who also well described the virtues of stones; of which he who knows the powers, esteems them most. For the first kings, who anciently held the city, adorned with gems their garments, gleaming with gold; of these the most remarkable was Aurelian,[150] who interwove his own robes with gems and gold.[151]

Theophilus: The Artist's Mission

Although architecture, sculpture, painting and goldsmith work were omnipresent in the life of the mediaeval church, Latin theology had never taken the trouble to formulate a coherent doctrine about the fine arts and their religious role. Much of the variety of early mediaeval art, as well as its occasional lack of polish, was due to this strange absence of rationalization, which contrasts so sharply with the Byzantine situation. The gap left by theologians was soon to be filled by artists. Theophilus was the first of a long list of artists who were also philosophers and who appropriated the right to define their own position. Theophilus' ideas seem to be influenced by Rupert of Deutz, who was his contemporary and who also lived in the same region.

David—renowned among the prophets, whom the Lord God, in His prescience, predestined before the world began, and whom He 'chose after His own heart'[152] because of his simplicity and humility of mind, and placed as a Prince over His chosen people, strengthening him with a princely spirit so that he might nobly and wisely establish the rule of so great a name—David, applying himself with the full force of his mind to the love of his Creator, among other things uttered these words: 'Lord, I have loved the beauty of Thy House.'[153]

149 Pliny the Elder, *Historia naturalis,* XXXVII, 59.

150 Possibly a reference to the emperor Aurelian (270–75).

151 Heraklius, *On the Colours and Arts of the Romans,* prologue, Chaps. V, VI, trans. M. P. Merrifield, *Original Treatises Dating from the Twelfth to the Eighteenth Centuries on the Arts of Painting* (London: J. Murray, 1848), I, 182, 186–90.

152 Acts 13: 22.

153 Psalms 25: 8.

It is true that a man of such authority and such great intellect may have meant by that House the habitation of the heavenly court, in which God presides over hymning choirs of angels in inestimable glory, and for which he pants with his whole being, saying: 'One thing have I desired of the Lord, that will I seek after: that I may dwell in the house of the Lord all the days of my life';[154] or else the refuge of a devoted breast and pure heart where truly God dwells, for, burning with a desire to entertain such a guest, he prays: 'Renew a right spirit within me, O Lord.'[155] Nevertheless, it is certain that he desired the embellishment of the material House of God, which is the place of prayer. For, he himself longed with a most ardent desire to become the founder of the House of God but, because of his frequent spilling of human, albeit enemy blood, he did not merit it and entrusted almost all the needful resources in gold, silver, bronze and iron to his son Solomon. For he had read in *Exodus*[156] that the Lord had given to Moses a commandment to build a tabernacle, and had chosen by name the masters of the work, and had filled them with the spirit of wisdom and understanding and knowledge in all learning for contriving and making works in gold and silver, bronze, gems, wood and in art of every kind. By pious reflection he had discerned that God delighted in embellishment of this kind, the execution of which He assigned to the power and guidance of the Holy Spirit, and he believed that nothing of this kind could be endeavoured without His inspiration.

Wherefore, dearest son, when you have adorned His House with such embellishment and with such variety of work, you will not doubt, but believe with a full faith, that your heart has been filled with the Spirit of God. And lest perchance you have misgivings, I will clearly demonstrate that whatever you can learn, understand or devise is ministered to you by the grace of the seven fold spirit.

Through the spirit of wisdom, you know that all created things proceed from God, and without Him nothing is.

Through the spirit of understanding, you have received the capacity for skill—the order, variety and measure with which to pursue your varied work.

Through the spirit of counsel, you do not bury your talent given you by God, but, by openly working and teaching in all humility, you display it faithfully to those wishing to understand.

Through the spirit of fortitude, you drive away all the torpor of sloth, and whatever you assay with energy you bring with full vigour to completion.

Through the spirit of knowledge accorded you, you are, in the

154 Psalms 26: 4.
155 Psalms 1: 12.
156 Exod. 31: 1–11.

abundance of your heart, the master of your skill and, with the confidence of a full mind, employ that abundance for the public good.

Through the spirit of godliness, you regulate with pious care the nature, the purpose, the time, measure and method of the work and the amount of the reward lest the vice of avarice or cupidity steal in.

Through the spirit of fear of the Lord, you remember that you can do nothing of yourself; you reflect that you have or intend nothing unless accorded by God, but by believing, by acknowledging and rendering thanks, you ascribe to the divine compassion whatever you know, or are, or are able to be.

Animated, dearest son, by these supporting virtues, you have approached the House of God with confidence, and have adorned it with so much beauty; you have embellished the ceilings or walls with varied work in different colours and have, in some measure, shown to beholders the paradise of God, glowing with varied flowers, verdant with herbs and foliage, and cherishing with crowns of varying merit the souls of the saints. You have given them cause to praise the Creator in the creature and proclaim Him wonderful in His works. For the human eye is not able to consider on what work first to fix its gaze; if it beholds the ceilings they glow like brocades; if it considers the walls they are a kind of paradise; if it regards the profusion of light from the windows, it marvels at the inestimable beauty of the glass and the infinitely rich and various workmanship. But if, perchance, the faithful soul observes the representation of the Lord's Passion expressed in art, it is stung with compassion. If it sees how many torments the saints endured in their bodies and what rewards of eternal life they have received, it eagerly embraces the observance of a better life. If it beholds how great are the joys of heaven and how great the torments in the infernal flames, it is animated by the hope of its good deeds and is shaken with fear by reflection on its sins.

Come now, therefore, my wise friend—in this life happy in the sight of God and man and happier in the life to come—by whose labour and zeal so many sacrifices are offered to God, be inspired henceforth to greater deeds of skill, and with the utmost exertion of your mind prepare to execute what is still lacking in the vessels of the House of God, without which the divine mysteries and service of the Offices cannot continue. These are they: chalices, candlesticks, censers, cruets, shrines, reliquaries for holy relics, crosses, covers for Gospel Books and the rest of the things which usage necessarily demands for the ecclesiastical rites. If you wish to make these, begin in this way.[157]

[157] Theophilus, *The Various Arts,* Preface to the Third Book, trans. William C. R. Dodwell, *Theophilus, De diversis artibus* (London, Paris, Melbourne: T. Nelson and Sons Ltd., 1961), pp. 61–63. Reprinted by permission of the Clarendon Press, Oxford.

INDEX

180